# Contents

# Filters

Rex Hayman

**Focal Press**
London & Boston

**Focal Press**
**An imprint of the Butterworth Group**
Principal offices in London, Boston, Durban, Singapore,
Sydney, Toronto, Wellington

**British Library Cataloguing in Publication Data**

Hayman, R.
Filters
1. Photography—Light filters
I. Title
771.3'56   TR590.5
ISBN 0-240-51114-X

**First published 1984**

Series designed by Diana Allen
Book designed by Hilary Norman
Cover photograph by G. B. Grunwell
Photoset by Butterworths Litho Preparation Department
Origination by Adroit Photo Litho Ltd, Birmingham
Printed in Great Britain by Robert Stace Ltd,
Tunbridge Wells, Kent

# The need for filters

Filters are the most often used, and at the same time misunderstood, of all optical accessories. In the early days of photography, filters were needed mainly to correct the deficiencies and limitations in the spectral response of then available photographic emulsions. These films were generally deficient in their sensitivity to the red end of the spectrum, rendering these colours dark in comparison with green and blue. Nowadays, filters are used with black-and-white films to manipulate the effect of certain areas in the subject, either by darkening or lightening other tones in the picture, or by increasing the contrast between similar colours. With colour film, the use of a suitable colour filter prevents noticeable and unnatural colour casts when the film is exposed under light of a colour different from that for which the film is balanced. More recently, filters are being used to deliberately distort the recorded colours for pictorial effect; they now provide the photographer with a valuable tool for creative self-expression.

Skilled photographers have learned by study or controlled experiment how filters work, and their effects on colours and materials. But with the rising cost of films and, more important, the risk of losing a never-to-be-repeated subject, this book aims at providing a working knowledge of filters, an understanding of their effect, and a guide to their use that will improve the pictorial standard of its readers' photographs.

Modern films are the result of more than a century of research and experiment; never before has the photographer had available materials capable of recording everything in full colour or representative tones of grey so faithfully. Modern emulsion chemistry is so advanced that very small quantities of the ingredients can be mixed to tailor the precise characteristics of the photosensitive material, and

very precise control of the mix ensures batch-to-batch consistency. Yet even such high-quality films as we have are so far incapable of reproducing all subjects precisely as we see them. This is due partly to the limitations in the available chemistry and dyes, and partly to the fact that each of us sees colours differently. Because our eyesight and response to the various colours is the standard by which all films and photographic results are judged, it is natural that we should attempt to alter the response of films to match what we see. To make matters more difficult, the eye is continually compensating automatically for the deficiencies and inaccuracies it sees, governed by the brain, which itself has been programmed by our experiences. Thus a sheet of white paper appears yellowish under indoor lighting and bluish under ultraviolet radiation, yet we automatically think of it as white under both of these circumstances.

A similar effect occurs with colours; few of us are capable of visualising the precise colour, say, of a scarf left at home, when trying to match it with a pair of gloves. But the eye is capable of noticing the difference between colours, shades and tones when a comparison is present. An incorrectly balanced picture on a colour television set may become acceptable once we are used to it, that is until the test card appears and we are able to compare the individual colours and grey tones. Similarly, a light bulb appears white until it is seen against daylight. Films, on the other hand, can record only what they see; they take no account of the quality of the light under which they are exposed, or the colour sensitivity of our eyesight, which is created by the millions of cone and rod-shaped receptors in the retina of the eye. The rods predominate towards the edges of the retina and are considerably more light-sensitive than the cones, but they cannot distinguish different colours. As they are connected in groups, though, the image recorded by the rods has lower definition than that produced by the colour-sensitive cones. In the centre of vision (the fovea), there are some 3400 cones, each of which is connected to the brain by a separate nerve fibre; it

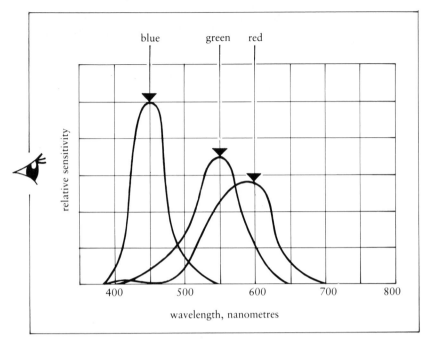

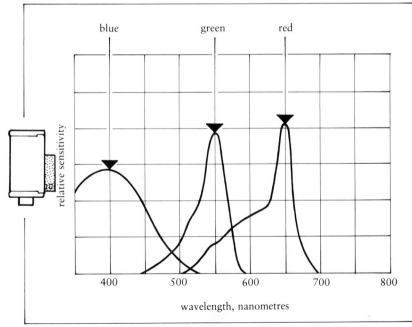

Left: the relative sensitivity to blue, green and red light of the human eye, and of the three layers of a typical colour emulsion.

is this area that has the most acute vision and colour sensitivity.'The remaining area of the retina has a mixture of rods and cones.

In 1801 Thomas Young discovered that mixtures of coloured lights produced visual effects of different hues. He concluded that this was due to the eye having three different colour receptors or 'cone' cells, each of which is sensitive to either red, green or blue, though with a degree of overlap. The various sensations of colour are produced when the three receptors are individually or collectively stimulated, the degree of stimulus having a direct bearing on the colour seen. This theory was further expanded by Helmholtz, who claimed that the eye automatically analyses the radiations it sees into three stimuli of different intensity, and that these intensities depended on the amount of red, green and blue present. The brain then interprets the amount of stimulation of each of the cone receptors as a particular colour. Of the three types of colour receptor cone, those sensitive to blue are the least

sensitive. Consequently, we see yellow and yellow-green as the brightest, followed by orange, red and then blue. The 'rod' cells, which detect only dim light, have their maximum sensitivity in the green region; so as the level of illumination falls, the colour sensitivity of the eye shifts from yellow-green to green, until at very low levels only the non-colour-sensitive rods are receptive and the subject appears to be almost colourless. This change in colour sensitivity is known as the Purkinje shift. In discussing the sensitivity and response of the eye, however, it must be remembered that what appears on the retina is interpreted by the brain. Since the brain learns by physical and psychological experience, it is the brain's interpretation that conditions our perception of light and colour, though certain physical conditions of the eye also play their part.

Early films were sensitive only to blue and violet light, but the discovery of colour-sensitising dyes resulted in orthochromatic ('correct colour') films, with their sensitivity extended into the green region and later also into the yellow. Orthochromatic emulsions are insensitive to orange and red and thus can be handled under safelights of either of these colours. Later came panchromatic emulsions sensitive to the whole visible spectrum, though not in the same proportions as the human eye. These emulsions are even today more sensitive to violet and red and less sensitive to green than the human eye; this means that violet and red record as comparatively light and green comparatively dark on the final print. Films are also sensitive to ultraviolet radiation, to which the human eye is virtually blind. Ultraviolet reflected from skies, foliage etc., appears unnaturally light in photographs.

### Filters for black-and-white photography
It is mainly for these reasons that filters are used in black-and-white photography. They bring the effective sensitivity of the film closer to that of the human eye, so that the final recorded and reproduced tones are related directly to the relative

Below: in low light the maximum sensitivity of the human eye shifts from yellow-green to green. This is known as the Purkinje shift.

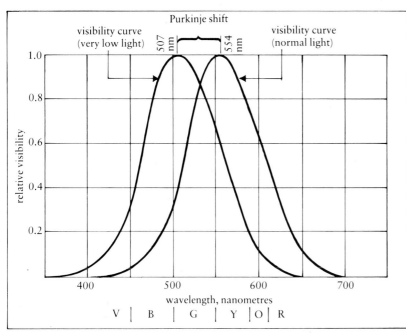

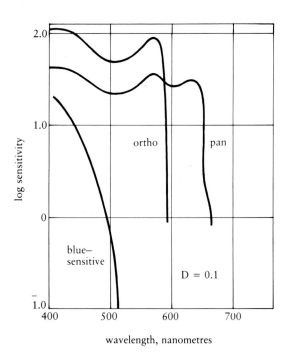

Spectral sensitivity curves of typical black-and-white materials (left) and of a typical infrared-sensitised material (above).

brightness of the original colours as we see them. Such filters are referred to as **correction filters**. Since black-and-white films reduce all colours to grey tones, certain different colours may reproduce as similar or even identical tones of grey. To render them different or to increase the difference between close tones of the same colour, the contrast between them is increased. To avoid two different colours appearing as similar tones, a suitable coloured filter is chosen which, while transmitting one of the colours, holds back all the others by absorbing them. This works most effectively with widely separated colours in the spectrum. The difference between similar tones of the same basic hue is increased by using a filter of that hue; this has the effect of increasing the contrast between the various tones. In both these cases, the filter used is known as a **contrast filter**. To reduce the effects of the film's sensitivity to invisible ultraviolet (UV) radiation, especially evident in pictures of distant landscapes and seascapes and at high altitudes, there are filters which absorb this radiation but

have no effect on visible light. These are known as ultraviolet-absorbing or haze filters.

**Filters for colour photography**
Within certain limits, colour films record all hues of the visible spectrum equally, roughly corresponding to human eyesight, though like black-and-white films they are also sensitive to UV radiation. Where colour films differ is in their total inability to compensate for the different types of light source. Manufacturers therefore balance their materials for exposure either by daylight or by artificial (i.e. tungsten) light. If you expose a daylight-type film by artificial light the resulting pictures will have a yellow or orange cast. On the other hand, if you take a picture in daylight on a film balanced for exposure by artificial light the result will have a pronounced blue cast. Filters designed to enable one type of colour film to be exposed by light of a different type are generally known as **colour-conversion** filters. There are occasions when the colour of the light source differs slightly from

the standard for which films are balanced, as when a film balanced for daylight (i.e. sun and white clouds) is used under an overcast sky. This is discussed in the next chapter under 'colour temperature'; in order that the film's results should not have an obvious overall cast, a suitable weakly-coloured filter is fitted in front of the camera's lens to bring the colour balance back to that for which the emulsion was designed. Such filters are known as **light-balancing** or **colour-correction filters**. The term 'correction' and 'conversion' are sometimes confused, and used as if they were synonymous. This should be avoided. Another type of coloured filter used in colour photography is the **colour-compensating (CC) filter**. This is used on the enlarging lens, and needs to be of full optical quality. It is generally used in making prints from colour transparencies, to take care of small errors in colour balance. These filters should not be confused with **colour-printing (CP) filters**, which have a similar effect but are used in the enlarger lamphouse between the light source and the original (negative or transparency) being printed.

Because of their high optical quality, CC filters can also be used in front of a camera lens when working with unusual light sources such as fluorescent tubes (page 78), or to compensate for reciprocity failure (page 118). Because of their lack of optical correction, CP filters should not be used in front of a lens, either on an enlarger or a camera, or the sharpness of the image will suffer.

### How filters work
White light is composed of all the hues of the visible spectrum, continuous through red, yellow, green and blue to violet. Basically, though, white light can be considered as a mixture of just three hues, red, green and blue, each corresponding to a transmission of approximately one-third of the spectrum. Subtracting one or more of these 'primary' hues from the light falling on, or reflected from, an object results in the object's appearing coloured. Variations in the amounts of the missing

hues determine the nature of the colour that is seen. If you remove red and blue from white light, for example, you are left with green. All natural colours can be made up from lights of the three primary hues, but in practice these three colours are rarely pure, and the colour you see is usually a mixture with one of the primaries predominating, owing to incomplete absorption of that primary. Black is simply a total absence of colour. Each person sees colours differently, and colour perception is influenced by surrounding colours, level of brightness, surface texture, etc. For example, glossy appears more colourful than matt. Many people also suffer from some degree of colour blindness (page 34).

Filters work by transmitting certain colours (or, more correctly, certain wavelengths) and absorbing (or filtering out) others. A green filter, for example, appears green because it transmits green light and absorbs red and blue; a blue surface appears blue because it absorbs red and green light and reflects blue. It is sometimes more useful to think of filters (especially those used in colour printing) in terms of the colours they absorb, rather than those they transmit. This way their effect can be more quickly understood and recognised and their use is less open to chance. Thus, instead of referring to a filter as 'red' think of it as 'minus-blue-and-green'. A yellow filter transmits red and green, and may be thought of as 'minus-blue'. This applies strictly only to deeply coloured filters; general-purpose camera filters do not have such a sharp cut-off.

Filters for colour printing, on the other hand, transmit a carefully controlled band of wavelengths. Filters used in the additive colour printing method are of the three primary hues, red, green and blue, each transmitting one-third of the visible spectrum, whereas those for the subtractive process are of the three secondary or complementary hues, each transmitting two-thirds of the spectrum; see page 139. Thus yellow (minus-blue) transmits green and red; cyan (minus-red) transmits green and blue; and magenta

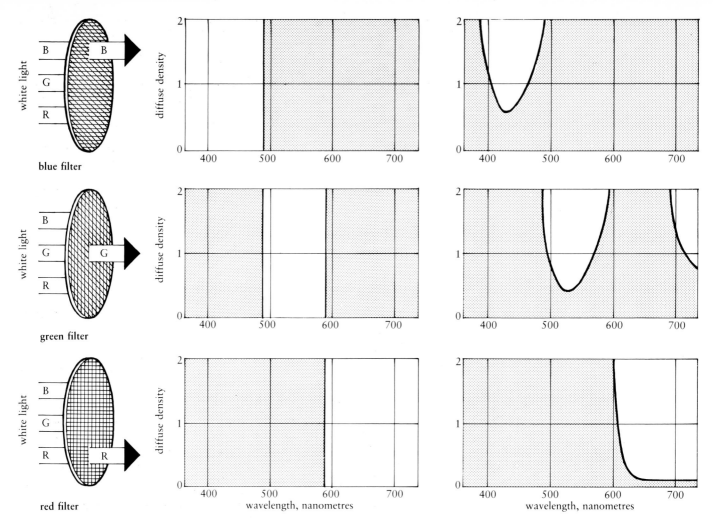

Spectral density distribution of ideal primary-colour filters (centre) and of practical filters (right).

(minus-green) transmits blue and red. The term 'complementary' evolved from the fact that when the missing hue is added to one of the complementaries, white light is produced. Incidentally, interposing any two of the complementaries between the light source and the subject results in the transmission of the single primary common to both. Thus magenta and cyan filters together transmit only blue (blue + red = magenta, blue + green = cyan). Put another way, magenta = white minus green; cyan = white minus red; hence magenta and cyan together = white minus both green and red, i.e. blue. Nevertheless, it must be conceded that most people prefer to refer to filters by the colour that they transmit, so this practice will be adopted throughout the relevant passages of this book.

**Filter factors**
The majority of filters absorb certain parts of the visible spectrum, and in so doing reduce the total amount of light reaching the film. Consequently, to

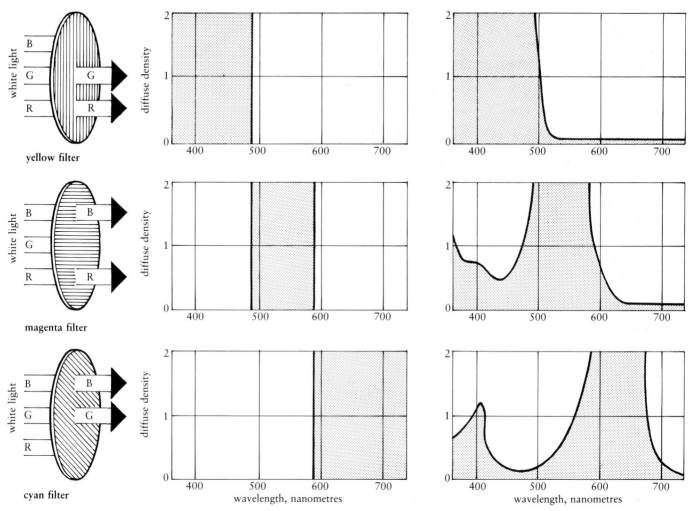

Spectral density distribution of ideal complementary-colour filters (centre) and of practical filters (right).

maintain correct exposure it is necessary to compensate for this, by extending the exposure time or by increasing the diameter of the lens aperture. The absorption factor of any filter depends on the proportion of the spectrum it absorbs and its density; it is also related to the spectral sensitivity of the emulsion (page 29) and the effect required. A medium red filter, for example, which has its greatest effect on blue, and also absorbs some green, may be used to darken the blue sky of a landscape to make clouds stand out; it

can also be used to create a 'moonlit' effect, if its use is coupled with a degree of underexposure.

The degree of light absorption of a filter is generally quantified as a filter factor, sometimes called an exposure factor, the figure by which the exposure needs to be multiplied by in order to maintain correct exposure. (Factors for individual colour filters are given in later chapters.) Thus a filter given a factor of 2× would require the measured exposure for a particular scene to be doubled, i.e.

11

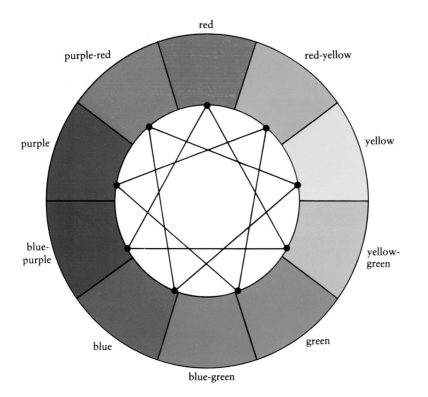

red

red-yellow

purple-red

yellow

purple

yellow-green

blue-purple

green

blue

blue-green

On the colour wheel the complementary of each colour is the one directly opposite. White light can be formed by adding two complementary colours.

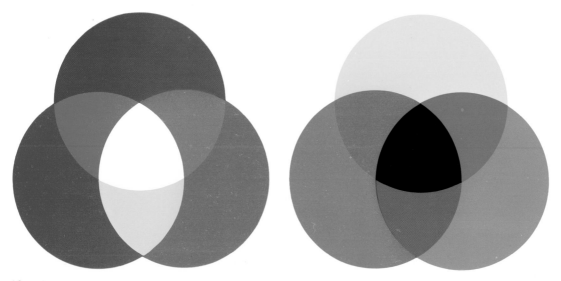

Far left: additive mixing of the three primary colours of light (blue, green, red). Left: subtractive mixing of the complementary colours (yellow, magenta, cyan).

12

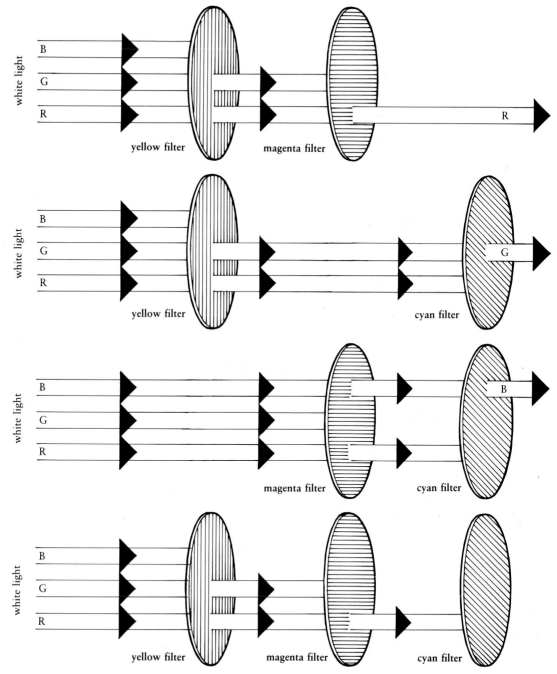

The effect of various combinations of complementary-colour filters.

the next lower *f*-number or the next longer exposure-time setting to that which would have been appropriate were the scene to be photographed without the filter. Similarly a 4× factor would require an exposure compensation of two stops, or four times the exposure time. As an example, consider an unfiltered scene with medium-speed panchromatic film; the exposure on a summer's day might be, say, $\frac{1}{250}$ second at *f*/11. Fitting a 2× yellow filter would mean you have either to change the exposure setting to $\frac{1}{125}$ second or the lens aperture to *f*/8 (not both!). Similarly using a 4× orange filter would require a change of exposure of $\frac{1}{60}$ second at *f*/11 or $\frac{1}{250}$ second at *f*/5.6. Factors are normally quoted by the filter manufacturer for their products used in connection with panchromatic or colour film under normal conditions (usually daylight), unless they are intended for special applications in combination with specialised emulsions such as infrared.

Exposure meters often have provision on their calculator dials for incorporating the filter factor into the exposure calculation. The well-known Weston Master meter, for example, has positions to one side of its normal pointer marked 2× and 4×; these indicate the correct exposure for 2× and 4× filters respectively, when aligned with the appropriate reading from the meter indicator needle. With meters having no such provision, dividing the (arithmetic) exposure index by the appropriate factor has the same effect. Thus when using ISO 64/19° film and a 2× filter, the film speed should be reset to ISO 32/16°. When using this method, it is essential to remember to set the film speed back to the correct figure when you remove the filter.

The method of adjusting the film speed can also be employed for cameras having built-in exposure meters, whether coupled or not to the camera's shutter and/or lens diaphragm, and the settings transferred automatically or manually. With many automatic cameras, adjusting the film-speed setting is the only way of taking the filter factor into

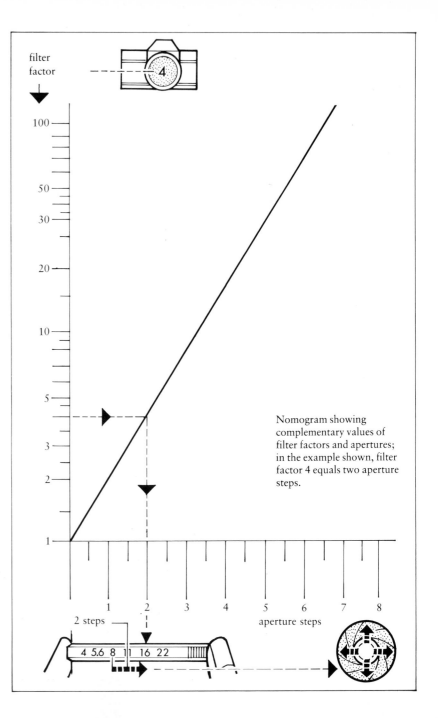

Nomogram showing complementary values of filter factors and apertures; in the example shown, filter factor 4 equals two aperture steps.

**Film-speed changes with filters**

| filter factor | ×2 | ×3 | ×4 | ×8 |
|---|---|---|---|---|
| change in ASA no. | ÷2 | ÷3 | ÷4 | ÷8 |
| change in DIN no. | −3 | −5 | −6 | −9 |
| no. of stops increase | 1 | $1\frac{2}{3}$ | 2 | 3 |

**Shutter-speed changes with filters**

| speed without filter | speed with filter of given filter factor | | |
|---|---|---|---|
| | ×2 | ×4 | ×8 |
| 1/500 | 1/250 | 1/125 | 1/60 |
| 1/250 | 1/125 | 1/60 | 1/30 |
| 1/125 | 1/60 | 1/30 | 1/15 |
| 1/60 | 1/30 | 1/15 | 1/8 |
| 1/30 | 1/15 | 1/8 | 1/4 |
| 1/15 | 1/8 | 1/4 | 1/2 |
| 1/8 | 1/4 | 1/2 | 1 |
| 1/4 | 1/2 | 1 | 2 |
| 1/2 | 1 | 2 | 4 |
| 1 | 2 | 4 | 8 |

**Aperture changes with filters**

| aperture without filter | aperture with filter of given filter factor | | | | | | | |
|---|---|---|---|---|---|---|---|---|
| | ×1½ | ×2 | ×2½ | ×3 | ×4 | ×5–6 | ×7–8 | ×16 |
| f/2 | f/1.6 | f/1.4 | | | | | | |
| f/2.8 | f/2.2 | f/2 | f/1.8 | f/1.6 | f/1.4 | | | |
| f/3.2 | f/2.8 | f/2.3 | f/2.2 | f/2 | f/1.8 | f/1.4 | | |
| f/4 | f/3.2 | f/2.8 | f/2.5 | f/2.2 | f/2 | f/1.6 | f/1.4 | |
| f/4.5 | f/3.8 | f/3.2 | f/2.8 | f/2.2 | f/2 | f/1.6 | f/1.6 | |
| f/5.6 | f/4.5 | f/4 | f/3.5 | f/3.2 | f/2.8 | f/2.2 | f/2 | f/1.4 |
| f/6.3 | f/5.2 | f/4.5 | f/4 | f/3.8 | f/3.2 | f/2.5 | f/2.2 | f/1.6 |
| f/8 | f/6.3 | f/5.6 | f/5.2 | f/4.5 | f/4 | f/3.2 | f/2.8 | f/2 |
| f/9 | f/7.7 | f/6.3 | f/5.6 | f/5.2 | f/4.5 | f/3.8 | f/3.2 | f/2.2 |
| f/11 | f/9 | f/8 | f/7 | f/6.3 | f/5.6 | f/4.5 | f/4 | f/2.8 |
| f/16 | f/12.5 | f/11 | f/10 | f/9 | f/8 | f/6.3 | f/5.6 | f/4 |
| f/22 | f/18 | f/16 | f/14 | f/12.5 | f/11 | f/9 | f/8 | f/5.6 |
| f/32 | f/25 | f/22 | f/20 | f/18 | f/16 | f/12.5 | f/11 | f/8 |

account unless the meter cell is covered by the filter when this is fitted over the lens as in through-the-lens (TTL) metering, where the readings are taken through the filter itself. Many modern compact cameras have their exposure meter cell sited within the forward-facing plate surrounding the front element of the lens, so that the filter covers the cell; when an exposure reading is taken with a filter in place, the filter's light absorption is then automatically compensated for. With these systems, you should not make any alteration to the film speed.

The spectral response of the various light sensors used for camera exposure-meter systems does not always match that of the film. In particular, many of them have a higher sensitivity in the red region than the blue; this may cause the reading to program the system to give rather less exposure increase than may actually be required for yellow, orange or red filters, and too much exposure increase for a blue filter. It is therefore worthwhile making some simple tests with any new filter, to determine what the exposure factor should be, and

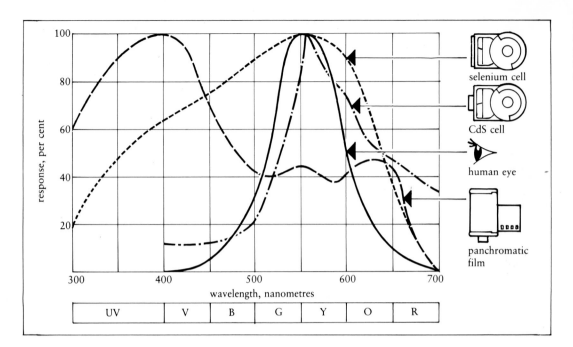

Spectral sensitivity curves for the human eye, a typical panchromatic emulsion and two types of light-sensitive cell.

whether the camera's metering system may be relied upon. This is important with correction and contrast filters used with black-and-white films, and with conversion and balancing filters for colour. In all of these cases, incorrect exposure can have an adverse effect on the results and can reduce the effectiveness of the filter.

**Checking filter factors**  A simple means of checking the exposure factor of a filter is to take a meter reading of the subject without the filter. Note this, and after the filter has been fitted over the lens take another reading and compare the result with the first figure. If the ratio of the two readings matches the recommendation of the filter manufacturer for the type of material being used, it is fairly safe to assume that the camera's metering system may be trusted for that particular filter-and-film combination. If the results are different by a half-stop or more, make some test exposures to determine which setting is correct. First give the exposure indicated. Next, fit the filter and make a

second exposure, as indicated by the new meter reading. Make a third exposure, giving the filter manufacturer's recommended increase over the unfiltered exposure. Two points should be noted here: first, mount the camera on a tripod and do not move it between exposures, to ensure that precisely the same area is metered each time; second, increase the exposure by opening the lens diaphragm (i.e. selecting a larger aperture), not by changing the shutter speed. Few shutters are totally accurate and consistent as marked, and precise exposure increases cannot be guaranteed. Also, half-stop adjustments may be impossible using the shutter alone, as with most camera shutters the speed control operates stepwise. Good lighting conditions should be chosen for these tests, so that exposures are in the region of $\frac{1}{125}$ second at $f/11$, typical of a fine day and medium-speed film (about ISO 100/21°). When the film has been processed, study the resulting pictures. Note any further slight adjustment considered necessary, and keep your notes with that particular filter.

This simple method of checking the exposure factor of a particular filter is adequate for most work with black-and-white films. The exposure latitude of these materials is often considerable, slight variations often going unnoticed. But for technical work or work of a precise nature, especially colour slides, latitude is severely reduced and exposure with filters must be carefully determined. Even inaccuracies as little as one-third of a stop may be detectable in the results. Therefore, before commencing tests to determine the factor of a particular filter, you need to check the camera's exposure system and adopt a rigid film-processing procedure for all tests, the result being the establishment of a camera/film/filter/processing combination that will give consistently accurate results under lighting of a specified colour temperature (page 23). For even more precision you can test each batch of film, as there are slight variations in sensitising dyes, ripening, storage etc., from one batch to the next. Most meters provide exposure readings that are perfectly adequate for general photography, but minor differences in individual calibrations may become apparent when two different cameras are used side by side.

Before making tests of the camera exposure system, you should have the camera shutter speeds checked by a qualified camera repairer, or by the importing agents, to determine their accuracy and consistency at the various settings. Once satisfied on this account, check the battery powering the camera exposure meter; replace it if it is below the stated voltage (some meter circuits have built-in compensation for battery-voltage variations). Next, set the exposure meter to the film speed recommended by the manufacturer for the film being used and, again with the camera mounted on a tripod, select a subject of average brightness range. Take care not to include too much bright area (sky, white walls, etc.) or too much dark area (shaded trees, shadows, etc.). Take a meter reading and set the camera shutter speed and aperture controls to this. With TTL metering systems it is essential to ensure that only light passing through the lens (i.e. reflected from the subject) is measured, and that no light leaks into the system via the viewfinder eyepiece. This is especially important with cameras equipped with automatic exposure control, if the eye is removed from the finder at the moment of exposure.

With filters intended for use in daylight these tests will probably consist of fifteen exposures, made up of five exposures in each of three different lighting conditions: bright sunshine, cloudy-bright and dull. Make an exposure at the indicated settings. Next, increase the exposure by half stop and make another exposure. Increase by a further half a stop and make the third exposure. For the fourth exposure close down the lens aperture setting by half a stop, and for the fifth exposure set the diaphragm to one whole stop less than that indicated by the meter. This series of five exposures should be made under each of the above conditions. If on subsequent processing of the film the meter appears to be more than one stop out, it should be sent to be recalibrated. If the tests are carried out with colour reversal film the differences will be more obvious on subsequent projection. You may prefer different exposure settings for the different lighting conditions. If so, it is necessary only to note the particular setting: for example, you might put '+½ stop' or '−½ stop' against the different lighting conditions.

Some people have a particular preference for giving a full exposure with negative films and slightly underexposing with colour-slide films, under the impression that this gives richer, more saturated colours. If so, carry out the tests with your favourite makes of each of these types and incorporate the results in your notes. You should also include the results of tests on high- and low-contrast subjects, and of light- and dark-coloured ones. With all of these tests completed you have a useful reference for shooting pictures under a wide range of lighting conditions. You can devise a similar series for indoor work, by either available light, Photofloods or electronic

flash, including the dedicated variety (i.e. those designed for a specific camera).

Having brought the camera-and-film combination to a useful level of reference, you now have a sound basis for carrying out the basic tests for determining the increase in exposure required for a particular filter. It is important to remember, however, that filter factors are not constant, even though the transmission characteristics of the filter itself do not change. The factor quoted by the manufacturer is usually for the filter when used in normal daylight conditions with a general-purpose panchromatic emulsion. Under other lighting conditions, such as tungsten-filament illumination, or with an emulsion of unusual spectral sensitivity, the actual filter factor may be quite different from that stated. This variation depends to a large extent on the colour of the filter. For example, the factor of a green or yellow-green filter used in artificial light rather than daylight may show little change, whereas that of a red filter may be halved and that of a blue filter doubled. In daylight, the time of day may also affect the filter factor. An orange filter used in early morning or late afternoon sunlight may have a much lower factor than that marked, as it transmits a much higher proportion of the available light than it would at noon on a sunny day. Similarly, a green filter used to photograph a large expanse of grass and trees will transmit the majority of the light reflected from the subject, far more than if the subject matter were made up of a wide range of hues.

The sensitometric characteristics of the film can also be important. Although for general purposes most black-and-white films have very similar characteristics, they are not all the same. With colour films, too, colour filters have a filter factor, which depends on the characteristics of the sensitising dyes used with the particular emulsions making up the film. There are also radiations that are invisible to the eye but to which film emulsions are sensitive. The most important are those in the ultraviolet (UV) region, which in colour films create a hazy blue-violet effect in distant landscapes and seascapes. Fortunately, the filters used to absorb these radiations are virtually transparent, and thus have a filter factor of unity (i.e. no increase in exposure is needed), so the filter may be fitted and forgotten. Indeed, many amateur photographers do so, not only for the UV-absorbing properties of this filter, but also to give some protection to the front element of the lens. The fallacy of this will become clear in a later chapter (page 49).

When filters are used in combination, their factor may be increased or it may remain unaltered, depending on the combination of colours. When a suitable single filter is not available it may be necessary to use a combination of filters to achieve a particular effect. This is not an ideal arrangement, for, among other things, the additional surfaces may give rise to unwanted reflections unless multi-coated filters (page 40) are used. With uncoated filters the light loss averages 5 per cent per surface. With certain combinations there can be a crossover of the colours absorbed by the filters, so that the combined filter factor may bear little resemblance to those of the individual filters. With some films the filter factor depends on the properties of that particular emulsion's sensitising dyes. All in all, it pays to be cautious; if your results differ from what the manufacturer says you should be getting, carry out the test described above, and you will probably find out why.

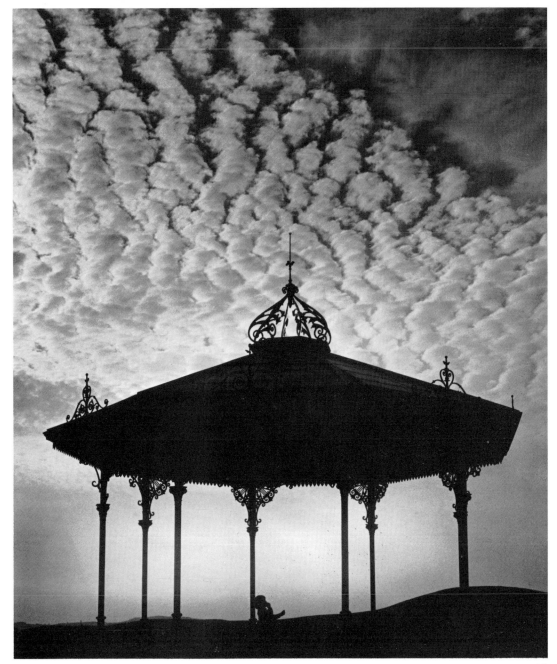

A 2× yellow filter has emphasised the pattern of the alto-cumulus cloud. *Valerie Bissland*.

# Describing colour

Photography is totally dependent on light. But what is light? Physicists down the centuries have striven to explain it; but it was not until 1669, when Newton put forward his corpuscular theory, that there was any degree of general acceptance. Newton suggested that light was made up of particles emanating from a light source: almost simultaneously, Huyghens proposed that light travelled as a wave motion. However, the way corpuscular theory accounted for shadows and reflections seemed more convincing at the time than Huyghens's theory, and Newton's reputation as a scientist swung the balance in favour of this theory.

Not until more than a century later, when Fresnel demonstrated diffraction and interference of light beams, and showed that these phenonema could be explained only in terms of wave theory, did this gain authority. Later still, Maxwell was to show that light was electromagnetic in nature, and that its velocity of propagation in empty space was the same as that of radio waves (discovered at about the same time by Hertz), namely 300 000 kilometres ($3 \times 10^8$ metres) per second. Experiments by other workers such as Foucault confirmed this. The visible spectrum was thus seen to be only a very small part of the electromagnetic spectrum.

What seemed to some to be a challenge to the electromagnetic theory arose when Planck discovered early in the twentieth century that some aspects of the behaviour of light could be explained only by assuming that electromagnetic energy is emitted in discrete bursts or 'quanta' of radiation; this quantum theory is used in the analysis of photochemical effects such as the formation of the latent image. Light is now generally considered to show properties of both waves and particles. The former model is used to interpret the different kinds

and colours of light, and the latter its energy and the results of its interactions with matter. As far as photography is concerned both models are necessary: quantum theory is used to study the effects of light falling on a photographic emulsion or an exposure-meter cell. However, for the purposes of this book we are concerned chiefly with effects of light that can be interpreted in terms of the somewhat simpler wave model.

Different types of electromagnetic radiation are distinguished by their wavelength, which is the distance from one wavecrest to the next. Wavelength is usually indicated by the Greek letter lambda ($\lambda$); its frequency, which is the number of wavecrests passing a given point in a second, is given the Greek letter nu ($\nu$). These quantities are inversely related: the higher the frequency the longer the wavelength, and vice versa. The constant of proportionality is the velocity of light, usually given the symbol $c$. Radio waves have the longest wavelengths, up to several kilometres; the shortest wavelengths belong to the very penetrating types of X-radiation known as gamma-radiation, given off by radioactive substances, with wavelengths down to 0.001 nanometre and less (a nanometre, abbreviated nm, is one thousand-millionth of a metre, written as $10^{-9}$ m).

## Light and colour
Within the visible spectrum the eye sees changes of wavelength as changes of hue, each hue being associated with a specific wavelength. What we call 'white light' is a mixture of all visible wavelengths in approximately equal proportions. Dull or pale colours also contain all wavelengths, but in varying proportions; highly saturated colours in general contain only narrow bands of wavelengths. The limits of human vision extend from a little under 400 nm (the hue we call violet) to somewhat over 700 nm (the hue we call red). Shorter wavelengths (ultraviolet) and longer wavelengths (infrared) are invisible, though the human eye has a slight sensitivity in the infrared which extends to almost 1000 nm.

For practical purposes we consider the visible spectrum as consisting of three main regions, namely 400–500 nm (blue-violet), 500–600 (green) and 600–700 nm (red). Within these regions there are other visually-distinguishable hues: blue, for example, appears between 450 and 500 nm, cyan (blue-green) in a narrow band centred on 500 nm, and yellow in a slightly broader band between 580 and 610 nm. In real-life situations, the hues that are seen depend as much on the lighting conditions as on the scene itself. The hue of the light source has a profound effect on the colours of an object, as we know from trying to match clothing by artificial light. Other variables include the quality of surrounding reflective surfaces; even the reflective qualities of the subject itself are important, a shiny object in general having a higher colour saturation than a matt one. The intensity and direction of the source also have an effect; a strongly-directional light gives brighter and more deeply-saturated colours. Subdued or diffused light, on the other hand, will tend to give desaturated colours. Incidentally, it should be noted that direct or specular reflections are not coloured, as light reflected in this manner does not penetrate the surface and thus no wavelengths are selectively absorbed.

Another aspect affecting our perception of colours is contrast. If you surround a coloured area with white, the colour of the area appears less saturated than if you surround it with a black border. You see a similar effect if you use a border of the same hue, but of a lighter or darker shade respectively. 'Warmth' is another factor to be considered in colour photography. Reddish colours are said to be 'warm' and bluish colours 'cold'. An indoor scene with a glowing fire appears warm in comparison with, say, a stretch of deep blue ocean in bright sunlight. Red colours also appear to stand out from a picture, while blue colours recede behind it. There are many other psychological factors which influence our perception of light and its component hues, but the subject is a complex one, and much of it is beyond the scope of this book.

### Light sources

Most light sources used for photography emit the full range of visible wavelengths, though in general not in the same proportions as daylight. Even daylight itself varies in its spectral content. So tolerant is our perceptual mechanism, however, that we do not usually notice any differences; not so with film, which records the light in its true proportions. Depending on the nature of the particular illuminating source and its spectral energy distribution, the colour of the light reflected from a given object may vary considerably. Only in extremes of variation can the eye detect a difference in isolation (it is a different matter when a side-by-side comparison can be made). The spectral quality of so-called white-light sources varies greatly; although this is of little importance in everyday life, it is of prime importance in photography.

In common with other forms of electromagnetic radiation, light is a form of energy. Heat is also a form of energy, and when we heat up an object (such as a lamp filament) to a sufficiently high temperature, some of the heat energy becomes converted to light energy. It can be shown that there is a relationship between the absolute temperature of a body (strictly, a non-reflective body) and the spectral energy distribution of the light it gives off. This provides a method of describing the colour quality of an incandescent light source, and this is known as the scale of colour temperature. It is measured in kelvins (K). An interval of one kelvin is the same as an interval of 1° Celsius (or centigrade); but whereas the temperature of melting ice is 0 °C it is 273 K (0 K being absolute zero, the temperature at which there is no heat energy left in a substance). As we raise the absolute temperature of our hypothetical non-reflective substance, it begins to emit long-wave infrared radiation at about 350 K (the temperature of very hot water); then, as it gets hotter, it begins to glow, first in the red region of the spectrum, then orange, yellow and eventually

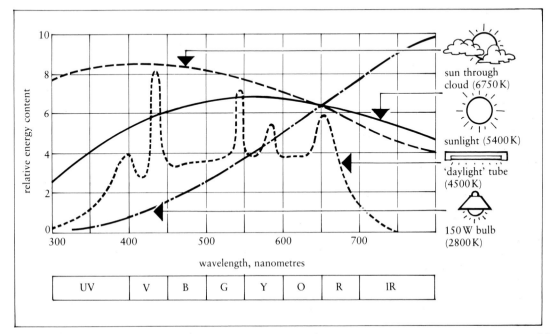

Spectral energy distribution of common light sources. Note the redness of the 150 W bulb and the discontinuous spectrum of the fluorescent tube.

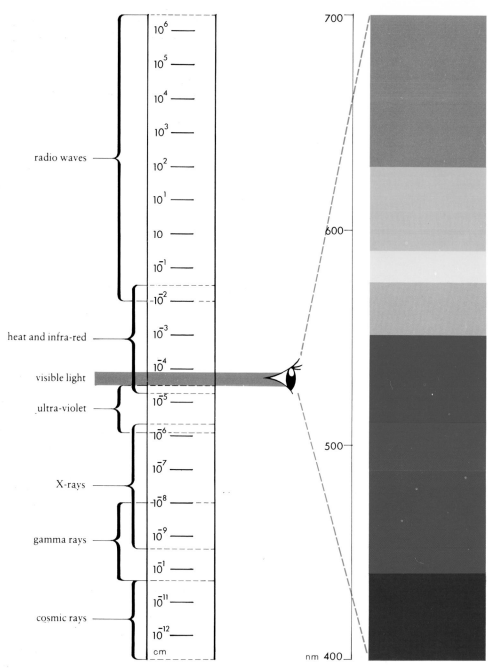

At the far left is the whole of the electromagnetic spectrum, including the small band of wavelengths comprising the visible spectrum. At the near left the latter has been expanded to show its colour composition.

radio waves

heat and infra-red

visible light

ultra-violet

X-rays

gamma rays

cosmic rays

$10^6$
$10^5$
$10^4$
$10^3$
$10^2$
$10^1$
$10$
$10^{-1}$
$-10^{-2}$
$10^{-3}$
$10^{-4}$
$10^{-5}$
$10^{-6}$
$10^{-7}$
$-10^{-8}$
$10^{-9}$
$10^{-1}$
$10^{-11}$
$10^{-12}$
cm

700

600

500

nm 400

white; if we could heat it still further it would become bluish, like the hottest stars.

For photographers the most important temperatures are those around the melting point of tungsten, and that of the surface of the sun. Ordinary household lamp-bulbs operate at a colour temperature of 2800 K. 'Photopearl' studio lamps operate at 3200 K, Photofloods (as used by most amateurs) and tungsten-halogen lamps at 3400 K. Average sunlight, blue flashbulbs and electronic flash are around 5500 K. A totally overcast sky is surprisingly blue, about 9000 K; and deep blue sky can be more than 12 000 K. The figure of 3200 K (or 3400 K) for photographic lamps depends on a number of factors; their age, the operating voltage, the type of reflector used, and so on. For black-and-white work this is not important until the need arises to use a filter. With colour films, however, these variations are very important indeed.

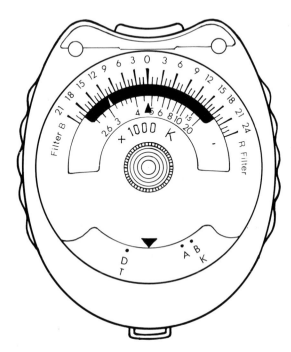

Basic colour temperature meter allows the balance between red and blue to be measured accurately.

There are various ways of measuring the colour temperature of a light source. The simplest type consists of a coloured reference strip alongside which is a series of coloured steps, each annotated with a specific colour temperature. This is held in the path of the source and the best match selected. A more accurate method is a colour-temperature meter; this compares the relative intensities of red and blue light emitted by the source. At one time this involved the use of two separate filters and the comparison of two readings, a somewhat time-consuming process; modern meters compare these intensities electronically, and give the colour temperature in digital readout form. For all practical purposes daylight provides white light composed of all visible wavelengths in equal quantities. This is the standard by which all other light sources are judged. Light from all continuous-spectrum sources, i.e. those that emit all the wavelengths of the visible spectrum, vary widely in the proportions of the various wavelengths they emit. You need only switch on a Photoflood alongside a domestic lamp to appreciate the difference both in colour quality and overall intensity.

Although colour temperature is a good means of classifying the quality of continuous-spectrum sources, non-incandescent sources such as sodium- or mercury-vapour street-lamps, or fluorescent tubes, emit their light energy in the form of a discontinuous or line spectrum. They cannot therefore be described in terms of colour temperature, as they cannot be matched exactly by the emission of a hot object. However, some fluorescent tubes are specially matched for photographic use; these can be said, approximately, to possess a colour temperature. The spectrum of an electronic flash, however, though strictly a line spectrum, has so many broadened lines that it is effectively continuous. By carefully choosing the mixture of gases (usually xenon with a little argon), and by coating the tube with metallic deposits, the spectrum can be brought to a close approximation of daylight, and used with

daylight-balanced films without further filtering (see page 76).

The relative inefficiency of domestic lamps for photography caused Photofloods and special studio lamps to be introduced. These not only give a greater intensity of light than domestic lamps, but the light emitted is less red. Colour-film manufacturers cater for the relatively low colour temperature of these lamps by producing a second line of films of suitable colour balance for one or other of these lamps (a film for amateur use balanced for Photofloods, and another aimed at professionals balanced for stuido lamps) which will also cope with the more recent tungsten-halogen lamps. In the case of Photofloods and studio lamps, however, their rated colour temperature only holds good when they are run at the correct voltage and are relatively new. As the voltage is lowered, or as the lamps age, their light becomes progressively more yellow. Modern flashbulbs burn at a slightly higher temperature than either Photofloods or studio lamps. It is now customary for all but the largest flashbulbs used for professional purposes to have a blue lacquer coating to raise their colour temperature to that of average daylight (5500 K). This makes them suitable for daylight-balanced colour films and avoids the need either to swap films or to use compensating filters. Unlike Photofloods, studio lamps etc., the intensity and quality of a flashbulb is unaffected by changes in the voltage applied to it, this being used only to ignite the filling.

### Hue, lightness and saturation

So far, only the basic spectral hues (red, yellow, green, blue and violet) have been considered. Passing reference has been made to colour density or saturation, but not to shades of brightness (or, more correctly, lightness). Because the vision of individuals varies, it is not scientifically legitimate to ascribe a particular colour to a particular object, but only to the light being reflected by that object. Objects have in themselves no characteristic colour; their appearance depends on the type of illumination incident upon them. Consequently, it is more convenient to describe the colour of objects when they are viewed by a particular light source, i.e. daylight, Photofloods, etc. To describe an object as 'green', for example, indicates only its hue, and gives no other details. We might qualify this by saying that it was 'dark green', and in doing so we would be describing its lightness. A further description, 'intense (or vivid) green', would describe a third characteristic, namely its saturation; this is a measure of its departure from a neutral grey of the same lightness. These three descriptions of the colour actually describe the sensations reaching the eye, as opposed to the stimuli of the object itself.

While normally capable of differentiating between various hues, lay descriptions tend to become confused when describing lightness and saturation. This is apparent when trying to decide whether two colours differ in lightness or in saturation. In colour photography, especially, this linguistic difficulty can affect judgement of colour rendition; this is often evident when people use the word 'bright' to describe saturation. Consider, for example, the number of shades of red lipstick available, and think how few words exist for describing them all. Could you pick the exact shade from a purely verbal description of it? The solution to the problem of classifying the enormous number of colours distinguishable by the human eye has to a great extent been found in the introduction of two basic systems acceptable to photographers, painters and physicists alike. Although the human eye cannot measure colour objectively, it can be used to match colours seen together. The two systems are known respectively as the Munsell and the CIE systems. They are in many ways complementary: the latter can be readily used for mathematical calculations concerning problems of colour reproduction, while the former is of use chiefly to the creative artist.

### The Munsell system

The Munsell system was devised by Albert H. Munsell, an American artist,

and is an orderly arrangement into a three-dimensional solid of all of the colours that can be prepared from samples of stable pigments. The general shape of the solid is a lop-sided sphere whose equator corresponds to a circle of hues covering red, orange, yellow, yellow-green, green, blue-green, blue, purple-blue, purple and red-purple. The vertical axis consists of a grey scale going from white at the north tip of the axis to black at the south. Saturated hues on the exteriors penetrate to the centre of the sphere with decreasing saturation. At the centre, where all colours meet, the saturation is zero. The ten hues making up the entire circle consist of five principals and five intermediates. The complete circle consists of 100 hues. Extending vertically through the centre of the hue circle is the scale of lightness (called 'values' in Munsell's terminology). At the top of the scale is a theoretically perfect white with 100 per cent reflectance. This is numbered value 10. At the bottom of the scale is a theoretically perfect black with nil reflectance and

numbered value 0. Nine other stages between these two positions are given numerical values, and represented by actual samples. These give visually equidistant steps in lightness under specific illumination. Because of the limitations of variation in possible saturation (called 'chroma' in Munsell's terminology) with hue and value, the colour solid is not symmetrical. For example, the highest chroma figure for red is 14, whereas the highest figure for blue-green, immediately opposite, is only 6.

For convenience the specimen colours are supplied in book form, each page corresponding to a meridian plane of the colour solid. An advantage of this system is that should a new pigment be introduced, permitting samples of higher saturation to be produced, the new samples can easily be added to the pack. Another advantage is that the numerical code provides immediate reference to a particular colour. The Munsell system, which permits very accurate colour matching, corresponds closely to our psychological concept of equal steps of hue, lightness and saturation. It is unique in that primary emphasis has been placed on the judgement of the observer in placing samples of each colour when they are illuminated by a standard source. The disadvantage for the photographer is that its ten basic hues do not correspond to the six basic hues (red, yellow, green, cyan, blue and magenta) used in photographic colorimetry.

**The CIE system** The second system was devised by the Commission Internationale d'Eclairage and is known as the CIE chromaticity diagram. This system has been adopted by most scientists concerned with colour analysis, and is based on the assumption that by mixing pure blue, green and red light in suitable proportions almost any colour can be matched. Acknowledging that not all spectrum colours can be matched with real primaries, especially those of high saturation, these nonetheless give data which can be mathematically transferred to provide a set of imaginary primaries with which all colours of the spectrum can be

The lop-sided sphere devised by Munsell to classify hues at different levels of saturation and luminosity. The central axis (neutral) runs from black at the bottom to white at the top.

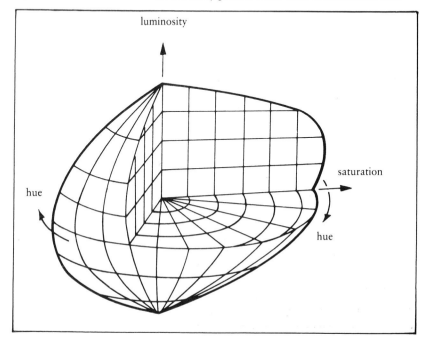

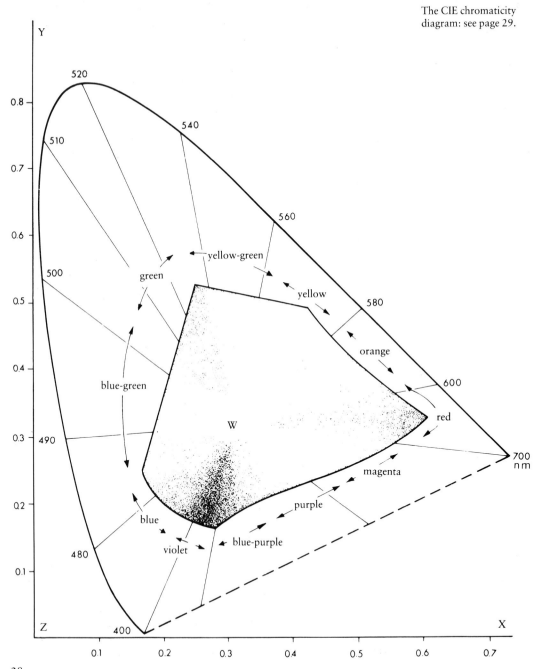

matched. In this system colour matching is usually carried out in a colorimeter, a device in which two colours can be compared side by side. The imaginary primaries are simulated by adding desaturating white light to the test colour at the same time as the colour is added to the matching colour. The chromaticity diagram is a graph, and each point on the graph corresponds to a colour. The coordinates of the colour are determined by the proportions of the primaries that would provide an exact match. These are X (red), Y (green) and Z (blue). In order to be able to plot these three quantities on an ordinary two-dimensional graph, X, Y and Z are expressed as percentages. The horizontal (X) axis of the graph represents the percentage of red, the vertical (Y) axis the percentage of green. The percentage of blue is the difference between the sum of the X and Y values and 100 per cent.

The other essential of the CIE system is its standardisation on a few light sources, the spectral energy distributions of which are well known and can be reproduced by a number of well-defined means. Since the CIE system is based on internationally-accepted data and not on the visual characteristics of an individual, any particular specification indicates a precise colour no matter where it is translated. Given a standard light source and standard form of observation, only a spectrophotometric curve of a sample is needed to compute its actual specification.

In the CIE chromaticity diagram the relationship of a given sample can be readily visualised by reference to what is, in effect, a map of all possible colours. The horseshoe-shaped boundary represents the positions of the spectral colours, which have the highest possible saturation. The central area represents the limit of saturation possible with modern printing inks, and near the centre of this area is the illuminant point for the standard light source, equivalent to daylight. This is also the position of any neutral grey illuminated by the same light source. It is not necessary to use red,

green and blue as the CIE primaries, and other CIE diagrams exist, in particular one with different imaginary primaries given the signatures U, V and W. It must be remembered that the coordinates apply to a filter only when it is illuminated by a particular light source. If the light source is changed, so too will be the colour of light transmitted by the filter, and its CIE coordinates.

## The spectral sensitivity of emulsions

All art forms in which the artist creates an impression of a scene from life offer a degree of licence to the final interpretation of that scene. Viewers of the final work allow, even require, that the result should display the personal interpretation of the artist via the materials, shapes, colours and even the format of the subject in relation to its actual size and surroundings. But with photography, unlike other art forms, most people demand that the result should be accurate, and this requirement for accuracy usually takes the form of representing correctly the size and shape of the subject relative to its surroundings, and portraying the subject in its environment. More important, though, the attitude towards photography is unique in that a photograph is expected to depict the subject's natural colours either as acceptable tones of grey, with separation between these tones recognisable as being similar to the visual differences between the various colours as they are seen, or as colours that faithfully match those of the original.

To make matters more difficult for the photographer (as opposed to the artist with paints and brush or mallet and stone), no account is taken by the viewer of the effects of different light sources and conditions on the subject, which our eyesight automatically accommodates, but which film can record only as it sees. Even less account is taken of the fact that photography relies on the application of chemistry and physics. While techniques have now been developed to a very high level of sophistication and controllability, photography still relies on materials and processes that are not

capable of interpreting in a manner identical with that of human visual perception. Add to this the fact that each person's visual concept is unique, and the photographer's task becomes seemingly impossible. Filters are the key to the overcoming of deficiencies in materials, the achievement of an acceptable balance and representation of tones, the correction of the effect of different light sources and lighting conditions and, in the case of colour photography, the balance of the results so that they appear sufficiently close to our visual concept.

Fortunately the two major factors, adaptable vision and visual concept, work also to the photographer's advantage, because, without side-by-side reference, we find it very difficult to make accurate comparison between our memory of the original subject and that which has been recorded and reproduced. Consequently tones can be compressed, exaggerated, or even eliminated; colours can be diluted or saturated; relative sizes can be changed and shapes distorted; yet the resulting photograph not only will be acceptable but may well be acknowledged as an accurate representation!

Like other art media, photography has the capacity for manipulation of the factors governing the subject, materials, processes and final presentation, to create a picture that gives freedom to display imagination, to create an image of shapes, tones or colours so unlike those of a draughtsman or architect that the very medium itself becomes the vehicle of self-expression. Here again, filters are an invaluable aid to the photographer, by helping to manipulate the spectral response of the materials, altering the nature of the light source, or affecting the balance of final colours in a print. In each case, though, whether to achieve accurate representation or to give rein to self-expression, predictable results can be obtained only by an understanding of the nature of the spectral response of the particular film in use, the transmission characteristics of the diferent filters and the final visual effect as interpreted by the eye.

30

## Recording colours as grey tones

In the early days of photography, general-purpose emulsions were sensitive only to blue and violet light; later the sensitivity was extended into the longer wavelengths, first to green and then to red light. Only the colours to which the early emulsions were sensitive could be reproduced as tones of grey in the final picture. All other colours appeared either very dark or completely black. When photographed with early blue-sensitive emulsions, white objects appeared in a similar tone to blue, because that was the only band of wavelengths to which the emulsion was sensitive.

The early blue-sensitive emulsions, which contained no colour-sensitising dyes, gave photographers little or no scope for using filters. Even a comparatively pale yellow filter could result in the absorption of the only wavelengths to which the emulsion was sensitive. Today, blue-sensitive emulsions are in use mainly in the form of films for copying and reproduction purposes and for most black-and-white printing and enlarging papers. Variable-contrast papers have their sensitivity extended into the green region, to permit contrast control by filtration (page 136). Blue-sensitive emulsions are sensitive to wavelengths up to about 500 nm and are sometimes referred to as 'ordinary', or (incorrectly) as 'non-colour-sensitive'.

The almost total replacement, for general photography, of ordinary and orthochromatic (blue-and-green-sensitive) emulsions by panchromatic emulsions sensitive to the whole visible spectrum, has helped to increase the effective speed of available films. Until only a few years ago, manufacturers quoted different speeds for their films according to whether they were exposed by daylight or red-rich tungsten light. The speed for calculating exposures by daylight was usually quoted as higher than that for exposure by artificial light. Now, with sensitising dyes incorporated to extend the response of emulsions to about 680 nm, this has been abandoned. Indeed, this extended sensitivity makes their effective speed virtually the

same under both daylight and artificial light conditions, the inherent latitude of the material taking care of any slight differences. One thing to bear in mind is that, while the blue-sensitivity of most panchromatic films is very similar, the red-sensitivity may differ slightly from one film to another, so filter factors should be checked by practical experiment where extreme accuracy is required. Incidentally, in the early days general-purpose orthochromatic films usually had the word 'chrome' incorporated in their name. For example, Verichrome and Selochrome, from Kodak and Ilford respectively, were household names. This practice continued for many years, and long after the introduction of panchromatic material on the professional and advanced amateur market, the general public continued to buy and use orthochromatic rollfilms. Eventually, however, it was decided that there was no real justification for continuing to produce ortho films for general use, and panchromatic versions were substituted, named respectively Verichrome Pan and Selochrome Pan. Today, however, the suffix 'chrome' is used to indicate a colour-reversal (i.e. colour slide) film, e.g. Kodachrome and Agfachrome. Colour-negative film is indicated by the suffix 'color' (e.g. Kodacolor).

### Wedge spectrograms

The spectral sensitivity of an emulsion is usually given by means of a plotted contour known as a wedge spectrogram. This indicates the spectral response of the material to different wavelengths throughout the visible (and invisible) spectrum, and is provided as technical information by all manufacturers on their products. Wedge spectrograms are produced by means of an instrument in which an image in the form of a spectrum is produced, and an optical density wedge is placed between the material under test and the light source. The results indicate the colour sensitivity of the emulsion to the various wavelengths. A wedge spectrogram can also compare the sensitivity of an emulsion to the various wavelengths under different light sources.

Wedge spectrograms made with daylight as source show higher peaks at the short-wavelength (blue) end of the spectrum, whereas those made by tungsten light have higher peaks at the long-wavelength (red) end. On the following page are wedge spectrograms for the various main emulsion types. Because wedge spectrographic instruments normally hold back ultraviolet radiation, the apparent fall-off in sensitivity in this region from the spectrogram contour is not strictly accurate here; most photographic materials are in fact fairly sensitive to UV radiation. It will also be apparent that the quality (colour) of the light source affects the effective speed of the emulsion, and this factor could prove important when choosing filters and estimating their exposure factor. While not sufficiently accurately portraying the spectral sensitivity for scientific purposes, wedge spectrograms do give a general indication of the material's response to the various wavelengths of the spectrum, and enable the response of different films to be compared. In addition, the quality of different light sources can be compared by producing a set of wedge spectrograms using a single emulsion, and the spectral absorption and transmission characteristics of filters can be ascertained by using the same combination of light source and emulsion with and without each of the filters.

Despite modern chemistry techniques, the sensitivity of current film emulsions still does not correspond exactly to that of human vision. In the accompanying relative luminosity curves, the eye's response to various wavelengths of light is shown. These clearly indicate that the eye does not see all colours as of equal brightness. Note that the highest peak is in the green region at about 530 nm, with the next peak at about 590 nm (yellow), and note how low is the peak of the blue. The visual luminosity curve shows the response of the eye of the spectrum of sunlight, with approximately equal energy throughout the visible wavelengths. The high sensitivity in the yellow-green region is immediately apparent. It can be clearly seen that

panchromatic emulsions are best for the majority of black-and-white photographic work. Not only does their spectral sensitivity come closest to that of human vision but, because of its wide spectral response, panchromatic materials permit the use of the widest range of filters, thereby offering the photographer greater control over the subject and the reproducing medium. By the use of suitable filters, the sensitivity of a panchromatic emulsion can be made to match that of an orthochromatic or even an ordinary emulsion. The tonal reproduction of a particular colour or range of colours can be enhanced or reduced, and the contrast between various similar tones (difference in tonal density) can also be controlled. Wavelengths to which the film is less sensitive than the eye can be enhanced, and vice versa.

This is not to say that non-panchromatic emulsions have no value to the photographer. Both orthochromatic and ordinary emulsions can sometimes be invaluable in copying when an original that has been stained, say with blue dye, is to be reproduced. In photographing colourless objects such as silverware, using such emulsions enables processing to take place under much brighter safelights than would be possible with panchromatic emulsions, giving the photographer the opportunity to develop by inspection and obtain exactly the desired type of negative. Darkroom safelights for panchromatic material are too dim to permit this. By making printing and enlarging papers sensitive only to the blue end of the spectrum, bright orange or yellow safelights can be used (page 133); this relieves eye-strain and provides more comfortable working conditions. Brighter working conditions also enable the printer to judge the final quality of prints being produced more accurately.

## Colour vision
The means by which we see and interpret colours is unreliable, but it is the only means we have. The retina of the eye is an extension of the brain; thus the brain interprets the stimuli received along the

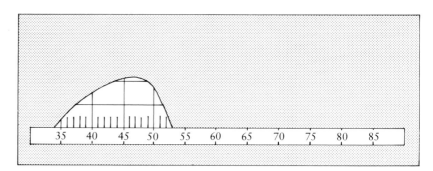

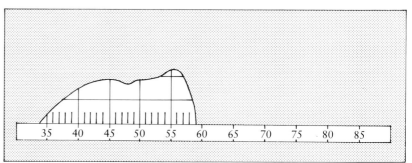

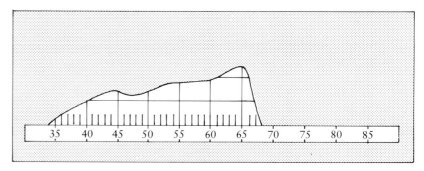

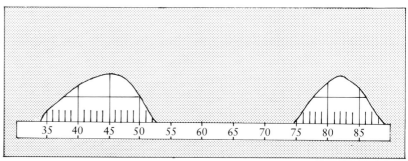

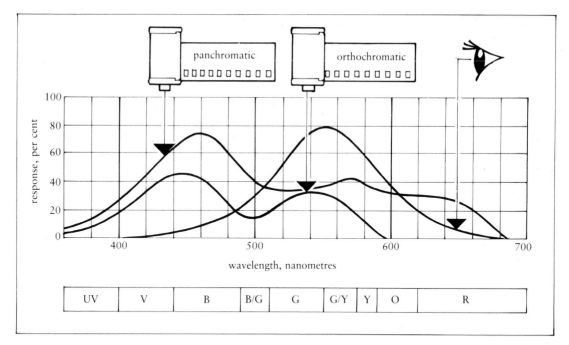

Left: wedge spectograms of (top to bottom) blue-sensitive, orthochromatic, panchromatic and infrared emulsions (in tungsten light at 2850 K).

Right: relative luminosities of spectral hues as seen by the human eye and two types of emulsion.

optic nerve directly from the retina. But the train is influenced by other stimuli too, by physical and psychological aspects, including our inbuilt experience and knowledge, over which we also impose standards and demands. Therefore in black-and-white photography the brain is persuaded by cultural influences into accepting the various grey tones as representing the different colours. In colour photography we seek to gain acceptance of the colours reproduced as a fair and accurate representation of the original scene, thereby ignoring the shortcomings of the materials and processes.

Normal vision, as we have seen, has its greatest sensitivity in the yellow-green regions and its lowest in the blue-violet. The term 'normal vision' is used even though different individuals probably interpret colours differently. Even more confusing is the way the eye readily adapts to the colour quality of the light source, and our inability to be really objective about white viewed under different conditions. When entering a room lit by artificial light, we note its yellowness compared with that of daylight out of doors; or, when going out of doors at night into a street lit by sodium lights, the distinct yellowness of the lights is immediately apparent. But we quickly become accustomed to it and, after a few seconds, virtually accept it as being white, owing to the adaptability of our perceptual processes.

We have considered how the appreciation of colour is influenced by surrounding colours and tones. As a practical test, try staring fixedly for about a minute at a bright red patch, preferably on a black background. Then quickly transfer your gaze to a sheet of plain white paper. You will see a cyan-coloured patch where the red one was. This is due to the red receptors of your retina having become fatigued, so that only the remaining receptors (i.e. blue and green) are fully turned on and transmitting. Similarly, a colour photograph mounted with a wide coloured border may appear

to have a slight overall cast of a colour at the opposite end of the spectrum to that border. This is due to changes in local colour sensitivity in the retina exaggerating the difference between two adjoining colours. This can be used to good effect when choosing backgrounds that either contrast with or harmonise with the subject being photographed, and can be achieved by the use of filters over lights or coloured backgrounds in the studio.

While accepting that responses to colours are different for different individuals, there is yet another aspect of vision that must be considered, as its effect is most noticeable when choosing filters for photography, and especially when colour printing. This is the effect of actual deficiencies in colour vision. It is now accepted that more than 5 per cent of men (though less than 1 per cent of women) have some form of anomalous colour vision. In approximately 2 per cent of men, and 0.05 per cent of women, colour vision is defective enough for it to be difficult or even dangerous for them to follow certain occupations. In most cases, though, the persons so affected are well aware of this deficiency at an early age, though it is surprising how many do remain unaware of it for the greater part of their lives.

Anomalies in colour vision vary considerably, some individuals seeing certain portions of the spectrum as grey. Such people have difficulty in distinguishing and naming certain colours. Colour-blindness can be diagnosed and its precise nature identified by a qualified ophthalmologist using test charts. However, even if you happen to be colour-blind, there is no reason for you not to practise colour photography, and no reason why you should not be able to judge and appreciate the results; but you may need to make allowances for the variables that could result from your deficient vision when making personal judgements. This is especially so with regard to the correction of colour balance when making colour prints or using light-balancing filters, especially with colour-slide

films. In particular you will have to be careful when working with red or green filters.

Another aspect of colour vision is that the lens of the eye is slightly yellow. This feature limits the eye's chromatic aberration (inability to bring all colours of the visible spectrum to the same point of focus). But it also limits our eye's response to short-wavelength (blue) radiations. As we age this yellow cast increases in density, thereby further affecting our response to colours. All of these points with regard to deficiencies in colour vision should be borne in mind in the event of disputes over colour rendition, especially if your are a freelance worker with an aging client to please. You may need to be tactful!

Taking the psychological aspect just a stage further, filters are a valuable tool in ensuring not only that the hue of the subject reproduced is visually correct, but also that its shade is psychologically correct. Objects having a familiar colour, such as a post-box, bus, cabbage, carrot etc., can often be reproduced with a slight change of colour without the viewer being visually or emotionally disturbed. But with certain other items, for example food such as margarine or eggs, any slight colour error is at once detected as 'wrong' and is therefore unacceptable. A similar effect occurs with the complexion of people in a photograph. For example, a slight warm tone or tan in the image of a light-skinned person is acceptable, but too red or too pale and the perceptual process, despite its accommodating nature, rejects the effect as unnatural.

It would seem, therefore, that the chances of a photographer producing an accurate tonal representation of an original subject in black-and-white or colour are very remote, even if every filter is to hand. Although when you place a photograph alongside the original subject any difference will immediately stand out, this is rarely demanded. The important thing is that the likeness should prove acceptable. If the viewer is relying on

A yellow filter and underexposure have darkened the (blue) sky to show up the hoar frost in this wintry shot. *Raymond Lea.*

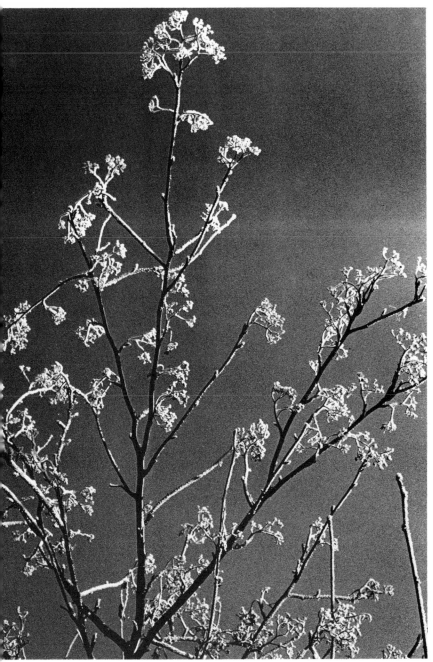

memory, slight differences pass unnoticed. The photographer should therefore attempt to reproduce accurately the main subject and the easily recognisable features of the picture, and use overall balance, harmony and contrasts to create the right psychological impression. Here lies one of the major uses for filters in both black-and-white and colour photography.

*Ed Buziak*

*Ed Buziak*

# Filter materials

Filters can be made from any transparent material. For general photography, where the filter is fitted in front of a camera or enlarging lens, the material must be optically flat, otherwise the filter can reduce the sharpness and accuracy of the image resolved by the lens. Other important qualities are: good batch-to-batch consistency; freedom from striations and blemishes; relatively inexpensive production, and reasonably long life. Glass and gelatin readily lend themselves to fulfilling these requirements, though high-grade plastics are now quite common, especially for 'effects' filters. To be optically flat generally demands that the two surfaces of the filter be parallel. In practice perfection is expensive and difficult to achieve. Manufacturing tolerances are small: the established maximum permissible deviation from parallelism of the surfaces of an all-glass filter is approximately 10 minutes of arc.

## Manufacture

The transmission and absorption characteristics of any filter are achieved by dyeing its surfaces or incorporating dyes in the material itself. Surface coating is used for some makes of plastics filters, and for short runs where scientific accuracy is demanded. The process involves vaporising the colour on to the surface of an optically flat material. While successful in its spectral transmission and absorption qualities, the resulting coating is susceptible to damage and to fading. Modern surface-coating techniques, however, are achieving results that will withstand rougher handling and resist abrasion. Filters for general photography are made from glass dyed in the mass, or a type of synthetic resin, the quality of which is relatively easy to control. Glass is more robust than plastics, of course; resin filters must be handled with a degree of care. Because of high manufacturing costs it is necessary to produce the

37

majority of filters in large quantities to keep down their unit cost. Less popular or unusual filters, especially where very high quality is demanded, are usually made to order from gelatin.

Gelatin filters are made by dissolving the appropriate dyes in gelatin and then coating this on to glass. When dry, the gelatin is peeled off the glass and cut to size. The resulting filter is usually no more than about 1 mm thick, and accurately flat. Despite having a protective lacquer (which itself is quite soft), gelatin filters are susceptible to heat, damp, fingerprints, scratches and physical pressure. Once marked or damaged, they are useless for optical work. For this reason the gelatin film is sometimes supplied sandwiched between two optically flat glasses. Otherwise, gelatin filters are supplied in standard-size squares ready for cutting to any particular shape or size by the user. This is easily done by sandwiching the filter between the protective tissue sheets in which it is supplied, marking out the shape and size required, and then cutting all three simultaneously with scissors.

The quality of glass filters currently available varies greatly, and although their retail price is some guide it is not always reliable. Any filter placed in front of a lens should affect only its spectral transmission and not its optical performance. The highest-quality glass filters are made from optically flat blanks of the same quality as those that would go to make up elements for a lens. Blanks for good-quality filters are sawn from annealed glass blocks produced in platinum-lined crucibles as used for making blanks for camera lenses.

**Plastics filters** The latest types of plastics filters are made of allyl diglycol carbonate polymer, generally referred to as CR-39. This is a lightweight plastics material of optical quality, first developed in 1940, and now widely used for spectacle lenses, aircraft cockpit canopies, camera lenses and watch glasses. The light-transmission characteristics of CR-39 material closely approximate to those of optical glass, and its refractive index is only slightly lower

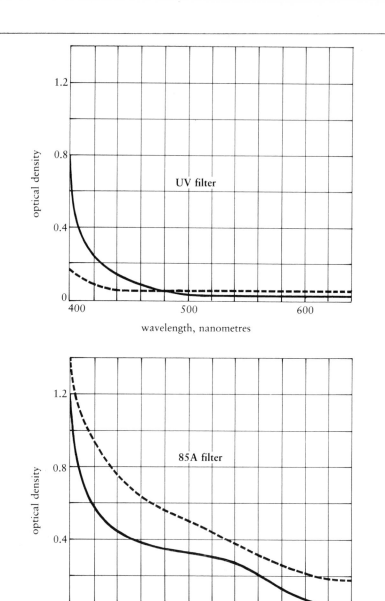

than that of crown glass. Filters and optical attachments made from CR-39 monomer are more scratch-resistant than those made from acrylics, polycarbonates and other polymers, and their optical qualities are maintained even under stress conditions. Age, moderate stress, or contact with solvents such as acetone will not cause deterioration in CR-39 or its filtering properties. One manufacturer of CR-39 filters offers to replace them free of charge at any time, should they become damaged.

The process of applying colour to CR-39 is somewhat complex, and basically involves dipping the filter in a special dye which penetrates the molecular structure of the material; the dye becomes uniformly distributed throughout the thickness of the filter and forms an integral part of the filter material. Thus it cannot be rubbed or scratched off as can the surface-sprayed colour of a lacquered filter. Graduated filters are built up by subjecting the material to repeated dips of diminishing depth in a weak solution of the coloured dye until the desired density or colour saturation is achieved.

Penetration-dyed filters give the manufacturer considerable control over the accuracy of their colour, so long as carefully monitored tests are first undertaken to ascertain absorption rates of the dye to be taken up by the material. From the user's standpoint, penetration-dyed filters are to be preferred to surface-coated types because they are less prone to accidental damage. Minor scratches to a penetration-dyed filter have little effect on its transmission characteristics (though optical properties may be impaired to some extent). A surface-coated filter on the other hand will have its filtration qualities impaired if it is marked or scratched. The large holder in which resin and other plastics filters are used enables the filters to be employed with different camera and film formats, and the majority of wide-angle, telephoto and large-aperture lenses as well as regular lenses. The filters simply slide into the holder, enabling them to

be positioned precisely, to affect the desired portion of the scene before the camera. It also permits two filters to be butt-jointed for a double-colour effect, or a graduated-density filter to be positioned exactly as required. The various plastics filters, their holders and/or their adaptors, cannot as a rule be interchanged between the different makes.

**Built-in filters** Because they are thin and of high optical quality, gelatin filters can be fitted between the elements of a lens, behind the lens, or within the camera body. Certain lenses, such as 'mirror' lenses, as well as some colour enlarging lenses, have filters that are built in by the manufacturer. In some cases the filters are on a rotating ring, so that a selection of filters can be brought into use. Such filters are better protected and less prone to damage than external filters. Internal filters are also used with ultra-wide angle lenses where the steeply curved front surface makes external filters difficult or even impossible to fit. Some photographers prefer to fix a colour-correcting filter behind the rear element of a lens to modify its colour transmission. Others may fit an ultraviolet-absorbing filter (see pages 47–50) inside the rear of the lens mount. If it is necessary to mount a filter behind the lens, use only a gelatin type, as an optical flat will displace the image plane and focusing will be incorrect. Cement the filter in place very carefully without damaging it, and ensure it does not foul the focusing or aperture-control mechanisms. Filters should be fitted behind a lens only if required for the great majority of work for which the lens will be used. Once fitted, the filter will be difficult to change.

**Anti-reflection surface coating**
Light incident on an optical surface divides into three parts: that which is transmitted, absorbed, and reflected. Some 5 per cent of incident light is reflected from an air-glass surface, so a filter loses approximately 10 per cent of the light incident upon it. (In reality it is less than 10 per cent, because the second surface loses 5 per cent of the light transmitted by the first surface. Assuming that

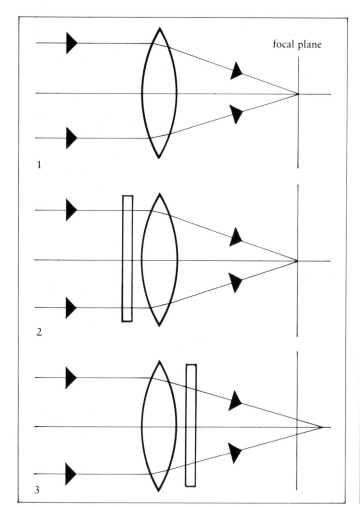

all colours etc. are transmitted equally, this is 5 per cent of 100 per cent, minus 5 per cent of the final amount transmitted by the filter material.) In addition, some light is reflected internally from the rear to the front and back again, thereby adding to the optical system's internal reflections, which degrade the final image.

Modern lenses have a number of surface coatings to reduce reflections, which can cause flare or streaks and thus reduce contrast and impair the image. The lens elements are coated with one or more layers of anti-reflection substances (usually fluorides) vaporised in a vacuum on to their surfaces; these help to suppress unwanted flare. Good-quality filters are often coated, and some are multi-coated. More expensive than the regular variety, coated and multi-coated types nonetheless show a significant improvement over uncoated filters. Plastics filters are not usually surface-coated, and it

Displacement of focus by a thick filter. Subject at infinity: (1) no filter; (2) filter in front of lens, no focus shift; (3) filter behind lens, focus shift. Subject close up: (4) no filter; (5) filter in front of lens, front shift; (6) filter behind lens, back shift.

is argued that their operating distance from the surface of the front element of a lens, plus the hooding usually provided by their holder, is sufficient to overcome any deleterious effects. This seems to be borne out with regard to flare under all normal conditions, especially when the filters are used in conjunction with an efficient lens hood. The effect on light transmission due to surface reflections is unaltered, of course.

Despite anti-reflection surface coating, filters should be used only when really needed. Lenses are designed to give their peak performance unaided, and the fitting of even a high-quality filter definitely does not improve the resolution of the lens. For this reason it is not good policy to leave even a colourless ultraviolet-absorbing filter fitted to a lens simply to protect the front surface, since it is unlikely to be made to the same high standards as the lens. Only under conditions where rain, spray or heat may reach the lens or its surface coating should a glass be fitted purely for protection.

Differences in reflection caused by two types of lens coating.

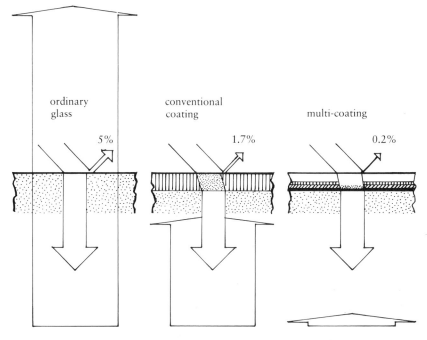

ordinary glass

5%

conventional coating

1.7%

multi-coating

0.2%

## Filter quality

In the past, filter quality has varied enormously. For optimum results with modern high-grade lenses, though, the quality of the filter must closely match that of the lens. Many manufacturers produce different grades of filters, ranging from 'camera filters' to optical flats for aerial, scientific and similar precision applications. At the other end of the scale, grades lower than those suitable for general camera work are produced for non-optical use, for fitting in front of light sources such as safelights, in colour-printing enlarger heads and studio lamps. While the colour quality of these is important, especially for colour printing, their optical standard and freedom from blemishes is only a secondary consideration.

I have been party to a range of tests designed to determine whether a number of the many available types gave a measurable shift in focus when fitted to a lens set to sharply resolve a target subject at one metre. Gelatin filters, when used alone, produced no change in the image or the imaging characteristics of the lens to which they are fitted. Also, there was no detectable focus shift of the test subject. Most of the glass filters (all of which were either coated or multi-coated) caused no measurable effect on image quality, though a slight shift of the focus of the image was detected. Two makes of glass filter, though, gave a 20 per cent image fall-off and a 45 per cent loss of definition respectively, indicating that great care is essential when choosing glass filters if lens performance is to remain unaffected. Of the various CR-39 filters that were tested, each gave a 10 per cent loss of definition accompanied by a slight focus shift.

All the foregoing indicates that gelatin filters should be used when the highest quality is required, where their lack of robustness is not important and where they can be easily mounted in front of a camera lens. Whether you choose glass or plastics filters depends on personal preference, convenience and adaptability. It takes longer to screw individual filters in and out of a lens when changing from one

to another. On the other hand, the edges of unmounted plastic filters are sharp and can cause minor cuts, especially when the holder stiffens with the cold. Plastics types also readily attract static, thereby demanding frequent cleaning, which often produces even more static. Good-quality glass filters are probably the best compromise for all-round use, and as prices are very competitive they can be excellent value for money. Use the plastics types when special effects are more important than ultimate image quality. The performance of all filters is improved by the use of an efficient lens hood.

## Filter mounts

The majority of glass camera filters are supplied in different sizes, fitted into circular mounts threaded for screwing into the inner threaded front rim of a lens. At one time, glass filters were supplied unmounted because it was more economical (though less convenient) to buy only one mount and then to interchange the filters. Both fixed and interchangeable mounts are usually made from aluminium alloy, the positive screw-in fitting ensuring that the filter is mounted truly parallel to the lens. This is important if the optical performance of the lens is to remain unimpaired. The mount has to be reasonably shallow, so that cut-off will not occur when two or more filters are fitted, and it should not clamp the filter glass too tightly or distortion could occur, again affecting the image quality. Screw-in filter mounts are internally threaded so that other filters, close-up lenses and/or a lens hood may be fitted at one time. The mount also helps to protect the filter from having its edges chipped or damaged, and avoids the need for it to be touched with the fingers. If cared for and protected against damage, good-quality optical-glass filters should last indefinitely. To reduce the number of filters that anyone need own for use with their various lenses, most manufacturers of cameras with interchangeable lenses standardise on the diameter of the filter mounting rings of their lenses. Usually quoted in millimetres, the most popular diameters are 49, 52,

55 and 58 mm. Step-down and step-up adaptors are also available. Push-on and bayonet types are available for specific makes of lens.

Plastics (synthetic resin) filters are available from a number of manufacturers, usually being supplied in 75–90 mm (3–3½ in) squares for use in a special graphite-loaded resilient plastics holder or compendium. This holder fits to a lens by means of an interchangeable adaptor ring that screws into the filter mount surrounding the front element of most lenses. The holder can then be fitted to any number of different-sized lenses by simply changing the adaptor. This makes it economic to buy only the one set of filters and a holder with the necessary adaptors; the holder itself accepts two or more filters simultaneously as well as a lens hood. Some holders also have provision for accepting gelatin filters.

## Lens and filter care

Lenses are computed to give their ultimate

The Paterson Optical Test Target has identical patches in black and white and each of the three primary colours, so it is ideal for testing the optical quality and basic transmission characteristics of filters.

performance unaided. With the exception of a lens hood, no device or attachment can improve the performance potential of any given lens. Fitting any filter, effects attachment, close-up lens or other optical device in front of a lens affects its performance. It is essential, therefore, to minimise any deleterious effect that the auxiliary attachment may have. Use a filter or attachment only when it is necessary to achieve a particular effect or result, so long as this result is an improvement on the potential from the unaided lens. Choose the best-quality attachment that you can afford, and always keep the attachment (and the lens) scrupulously clean. The last of these points is often overlooked. Too often the optical surfaces are allowed to gain a coating of dust and fingerprints. Not only will these impair the resolution of the lens, but they will also reduce image contrast. Scratches will have similar effects, the scratch itself being particularly prone to produce flare.

All filters should be handled only by their mounts or, in the case of plastics or gelatin types, only by their edges. Frequent dusting may create static and attract more dust. But when a filter needs to be dusted, use a soft brush (squirrel hair) as one would for a lens. For glass or plastics types, use a lens tissue or a non-impregnated type of cloth. Grease can be removed from glass filters by using one of the popular domestic dry-cleaners containing carbon tetrachloride or a similar solvent. If necessary, a brief wash in warm water to which a few drops of washing-up liquid have been added will remove most marks. This is also the best way to clean plastics filters. In hard-water districts, first boil the water than allow it to cool. Gelatin filters may be dusted but must not be cleaned; a filter bearing fingerprints must be replaced. Before fitting a filter or adaptor ring to a lens, clean the threads of its mount and that of the lens to remove any grit or foreign matter that might cause binding and make the attachment difficult to remove. To minimise these problems, always keep lenses capped, front *and* rear whenever possible; the same applies to teleconverters and other optical attachments.

Filters, close-up lenses, etc. should always be kept boxed or in wallets as supplied. Keep all optical items away from heat and damp. To clean an optical surface, first dust it lightly to remove all loose particles of grit etc. Further cleaning can then be done with lens tissue or cotton buds and optical cleaning fluid as required. Always ensure that any fluid is suitable for the material and surface to be cleaned.

All filters may fade with prolonged exposure to light. In most cases this will take a considerable time and the gradual effect may be unnoticed for general photography. Narrow-cut filters for scientific work should be checked at regular intervals against new ones, or against known standards, and replaced when unserviceable. All filters should be kept boxed and well protected. Even minor scratches can cause impairment of the performance of a lens. Do not buy filters that have been on display in a shop window, or those that show signs of damage or scratches; beware particularly of second-hand filters.

*Frank Peeters*

# Filters for black-and-white photography

It is perfectly possible to practise black-and-white photography and never use a filter. As long as the film is correctly exposed and processed, the resulting negatives will display tones that accurately represent the hues and shades as seen in the original subject. The final prints will then reproduce these tones in the correct proportions and densities. But because of the limitations of human vision and of available photographic materials, this ideal situation rarely occurs. Often, the photographer realises that certain features in the original scene have not been fairly represented, there being areas that are either too light or too dark in comparison with the rendering of other coloured objects. In some instances, features of the subject may not be present in the final photograph. Typical examples of this are light clouds against a blue sky of a landscape picture, or a child's green kite against a blue sky. A green dress worn by a girl sitting under a tree may appear only very slightly different in tone from the lawn on which she is sitting; the subtle grain in the wood of a piece of furniture may have disappeared completely, and so on.

We have seen that the spectral response of the eye is high in the green region, and that this is not matched by the spectral response of any black-and-white film. Moreover, the quality of the light incident on the subject may also affect the results possible with the film, moving its tonal rendition farther from that acceptable to the eye as a fair representation of the original colours. This is further affected by the colour shift in the sensitivity of the retina of the eye as the level of illumination is reduced (see page 7). Filters can reduce these effects. The range of available filter colours covers the five major hues of the visible spectrum. In addition, different densities and mixtures of colours are available so that control of tones can be

brought within fine limits. Filters for black-and-white photography can lighten some tones, darken others, increase or reduce contrast, and either correct or deliberately falsify the final result to satisfy the requirements of the photographer and viewers of the final pictures.

## Basic types of filter

Of the three main types of filters used in photography, all can be used with black-and-white films. As has been seen, each filter, in selectively transmitting certain visible wavelengths and absorbing others, requires an increase in the exposure that would be required without a filter. This selective transmission is best expressed by means of a curve in which the density and transmittance are plotted against the various wavelengths. In contrast with spectral response curves that show the highest point of transmittance as a peak, the curve plotted for a filter shows its absorption the higher up the vertical (density) scale it climbs. Troughs represent the filter's greatest transmittance. The denser the colour of the filter, the steeper the climb of the curve and the flatter the troughs. Steep cutting is usually only required for colour photography, in colour-separation work and in colour-balancing work such as in colour printing. To buy such filters for black-and-white work would be uneconomic and unnecessary, the filters being prohibitively expensive.

Filters for black-and-white work fall into the following categories: correction, contrast, ultraviolet-absorbing, neutral-density and polarising. In cine work and in technical and industrial photography a monochromatic or 'pan-vision' filter (page 118) may also be used. Technical, industrial and scientific work may also require the use of an ultraviolet-transmitting filter (page 127), infrared (page 125), photometric filters or liquid filters (page 130), interference filters (page 121) etc. Safelight, Multigrade and other darkroom filters are discussed in the final chapter.

Correction filters are used for the recording of

colours of the original scene in their correct luminosity. For practical purposes, partial correction is normally sufficient because of the adaptability of the eye, but in some circumstances full correction may demand a very deep filter with an impractically high exposure increase factor. Partial correction for daylight photography entails the prevention of blue parts of the subject from being rendered too light, and green areas from being rendered too dark. Pale yellow filters are ideal for this purpose, as they improve the rendering of skies by darkening them to a tone more acceptable in comparison with others in the picture: the darker the sky, the white and more dramatic is the appearance of clouds. For landscapes, especially, if the naturally high sensitivity of the emulsion to blue were to remain uncorrected, skies would appear as overall light grey and devoid of clouds, or 'bald'.

Full correction in daylight requires the lightening of green areas in addition to darkening of the blues. Since the average single-colour filter, in absorbing some blue, at the same time absorbs some green, a yellow-green filter is employed. This filter must not be confused with a yellow-and-green two-colour effects filter (page 105). Partial correction in tungsten light, which in comparison with daylight is high in red and low in blue, often results in reds being recorded too light and blues too dark. In a portrait, for instance, red lips can be too pale and blue eyes too dark. A pale blue or blue-green filter brings the rendering closer to an acceptable level. Full correction under tungsten lighting can be achieved by using a blue-green filter, i.e. a filter with a high blue and low red transmittance. Such a filter would have a large filter exposure factor and the results, especially in portraiture, would look false and exaggerated.

Contrast filters control the contrast between tones in the final picture. These filters can increase the tonal difference (contrast) between shades of the same hue, e.g. shades of green in a wooded landscape, or the tonal rendering of two different

On the left is a red pepper, on the right a green, but an 8 × red filter eliminates the tonal difference. *Neville Newman.*

also used to create an effect, by dramatically lightening or darkening a particular colour. To lighten a colour, choose a filter that has a high transmittance in that region of the spectrum. This means using a filter that is of the same hue as that which is to be recorded lighter. To darken a hue, the reverse applies: the filter should be of a hue complementary to the one to be darkened. This does not hold exactly for all hues, The maximum effect is achieved by using a filter that transmits only a narrow band of wavelengths. This type of filter is called a *narrow-cut filter*.

Most general-purpose correction filters used in front of a camera lens differ from contrast filters only in the depth of the particular colour. For example, a light yellow is a correction filter whereas, by the nature of its exaggerated results, a deep yellow is classed as a contrast filter. The usual correction filters are light yellow, medium yellow, yellow-green, light green, and green. Contrast filters are usually deep yellow, light orange, deep orange, light red, deep red, blue and blue-green. Special filters include neutral-density and polarising filters.

### Ultraviolet-absorbing filters
These are colourless filters used to absorb invisible ultraviolet (UV) radiation to which all photographic emulsions are sensitive. The wavelength of UV radiation is shorter than that of violet, i.e. less than 380 nm. Most lenses are not corrected for these wavelengths, so the image formed by UV radiation may not be at the same focus as the image created by all of the other colours. The overall effect is an apparent loss of crispness on pictures taken at full aperture, especially with large-aperture lenses.

Most UV radiation is absorbed by a modern lens, but with older lenses the absorption may be only partial, so rather than compute the optics to focus UV (which, in any event, is undesirable) it is easier to block off this radiation; for this reason a UV-absorbing filter is used. It is worth noting that

colours that would otherwise result in a similar grey tone, e.g. orange and green. Visually these colours are quite different, but the spectral sensitivity of the film may render them as virtually identical tones of grey. Contrast filters are employed when correction filters are inadequate, or when tonal differences must be exaggerated. This may be done either to reveal the presence of subtly different shades or to satisfy the eye by creating a clearer difference between hues. Contrast filters are

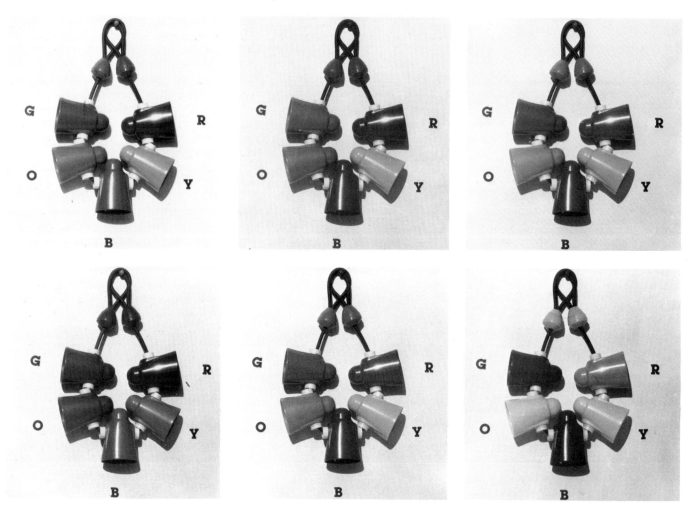

not all of the sun's UV radiation reaches the subject. Radiation below about 290 nm is absorbed by the ozone layer that surrounds the earth. At a lower level a layer of haze surrounding the earth absorbs some of the radiation between 290 and 400 nm, but in mountainous areas (above 1000 m) there is no haze to attenuate this radiation. Haze particles are also less in evidence by the sea. This is why one is more likely to suffer from sunburn under these conditions.

Climatic conditions, and the season of the year, have a marked effect on the degree of ultraviolet radiation present. During summer months the sun's rays have a higher intensity over the entire spectrum, and UV radiation extends farther into the short wavelengths. In humid conditions the effect is attenuated, because the minute specks of dust in the air gather up moisture, forming tiny droplets a few micrometres in diameter (a micrometre, abbreviated μm, is a millionth of a

metre); each of these reflects UV radiation. The effect increases with the level of humidity, and as sunlight passes through the haze its UV content is scattered; this is why one is less likely to suffer from sunburn in a humid climate. The effects of ultraviolet radiation on the emulsion can easily be confused with the effects of haze and mist. A UV-absorbing filter may thus appear to be doing the same as a haze-penetrating filter (page 61), though in fact it does not penetrate genuine haze or mist. Incidentally, the exposure factor of a UV-absorbing filter is 1; that is, it requires no increase in exposure.

One school of thought recommends that an ultraviolet-absorbing filter should be left in place permanently 'just in case', and to act as added protection for the front element of the lens. Another school insists that the filter should be fitted only when it is actually needed and should be removed when it is no longer necessary. Furthermore, subscribers to this second school aver

that, as filters are usually optically inferior to the lens with which they are used, they should be fitted only when their effect is essential. There is a good deal of sense in this view. Lenses in general are computed to yield their best performance without additional optics, even when those are of high quality. An ultraviolet-absorbing filter (or any other filter, for that matter) is no substitute for a lens cap. Only in conditions where the front element of the lens is at risk during the photography itself, for example from heavy rain, sea-spray, wind-blown sand or dust, should it be used as a protection. Under these conditions the additional and frequent cleaning is best done to a filter rather than the lens. Should damage occur to the front surface under the conditions, it is relatively inexpensive to put right: only the filter needs replacing. However, in normal situations there is nothing to be gained from placing two glass-air surfaces between the subject and the lens. Many modern high-quality lenses, moreover, do not need a UV-absorbing filter under any

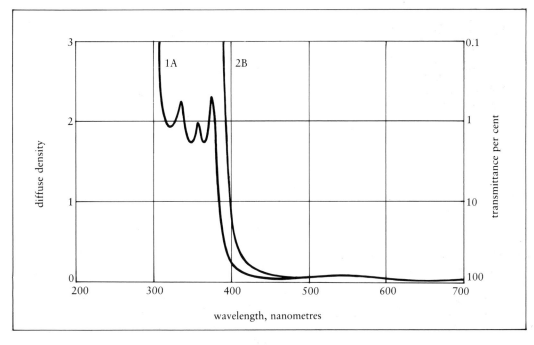

Absorption characteristics of two ultraviolet-absorbing filters.

conditions. Typical examples are the Zeiss Planar lens and Leica lenses made from about 1965 onwards. These lenses and many more, by the use of certain types of glass and the special cement used to bond together the various elements, are virtually opaque to ultraviolet. Leitz guarantees identical colour transmission characteristics for all its lenses, and a neutral colour reproduction even at very high altitudes.

Another reason for not fitting a UV-absorbing filter when not required is the risk of internal reflection and flare, even with coated, optically flat glasses, especially in photographs of sunrises and sunsets, night shots that include street lights or other bright light sources, and very bright subjects with very dark surrounds, such as archways. The result is often overall degradation of the image caused by a lowering of contrast, particularly in the darker areas. With wide-angle lenses, too, the use of a UV-absorbing filter carries the risk of further loss of quality from uneven illumination, as marginal rays entering the lens must travel farther through the filter than those at or near the axis. This is especially evident with colour reversal films. For this reason, many manufacturers recommend that their ultra-wide-angle objectives should not be used with external filters at all. This prompts them to build filters into the rear of the lens mount (page 39).

With so much argument against the use of ultraviolet-absorbing filters, are there really any conditions in which they are necessary, or even useful? At sea, in coastal regions, or at altitudes of more than 1000 metres, the use of a UV-absorbing filter is often worthwhile. But note that this filter is not the only filter that absorbs ultraviolet radiation. As we shall see later, many of the contrast filters so favoured by pictorial and landscape photographers also absorb UV radiation, while providing their own distinctive effects (pages 60–63): the separation of different colours that would normally be rendered in similar tones, or the separation of similar hues in the final result.

There are two types of UV-absorbing filter; those that absorb only invisible radiation, and those that also absorb some blue. The diagram on the previous page shows the characteristics of each of these. For black-and-white film, the difference between the two is of no consequence, but with colour films it can be quite appreciable (page 82). Some manufacturers of filters produce variations on the UV-only absorbing filter, their numbers indicating the longest wavelength of UV radiation that they control. Nikon, for example, produces L37, L37C and L39 filters, indicating absorptions of shorter wavelengths than 370 nm and 390 nm respectively. The latter produces a more pronounced effect in black-and-white photography. It is worth noting here that it is essential when making colour prints to have a UV-absorbing filter (such as a Kodak 2B) in the light path. This is 'built-in' in most colour heads.

### Neutral-density filters

The use of neutral-density (ND) filters in cinematography (page 116) has for many years been a necessity, as the exposure time is fixed and exposure control is possible only via the iris diaphragm. Comparatively recently, many still photographers have turned to neutral-density filters, used in conjunction with the high-speed films they tend to use under all lighting conditions and for all photographic situations. Their use greatly reduces the amount of knowledge it is necessary to acquire regarding emulsion characteristics and response to exposure and processing variations. Despite their shortcomings with regard to enlarging potential, fast films offer advantages. These include the opportunity to maintain high shutter speeds and moderate lens apertures, even when using deeply coloured filters in daylight; very short exposure times, to arrest movement; minimum aperture when maximum depth of field is required; the ability to obtain viable pictures when lighting conditions deteriorate, and to expose by artificial lighting without having to resort to the use of flash. But there are occasions when this very advantage of

high sensitivity works to the disadvantage of the photographer, and it may prove difficult or even impossible to avoid serious overexposure. On a beach in bright sunlight, for instance, when even the shortest exposure time and smallest aperture are inadequate; when large lens apertures are required for critical zone-focusing; or when comparatively long exposure times are needed to achieve an impression of movement or speed by creating blur. On such occasions a neutral-density filter can prove very useful.

Neutral-density filters reduce the amount of light transmitted, uniformly across the visible spectrum, by a fixed ratio; they thus have no effect on individual hues in the original scene. The spectral transmittance or density curve of this filter is not very exciting; it is a virtually horizontal line, indicating uniform absorption at all wavelengths. A neutral-density filter thus has no effect on the spectral response. Neutral-density filters can be made from many different types of materials and in

various forms. They may also be diffusing (page 105) or clear, uniform or graduated-density (page 116). Optical-quality ND filters for use within image-forming paths are usually made by suspending dispersed colloidal carbon in gelatin. Dyes are also added; these are chosen so that their spectral absorption properties when combined with the brownish colour of the colloidal carbon give the necessary uniform absorption spectrum. A disadvantage of dyed filters, though, is that the dye may fade with use. The effect does take time, but may eventually result in uneven spectral absorption. Fade-resistant dyes are the subject of constant research.

The light-scatter/transmission properties of a neutral-density filter are usually quoted as the Callier coefficient or Q-factor. These are based on the Callier effect, which is more usually associated with the effective transmission density of a photographic negative in an enlarger having condenser-type illumination. The Q-factor is the

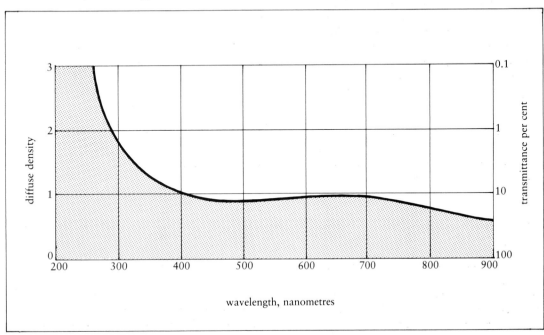

Absorption characteristics of a typical neutral-density filter.

ratio of total transmitted light (including scattered light) to directly-transmitted (i.e. unscattered) light. A Q-factor of unity is a no-scatter condition, and can be achieved only when the neutral density is produced by pure dye, no solid particles being present. Suspended colloidal carbon has a Q-factor of only 1.2, and is therefore an excellent medium for use in front of or behind a lens, i.e. within the image-forming light path. Photographic film (another material from which useful neutral-density filters are produced) when uniformly exposed, and processed to a suitable density, is an effective and efficient ND filter for visible and near infrared wavelengths; however, it has a Q-factor of 1.4, indicating that its light-scattering properties are too great for use in the image-forming light path. Evaporation of the alloy 'inconel' on to glass gives a Q-factor little higher than unity; filters made in this manner give a very good neutral density that is non-light-scattering. Unfortunately, since its effect is achieved by a combination of absorption and reflection, specular reflections from its surfaces can prove troublesome under certain circumstances.

Neutral-density filters are supplied in a range of densities. Manufacturers of glass and plastics types generally offer at least two or three densities. In gelatin there are a dozen or more, graded in density from 0.1 to 4.0, the latter having a transmittance of only 0.01 per cent, i.e. a factor of 10 000, requiring an exposure increase equivalent to 13½ stops. Different manufacturers use different codes, but most often a neutral-density filter has the prefix ND followed by a number that represents its density, its exposure increase factor, or the percentage of light that it transmits. Densities can be built up by combining two or more filters. Adding their densities gives a slightly lower result than the effective density, owing to light lost through reflection at the surfaces of the filters, though in general this difference can be ignored. ND types may vary slightly in their actual density, but they have to meet the relevant international specifications. If required for very precise or

### Neutral-density filters

| density | transmission | filter factor | exposure increase |
| --- | --- | --- | --- |
| 0.1 | 80 per cent | 1¼ | ⅓ stop |
| 0.2 | 63 | 1½ | ⅔ |
| 0.3 | 50 | 2 | 1 |
| 0.4 | 40 | 2½ | 1⅓ |
| 0.5 | 32 | 3 | 1⅔ |
| 0.6 | 25 | 4 | 2 |
| 0.7 | 20 | 5 | 2⅓ |
| 0.8 | 16 | 6 | 2⅔ |
| 0.9 | 13 | 8 | 3 |
| 1.0 | 10 | 10 | 3⅓ |
| 2.0 | 1 | 100 | 6⅔ |
| 3.0 | 0.1 | 1000 | 10 |
| 4.0 | 0.01 | 10000 | 13⅓ |

scientific work, they should be calibrated under controlled conditions, using a standard reference.

Fitted to a lens, a neutral-density filter reduces the proportion of light transmitted, enabling larger apertures or longer exposure times to be used; fast films to be used under bright lighting conditions when the fastest shutter speeds and smallest apertures would still result in overexposure; and exposure control with mirror lenses, which have no iris diaphragm. For the movie buff, limited to controlling exposure through the lens diaphragm, a neutral-density filter over the lens prevents overexposure when the smallest lens aperture is inadequate. In both the still and cine world there is a tendency nowadays for manufacturers to fit standard lenses of very large apertures, and this raises mechanical difficulties in obtaining f-numbers higher than f/16; in any case, the use of very small apertures can adversely affect optical performance. When such lenses are used in combination with relatively fast films, many workers feel the need for a neutral-density filter, especially when holidaying abroad under bright conditions of sun or snow. In indoor portraiture,

they enable large apertures to be used to achieve zone focusing, or to cope with over-powerful lighting in restricted surroundings. Neutral-density filters have good ultraviolet-absorption properties, so an additional UV-absorbing filter is not necessary.

The use of an exposure factor for a neutral-density filter does not differ from that for a colour filter. All you have to remember is that each 0.3 in the ND number corresponds to an exposure factor of $2\times$. Thus ND 0.6 is a factor of $4\times$, and if you use a 0.6 neutral-density filter you give exactly the same exposure as you would, say, to a $4\times$ orange filter. If you need to use a colour filter and a neutral-density filter together, their combined filter factor is obtained by multiplying their individual factors; e.g. ND 0.6 and $4\times$ orange gives a factor of $4 \times 4 = 16$.

The most popular neutral-density filters, and probably the most generally useful, are those with a density of 0.3, 0.6 and 0.9. These require exposure increases of 1, 2 and 3 stops respectively. Fitted to the camera, this means that an an exposure of $1/500$ second at $f/16$ without an ND filter would become either $1/250$ second at $f/16$ or $1/500$ at $f/11$ with the 0.30; $1/250$ at $f/16$ or $1/500$ at $f/8$ with the 0.60; and $1/60$ at $f/16$ or $1/500$ at $f/5.6$ with the 0.90. Cameras with through-the-lens metering systems need no manual adjustment for the filter; the meter reads through the filter and thereby determines the appropriate setting. Cameras with separate metering should have the exposure increase set manually after a reading has been taken; alternatively the meter's film speed setting can be reduced accordingly. Thus the ISO arithmetic index should be halved for each whole stop increase required, or the ISO logarithmic index (if used) should be reduced by 3°.

Neutral-density filtration can be combined with colour filtration, if desired with graduated density. Even the disadvantage of light scattering can be turned into an actual advantage. By using a perforated-plate type, or one with a wire mesh pattern, the light-scattering effect produced gives an attractive star-burst effect.

## Polarising filters

As explained earlier, light may be considered as travelling as a wave motion. The waves are transverse waves; that is, the vibrations are at right angles to the direction of motion. In ordinary (unpolarised) light, the orientation of these vibrations is random. However, under certain circumstances the vibrations can be aligned so that they are all oriented in a single plane. Such light is said to be linearly polarised. Although the human eye cannot distinguish polarised from unpolarised light, we can make use of the phenomenon of polarisation. Polarised light occurs naturally, and when it does we can either select it or suppress it by means of a polarising filter. We can use polarised light in the study of crystals in photomicrography, for example (page 125), or visualise stress patterns in certain materials. We can also utilise the phenomenon in an ultra-high-speed shutter that has no moving parts, for photographing extremely rapid phenomena such as the flight of a bullet, the discharge of an electric spark, or an explosion. We can employ the principle in the production of totally non-reflective glass covers for surfaces such as illuminated instrument dials, radar screens, etc. Another use for polarised light is in the viewing of stereoscopic movies, a process pioneered by the Polaroid Corporation and called by them 'Vectographs'.

Light reflected from a polished non-metallic surface such as glass, shiny furniture or plastics, or water, is linearly polarised, and we can use this property to eliminate, or at least to suppress, these reflections. The polarisation is not total except at a specific angle of incidence known as the Brewster angle; this angle varies from one material to another, but is usually in the region of 53° to 57°. (Angles of incidence are measured from the *normal*, which is an imaginary line perpendicular to the surface. An angle of incidence of 53°, if measured from the

surface, would be 37°; when measured in this way, the angle is called a grazing angle.) Light, even polarised light, that is incident on a matt or diffusing surface becomes depolarised on reflection.

Light also becomes polarised by certain natural phenomena: the light of a rainbow is polarised, as is light reflected by ice crystals in the upper atmosphere (mock-suns, haloes etc.). But the most important source of polarised light is a clear blue sky. The direction of polarisation at any point is at right angles to a line joining that point to the sun. By partially blocking off this light we can darken the sky without affecting any other part of a photograph. As only the sky is affected we can use this effect with colour material as well as with black-and-white.

In order to control polarised light we need an optical device (in the language of physics called an analyser) which itself polarises light. Although certain naturally-occurring substances (such as calcite) polarise light, polarising filters are nowadays made of a substance called 'Polaroid', a product of the Polaroid Corporation (or made under licence from them). This material totally polarises any light passing through it. As far as the photographer is concerned its most important property is that if light which is already linearly polarised falls on a piece of Polaroid material, the amount transmitted depends on the orientation of the Polaroid relative to the orientation of the plane of polarisation of the light. If the orientation is the same, all the light will be transmitted; if the orientations are at 90° to one another, no light will be transmitted. Any unpolarised light will, of course, pass through the filter material, though it will emerge polarised and somewhat attenuated. A piece of Polaroid material made into an optically flat filter can thus be used to control reflections from polished surfaces and to darken a clear sky, to emphasise clouds. No guesswork is required, as the effect is visible when one looks through the filter (it is made use of in Polaroid anti-glare sunglasses).

This series shows a comparison of progressive haze penetration and sky darkening with panchromatic and infrared film. Left: panchromatic film. Above right: panchromatic film with polarising screen. Below right: panchromatic film with Wratten 25 filter (deep red) and polarising screen. *Kodak.*

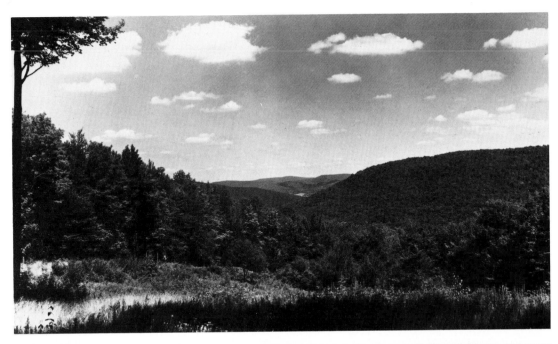

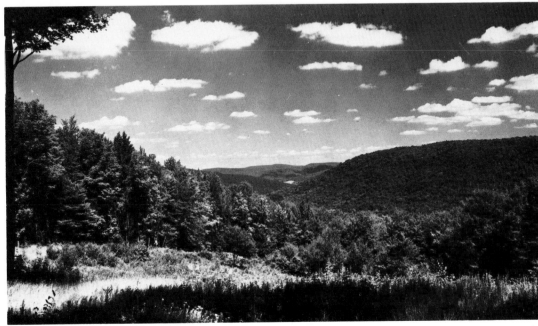

The main uses of a polarising filter are to eliminate or reduce unwanted reflections from shiny surfaces such as glass, water, polished wood, paint, linoleum, leather, oil or wet surfaces, leaves and foliage, plastics and even moist skin. Typical examples are when photographing shop windows, a person in a car, an ornate floor of a swimming pool, a person wearing spectacles, a painting behind glass or a glossy photograph. In reducing unwanted reflections, colour saturation is often increased. Polarising filters also control the rendering of blue sky by making it darker as required, affecting only the sky and not other colours or tones. Although a theoretically perfect polarising filter would actually halve the intensity of incident light, giving an exposure factor of $2\times$, in practice the factor is about $3\frac{1}{2}\times$.

To use a polarising filter on a non-reflex camera, look at the scene through the filter and slowly rotate the filter until the reflection is eliminated or sufficiently reduced, or until the sky is as dark as you want it. Without altering the orientation of the filter, fit it over the lens. Obviously, if the lens rotates when being focused, the filter should be adjusted after the lens has been focused; polarising filters are fitted in rotating mounts marked to show their direction of polarisation, to facilitate adjustment. If you are in a hurry, simply rotate the filter so that the mark is perpendicular to the shiny surface (or points towards the sun, for darkening the sky). To increase the colour saturation of grass and other horizontal surfaces such as roads, set the indicator vertical (i.e. position it at the top of the lens).

The exposure factor of a polarising filter may be taken into account in a way similar to that used with other filters, by resetting the exposure manually, adjusting the film speed, or taking a meter reading through the filter. With some through-the-lens (TTL) metering systems a beamsplitting device is used to direct some of the light on to the meter cell. Some types of beamsplitter themselves polarise light to some

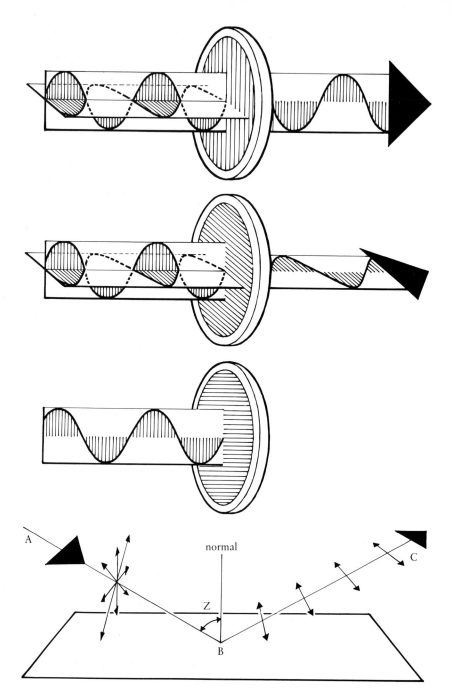

Left: a polarising screen, here represented as a grid, polarises light vertically or horizontally depending on the screen's orientation. When suitably oriented, it completely blocks light that is already polarised. Unpolarised light A–B becomes partly polarised B–C on being reflected by a shiny non-metallic surface; polarisation is greatest when the tangent of angle Z equals the refractive index of the reflecting material.

Right: in each of these examples, a polarising screen was used to eliminate reflections from a bright light source outside the picture area.

extent, and when a polarising filter is used they may further cut down the light, resulting in a false reading and consequent overexposure. If you are unsure of your particular camera, make a brief test: set up the camera on a dull or overcast day, so that the general lighting is completely unpolarised. Next, fit the polarising filter to the lens and slowly rotate it through 180°, watching the exposure reading as you do so. If there is no discernible change as you rotate the filter, you can safely assume that all is well, that the meter optics do not polarise light, and that meter readings can be taken with confidence when the polarising filter is in position. Should there be a noticeable change in the meter reading during the test, the light split off for the meter cell is indeed being polarised, and in future you will have to take readings before fitting the polarising filter, and increase the indicated exposure by the appropriate factor.

Polarising filters can serve a useful purpose as neutral-density filters. A filter on its own behaves as

if it were a neutral-density filter of value approximately ND 0.5. Two filters in the same orientation are equivalent to an ND 1.0. However, by rotating one of the filters relative to the other you can obtain any density you like, the maximum density being in the region of 5.3, an attenuation of some 200 000 times!

This is a good way of producing fades in the camera in cine work, provided you can switch out any automatic exposure-control mechanism. The absorption effect is not linear; most of the effect occurs during the final few degrees of the rotation, so it may be difficult to achieve a smooth, gradual fade unless you devise a lever or some similar means to rotate the filter slowly.

### Correction filters
The spectral sensitivity of even the best of today's panchromatic films does not match that of the human eye. The average panchromatic emulsion is more sensitive to blue than to red and more

sensitive to red than to green, with the result that the final print, if matched for a correct tone in, say, red, will show blues too light and greens too dark. Because of this blue skies, in particular, will be reproduced too light, and any white clouds that were visible in the original scene will be almost invisible in the print. The problem is solved by taking the photograph through a weakly-coloured filter of the hue complementary to blue, i.e. a pale yellow. For fuller correction of the whole scene a light yellow-green filter is suitable, the green slightly reducing the sensitivity of the emulsion to red; the result is a film sensitivity that closely matches that of the eye.

Under tungsten-filament illumination a different filter is required, this time to counteract the excess of red and lack of blue in the illumination. To bring the response of the film closer to that of the eye in daylight, the filter required must absorb some red and a little of the green. The blue must not be absorbed this time, as there is so little blue in tungsten light. The appropriate hue for the filter is thus a slightly greenish blue. In fact, completely accurate rendition is seldom required in black-and-white photography, and a slight imbalance, especially in portraiture, is not only acceptable but often desirable. Precise accuracy is usually required only in certain types of professional and scientific work.

**Yellow**  This has traditionally been the choice as a general-purpose filter for blue sky correction, though improvements in the red sensitivity of panchromatic emulsions have resulted in a shift to yellow-green. Yellow filters absorb blue, violet and ultraviolet, darkening skies and increasing contrast between sky and clouds. Light yellow filters are suitable for portraits out of doors, as they produce a natural tonal rendition of the skin, lighten fair hair and freckles, and slightly darken blue eyes. Medium and deep yellow filters are useful for snow scenes, as they darken blue shadows in the snow that would otherwise record too light. As the density of the colour increases, its effect becomes

more pronounced, and the exposure factor rises. Typical factors for daylight are light yellow $1\frac{1}{2}\times$, medium yellow $2\times$ and deep yellow $3\times$. Choose a light yellow when the exposure increase has to be the least possible, and a medium or deep yellow for a more pronounced effect.

**Yellow-green**  Probably this is the most useful all-round correction filter with panchromatic film, as it affects blue and red in almost equal proportions. It brings the spectral response and

A pale yellow filter has slightly darkened the sky to reveal light clouds. A fine diffusing screen was also used to give the effect of a painting.

58

A deep yellow filter was used to bring out more detail in the ropes and timber post. An orange filter would have made the blue hull of the boat too dark, causing it to merge with the water.

**Green** This is the best landscape filter for black-and-white photography, providing valuable tonal separation between the hundreds of delicate shades of green in grass and foliage. Without a filter, most of the greens of nature blend into uninterrupted grey tones, giving the picture a dull and lifeless appearance. The green filter separates the various tones, giving the picture sparkle and contrast. For outdoor portraits in bright sunshine the green filter darkens skin tones, giving an almost sun-tanned effect; freckles and various facial blemishes are emphasised by being darkened. A better all-round filter than yellow, green filters absorb ultraviolet, blue and red, partially or completely, so the colour balance of the subject must be considered carefully. A light green filter is also useful under artificial light to reduce the over-emphasis of red. Average daylight exposure factors are light green 2–3×, deep green 3–5×.

**Light blue** This is probably the least used, and least understood, of all correction filters for black-and-white photography. Yet it can be especially useful to the pictorialist. It absorbs none of the visible wavelengths completely, but has its maximum effect on red. It also transmits ultraviolet and infrared radiation. Light blue has its major use with panchromatic film in artificial light, where its red-and-yellow absorption prevents skin tones, lips, etc. from being rendered too light and blue eyes too dark. It tends to emphasise freckles and skin blemishes. Out of doors, in daylight, the light blue filter comes into its own: in transmitting ultraviolet, it increases the impression of aerial perspective, giving greater depth to a scene and causing the viewer instinctively to seek detail in the veiled distance. It gives greater emphasis to the foreground, a device much used by painters. This light blue panchromatic correction filter should not be confused with the blue photometric filters used for colour balancing or the blue conversion filter used in colour photography. Light blue filters have an average exposure factor for daylight of approximately 1½×, and for tungsten light of approximately 2×.

tonal rendition of the material closest to that of human eyesight. This filter darkens blue skies to enhance cloud effects; produces good skin tones out of doors; reduces over-sensitivity to red during early morning or late afternoon sunlight; and in landscape work has a useful tonal-separation effect on foliage. Average daylight filter factors range from 2½× to 3×. Depending on the particular colours in the subject, a yellow-green is generally more useful than a light yellow. This is a good filter for recording autumn colours, too.

## Contrast filters

Correction filters are mostly used to bring tonal rendering of a coloured subject closer to that acceptable to human eyesight. But the effects that these produce, while tonally 'correct', may cause the resulting picture to look flat, dull and lifeless. Colours at opposite ends of the spectrum will be rendered as a similar grey tone and, if close together, may even be indistinguishable. A man wearing an orange and blue club tie, for example, may well appear to be wearing a plain grey one when his portrait is reproduced in black and white. Producing a picture whose tones are correctly balanced is all very well, but the result could appear dull and flat from a pictorial standpoint. More often, the separation between the various tones must be enhanced to give the picture life and sparkle. In so doing, the colour contrasts of the original subject are exaggerated by using a contrast filter.

A contrast filter is usually of a deep colour, orange or red, for example, and is used to significantly lighten or darken the resulting tone representing a given colour. In general, a contrast filter lightens anything possessing the same (or a similar) hue and darkens anything of a completely different hue. Thus whereas objects of two quite different hues might appear as similar tones on a print, a suitable contrast filter lightens one and darkens the other.

Typical of this is the case of green and orange: although visually quite different, they appear quite similar when reduced to tones of grey by an unfiltered negative. Fit an orange filter over the camera lens, however, and the tonal representation of orange is significantly lightened and that of green darkened. More subtle is the filter's ability to cause greater separation between various closely matched tones of its own hue; a green filter, for example, has this effect in a landscape picture. Another name given to a contrast filter used for separating tones of its hue in this manner is a 'detail filter', because it enhances detail in a coloured subject while making it stand out among its surroundings.

**Orange**  The most commonly used contrast filter is the orange; it takes over from deep yellow when greater separation is required between blue sky and clouds. It absorbs all wavelengths from ultraviolet to green, though its effect is not as pronounced as a red filter, nor does it have so large a filter factor. Curiously, an orange filter does not always give the expected results. On a dull day, for instance, or even a hazy one, its effect on the rendering of a sky may be hardly noticeable. But on a bright day it will darken a blue sky, producing a dramatic cloud

A green filter was used to increase the contrast between the different shades of the foliage.

effect where possibly only light cloud is visible. The effect is more apparent, though, when the sun is angled and behind or to one side of the camera. The filter has little or no effect when shooting against the light, as the sky area is then usually brilliant and much whiter, and quite likely to be overexposed, thereby almost totally nullifying the filter's effect. An orange filter is ideal for winter pictures, especially those of sunshine on snow, where the pronounced shadows it produces result in an attractive three-dimensional effect. Orange filters lighten reds and yellows, darken blues and greens and remove light haze and ultraviolet from landscape pictures, making detail in distant scenes cleaner. They are especially useful with telephoto lenses. Suntanned skin and freckles appear lighter, as do yellow colours. Blue eyes are rendered dark.

An interesting point about orange filters is that green grass and foliage are not darkened, as might be expected, but actually appear lighter. This is sometimes said to be due to the fluorescence of

chlorophyll at infrared wavelengths. In fact, chlorophyll does not fluoresce to any extent. It reflects green very strongly, with a peak at about 500 nm. It also reflects deep red and infrared, from about 690 nm; the infrared here is irrelevant, as panchromatic film is not sensitive to it. The human eye is more sensitive to green than to red, which is why foliage looks green rather than yellow or red; but with an orange filter in front of a panchromatic emulsion, the maximum effective sensitivity of the emulsion is at the long wavelengths of the visible spectrum. Hence the red content of the reflected light makes foliage look lighter. As might be expected, the effect is stronger for a red filter (and even stronger for infrared-sensitive film). The average filter factor for orange filters when used with panchromatic film in daylight is $3-5\times$, and under tungsten filament lighting $3-4\times$.

**Red** Red filters produce the most dramatic effects of all. This is mainly because of their restricted transmission: for a light red filter, wavelengths longer than some 600 nm are transmitted; for a deep red, some 650 nm. Thus dark red transmits only red and infrared, and light red transmits orange as well. The overall effect with panchromatic film is bold, even harsh, reds being light and all other hues dark. The effect is at its strongest when exposure is held to the minimum; as with most filters, if exposure is increased the effect is reduced. Underexposure of a scene taken in sunlight with a red filter gives a quasi-moonlight effect, which can be enhanced by including reflections from water, or by turning on car or house lights that will be in the picture.

Red filters accentuate the lightening effect with foliage and grass, causing them to be rendered very light. They have strong haze-cutting properties (often revealing details invisible to the eye), give partial penetration of mist, and may occasionally cause a detectable shift in focus. Lenses corrected for chromatic aberration (i.e. all general-purpose lenses) may exhibit a slight error in focus at the extremes of the visible spectrum; under some

Absorption characteristics of a range of contrast filters.

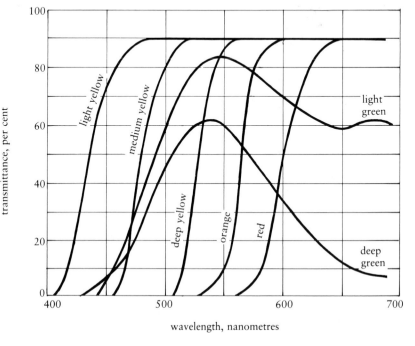

circumstances this may become apparent in the print. Because of this, the lens of a reflex camera should always be focused with the filter in place, i.e. on the viewing lens of a twin-lens reflex and the taking lens of an SLR. A feature of red filters is that detail is often lost in shadow areas that are normally bluish in daylight; also the sky may appear almost black, and clouds show stark and brilliant. The average filter factor in daylight is 6–10×, depending on density, and in tungsten lighting 4–8×.

**Steep-cut filters** Three contrast filters not usually employed in general or amateur photography are the 'steep-cut' filters of the so-called secondary hues, namely yellow, cyan and magenta. Each transmits precisely two-thirds of the visible spectrum and is opaque to the other one-third. Yellow transmits red and green, and absorbs blue, rendering blues very dark on the final print. Magenta transmits the two-thirds of the spectrum made up of blue and red wavelengths and absorbs most of the green. It thus represents green very dark on the final print. The cyan (blue-green) filter transmits the two-thirds made up of blue and green wavelengths and absorbs red; thus red appears very dark on the final print. Exposing panchromatic film through a cyan filter in effect converts its spectral response to that of an orthochromatic film.

**Tricolour filters** These also come in sets of three; their basic hues are those of the three primaries: red, green and blue. Each passes approximately one-third of the visible spectrum, and their overlap is such that the total transmittance as shared between the three is uniform throughout the spectrum. Tricolour filters were used originally in making colour photographs of great accuracy at a time when single-exposure colour films were in their infancy. Three separate exposures were made on three separate films (or more often plates), one through each filter. The resulting negatives were then printed, each in the hue complementary to that of the filter, and the prints were superimposed by physical ('Carbro') or chemical ('dye-transfer')

methods, resulting in a print in natural colours, and archivally permanent. Many Carbro prints are still in existence; the dye-transfer process is still extant. The original Technicolor process worked on the dye-transfer principle. For making colour-separation negatives from less 'pure' sources such as colour transparencies, a different set of tricolour filters was used (and indeed still is, in the printing industry). These pass only a narrow band of wavelengths, which do not significantly overlap. They are known as narrow-cut tricolour filters.

A 5× red filter lightened the tops of these toadstools and revealed further detail in the foliage.

Tricolour filters are of use in general monochrome photography chiefly in situations where a comparatively narrow band of hues is to be selected; they may be considered as an extreme example of contrast filter. Thus a green tricolour filter would be used where it was desired to render all reds, and all blues, as black; correspondingly for the other primaries. Exposure factors for tricolour filters varies widely, from 3× for a red broad-cut filter to 30× for a narrow-cut blue filter, both under tungsten lighting. Because of these wide variations, reciprocity failure (page 118) must be taken into consideration when making sets of matched negatives, and it is difficult to make adequate sets of separation negatives without sensitometric control of exposure and processing. Fortunately for today's generation of printers, computer control has taken over the more awkward aspects of this kind of work.

An orange filter has revealed faded words on this amber jade snuff bottle.

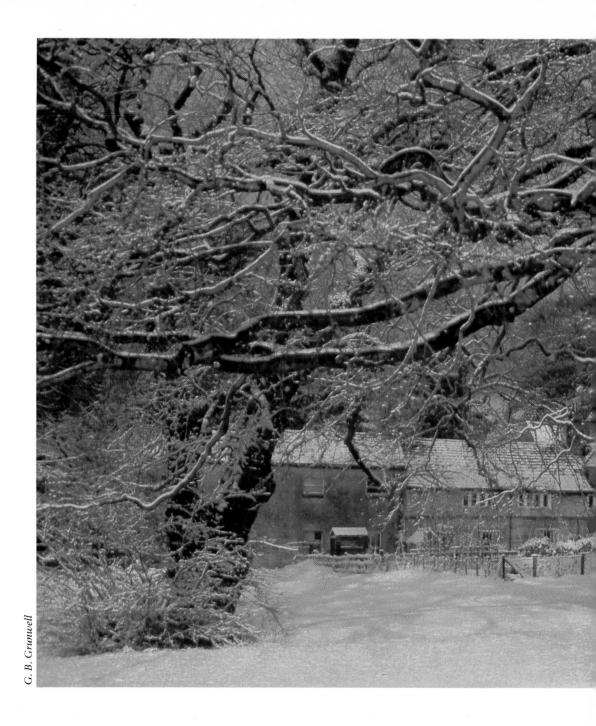

*G. B. Grunwell*

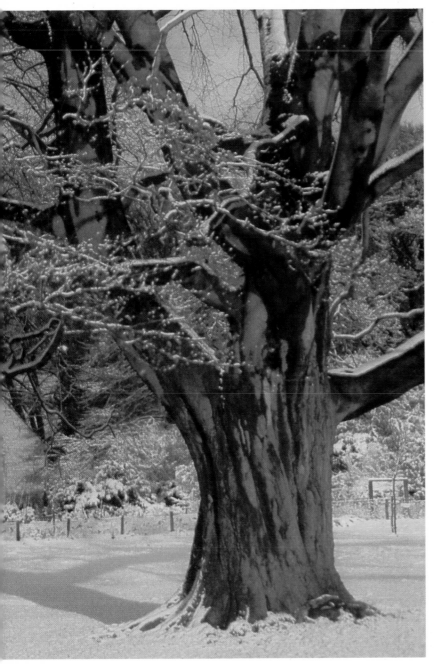

# Filters for colour photography

The problems facing the photographer trying to produce a 'correct' representation of colours in tones of grey are small in comparison with those faced when attempting to reproduce all of them as seen, or as we expect them to be seen. Accepting that the dyes in the emulsion that are used to record the various colours leave much to be desired, these dyes are nonetheless still capable of recording and reproducing all the spectral colours far more accurately than we are able to recall them, which is probably a good thing. Colour film has less latitude (i.e. tolerance) to incorrect exposure than black-and-white film, and while we expect it to record the colours faithfully, we must not forget that colour films are highly sensitive to changes in the quality of the lighting.

Colour processing, which has a direct bearing on the fidelity of the colours in the final picture, is not within the scope of this book. Exposure must be considered, though, as a factor that governs not only the colour rendering of the film, but also the effect of any filters that may be used with it. To achieve the desired effect from a particular filter, the film must be correctly exposed and processed.

### The quality of light
The overall rendering of a colour film is strongly influenced by the quality of the light under which the film is exposed. Consequently, manufacturers produce materials suitable for exposure to particular qualities of light, the most important being daylight. A second type (for exposure by artificial light) is subdivided into types suitable for Photoflood lamps and studio lamps. For the sake of simplicity we shall consider these films to be colour-slide or 'reversal' films, which yield positive colour transparencies directly on being exposed and processed. Colour-negative films have prints made from them using an enlarger with a colour

head, in which the errors in overall colour rendering in the print can be corrected with filters.

In a previous chapter we considered the speed at which the eye adjusts to changes in colour quality in different light sources. The eye quickly accepts most of these as emitting white light, whether daylight, street lamps, floodlights, room lights or even torches or candles. But we must also appreciate not only that these sources have different intensities, but also that they are of different basic hues, being composed of different quantities of the various wavelengths of the visible spectrum. The resulting lights are of differing colour qualities, these being described (for incandescent sources) in terms of colour temperature, expressed in kelvins (page 23). From the accompanying table it is clear that not only do the different light sources have different colour temperatures (which become lower as the lamps age), but that daylight itself does not have a fixed colour temperature. The content of early-morning or late-afternoon sunlight, for example, is high in red. This is because the sun is low in the sky, and

the light has to pass through a thick layer of atmosphere containing microscopic particles of dust, which tend to scatter the shorter wavelengths so that the longer ones predominate. When the sun is high in the sky the light has to pass through a much smaller thickness of atmosphere, and the blue content of the light is much less affected. The blueness of the sky is the result of the scattered blue light. To our eyes it is all 'sunlight', but a colour film can see the difference, and when we look at a slide, so can we. Hence in colour photography the colour temperature of the source is an important factor.

**The colour balance of films**
Earlier, we saw that colour-slide films are manufactured with their colour-rendering balanced for exposure either by daylight or by Photofloods or studio lamps. The daylight types are balanced in terms of a fixed international standard known as 'mean noon sunlight' (5400 K). The films are actually balanced for 5500 K, to allow for the added effect of blue sky. Films made for exposure by Photofloods and tungsten-halogen lighting are

| Colour temperature of some common light sources | colour temperature | mired value |
|---|---|---|
| clear blue sky | 10000–20000 K | 100–50 |
| blue/cloudy sky | 8000–10000 K | 125–100 |
| cloudy sky | 7000 K | 143 |
| sun through clouds (midday) | 6500 K | 154 |
| average summer sunlight (10 am to 3 pm) | 5500–5600 K | 182–179 |
| morning/afternoon sunlight | 4000–5000 K | 250–200 |
| sunrise/sunset | 2000–3000 K | 500–333 |
| electronic flash | 6000 K | 167 |
| blue flashbulb | 5500 K | 182 |
| fluorescent lamp | 3700–4800 K | 270–208 |
| photolamp (Photoflood) | 3400 K | 294 |
| tungsten-halogen studio lamp | 3300 K | 303 |
| studio tungsten lamp (Photopearl) | 3200 K | 313 |
| 150 W household lamp | 2800 K | 357 |
| standard candle | 1930 K | 518 |

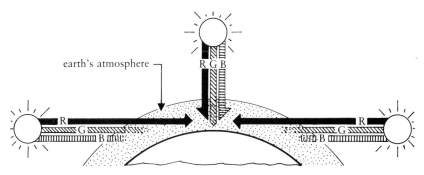

earth's atmosphere

Morning and evening sunlight must penetrate a greater depth of atmosphere, which absorbs a greater proportion of blue wavelengths.

balanced for 3400 K, and those intended for exposure by photographic studio lamps are balanced for 3200 K.

With the artificial-light types of film photography is fairly straightforward unless the supply voltage changes significantly (if it rises, so does the colour temperature of the lamp), which is rare, or until the lamps begin to age, when their colour temperature begins to fall. With daylight-balanced colour films,

pictures taken outside a period of about four hours either side of noon in summer (two hours in winter) will appear warmer than we may wish. Also, there are occasions when we should like, or need, to expose a particular film under lighting different from that for which it is balanced; it is mainly for these reasons that colour filters are used with colour films.

As with black-and-white photography, uncoloured filters can be used to absorb ultraviolet radiation and reduce the effect of atmospheric haze, to eliminate or reduce reflections or darken the sky (polarising filters), and to reduce the intensity of the light striking the film (neutral-density). In the main, colour filters used for colour photography are usually fairly pale, with the exception of those intended to prevent strong overall casts when the film is exposed under a light source of a colour temperature totally different from that for which it was intended. Typical examples of this are the use of a daylight-balanced film under studio or

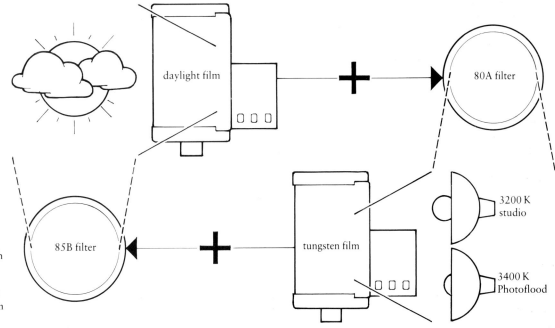

A bluish conversion filter (e.g. 85B) is used to give neutral colour balance with tungsten-balanced film in daylight, an amber conversion filter (e.g. 80A) with daylight-balanced film in artificial light.

Photoflood lamps, and vice versa; a less obvious example is when exposing daylight-type film under a brilliant blue sky. All these instances will result in an pronounced overall colour cast if a colour-balancing filter is not used. The first instance (daylight film in artificial light) will be overall orange-red; the second (artificial-light film in daylight) will be overall blue; the third will also be overall blue, as a result of blue light scattered by the atmosphere reaching the ground from a great expanse of sky.

Average daylight is a mixture of white sunlight and light reflected from the sky partially covered by cloud. Depending on the balance, the resulting effect can appear natural, or slightly cold when the sky predominates. The position of the sun is important. Shadows illuminated only by blue sky will appear quite blue, even when the sun is at a low angle, and the blue effect will be more obvious because of the contrast with the orange-red hues of the sunlight, and sunlit areas of the subject.

While on the subject of colour casts caused by reflected light, it is as well to remember that large areas of colour close by the subject influence its appearance. Typical examples are of a red brick wall giving a red tinge (or cast) to skin tones, or very light clothing, of someone standing close by; a child sitting on a lawn appearing to wear a dress tinged with green; a blue scarf reflecting this colour on to the wearer's chin, cheeks, neck and shoulders, etc. Indoors, furnishings, curtains, carpets, wall covering, indeed almost any expanse of bright or saturated colour, may cause other parts of the subject to reflect their own colours.

**Colour films**
Colour films that are balanced for exposure to either daylight or artificial light are balanced for a specific colour temperature. If the quality of the light source varies the film will detect the change. It would be uneconomical (though not impossible) for film manufacturers to make films suitable for each of the different light sources, so we have to

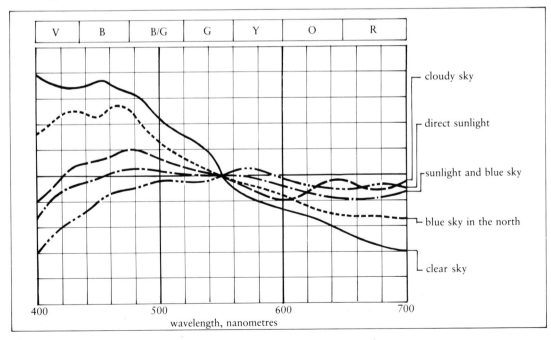

cloudy sky

direct sunlight

sunlight and blue sky

blue sky in the north

clear sky

| V | B | B/G | G | Y | O | R |

wavelength, nanometres

400    500    600    700

The distribution of wavelengths in daylight varies, producing the strong blue of a clear sky, the slight yellow of direct sunlight, etc.

choose which to load the camera with. If the majority of the pictures to be taken are to be exposed by daylight, electronic flash or blue flashbulbs, then daylight-balanced film is obviously the type to use. If, on the other hand, the majority of the pictures are to be taken by Photofloods, a film balanced for artificial light of 3400 K must be used.

If you are going to take roughly the same number of pictures by daylight and artificial light, the choice becomes difficult, for you will have to use a conversion filter for at least half your exposures. If you use a daylight-type film under artificial light, you will need to fit a deep blue filter over the camera lens to prevent an overall orange-red cast. Conversely, if you expose an artificial-light type film by daylight you will need a salmon-pink filter to avoid an overall blue cast. The blue filter has a higher exposure factor than the salmon, so if the films are of similar speed there is an advantage in using the artificial light-type with the salmon filter to minimise the loss of effective emulsion speed.

Either way the results of the daylight-type film plus blue filter will not be identical to the artificial-light type film (and vice versa), so final colour rendition may be a major factor compared with effective film speed. These are major changes. Mostly, changes are in the quality of the light source for which the film is balanced. Daylight is constantly changing; Photofloods and studio-lamp bulbs begin aging from the moment they are first switched on; these changes are subtle. It is to cope with these much smaller shifts in balance that the majority of filters used in colour photography are intended. These pale, low-density filters are known as light-balancing filters; they are intended to raise or lower the colour temperature of the light reaching the film by comparatively small amounts.

### Mireds and mired shifts
Any one filter always raises, or lowers, the colour temperature of light, regardless of where in the visible spectrum that light falls. But since colour temperature does not have a linear scale, the amount of raising or lowering of the colour temperature varies according to the light source and the colour of the filter. In order to simplify the rating of light balancing filters, it is usual to allot each of them a 'mired factor', otherwise each would need to be accompanied by a lengthy chart showing how they affect the colour temperature of all possible light sources.

Mireds (an abbreviation of 'micro reciprocal degrees') are calculated by dividing the colour temperature (in kelvins) into 1 000 000. It is found that when colour temperature is expressed in this way the numerical shift in mireds is constant for any given filter. The hue-shift of the filter can thus be expressed as a specific number of mireds. Bluish filters, which raise the colour temperature (and therefore lower the mired value), are considered to have a negative shift; this is indicated by a minus sign preceding the mired shift value. Salmon filters (often collectively referred to as red) reduce the colour temperature (and therefore raise the mired value), so they have a plus sign preceding their mired shift value. However, most manufacturers now simply designate their filter with a prefix B or R (blue or red) followed by a number to indicate their shift in decamireds (i.e. mired value $\div$ 10).

Thus a filter with a positive mired shift can be used to lower the colour temperature with any film, be it a daylight or artificial light type, and a filter with a negative mired shift raises the colour temperature regardless of the balance of the film. As an example, it may be possible to fit the same bluish (negative) filter to counteract the effect of early morning sunlight for daylight-type colour film, as well as the effect of household lamps when using colour films balanced for Photofloods.

To calculate which filter to use, subtract the mired value of the light source which is to be used from the mired value of the light source for which the film is balanced. A minus figure indicates a negative shift, i.e. the mired value needs raising, and you will

**Mired equivalents of colour temperature**

| K | 0 | 100 | 200 | 300 | 400 | 500 | 600 | 700 | 800 | 900 |
|---|---|-----|-----|-----|-----|-----|-----|-----|-----|-----|
| 1000 | 1000 | 909 | 833 | 769 | 714 | 667 | 625 | 582 | 556 | 526 |
| 2000 | 500 | 476 | 455 | 435 | 417 | 400 | 385 | 370 | 357 | 345 |
| 3000 | 333 | 323 | 313 | 303 | 294 | 286 | 278 | 270 | 263 | 256 |
| 4000 | 250 | 244 | 238 | 233 | 227 | 222 | 217 | 213 | 208 | 204 |
| 5000 | 200 | 196 | 192 | 189 | 185 | 182 | 179 | 175 | 172 | 169 |
| 6000 | 167 | 164 | 161 | 159 | 156 | 154 | 152 | 149 | 147 | 145 |
| 7000 | 143 | 141 | 139 | 137 | 135 | 133 | 132 | 130 | 128 | 127 |
| 8000 | 125 | 124 | 122 | 120 | 119 | 118 | 116 | 115 | 114 | 112 |
| 9000 | 111 | 110 | 109 | 108 | 106 | 105 | 104 | 103 | 102 | 101 |
| 10000 | 100 | 99 | 98 | 97 | 96 | 95 | 94 | 93 | 93 | 92 |
| 11000 | 91 | 90 | 89 | 89 | 88 | 87 | 86 | 85 | 85 | 84 |
| 12000 | 83 | 83 | 82 | 81 | 81 | 80 | 79 | 79 | 78 | 78 |
| 13000 | 77 | 76 | 76 | 75 | 75 | 74 | 74 | 73 | 72 | 72 |
| 14000 | 71 | 71 | 70 | 70 | 70 | 69 | 68 | 68 | 68 | 67 |
| 15000 | 67 | 66 | 66 | 65 | 65 | 65 | 64 | 64 | 63 | 63 |
| 16000 | 63 | 62 | 62 | 61 | 61 | 61 | 60 | 60 | 60 | 59 |
| 17000 | 59 | 58 | 58 | 58 | 57 | 57 | 57 | 56 | 56 | 56 |
| 18000 | 56 | 55 | 55 | 55 | 54 | 54 | 54 | 53 | 53 | 53 |
| 19000 | 53 | 52 | 52 | 52 | 52 | 51 | 51 | 51 | 51 | 50 |

need a blue filter. If the result is a positive number, you need a salmon (R-series) filter. For example: when exposing a daylight-type colour film under Photoflood lights (5500 K and 3400 K respectively) the mired shift is 182 − 294, i.e. minus 112. This indicates that the colour temperature of the light source is too low and you need a B11 (blue) filter. This filter, incidentally, is also called a Wratten (or Kodak) 80B. The factors for the blue-series compensating filters are in general higher than those of the red series for a given mired shift; but, within each series, the filter factors depend directly on the mired shift.

Mired shifts are sufficiently accurate for general photographic purposes, and filter manufacturers provide tables of mired values of various colour temperatures for handy reference. These tables enable conversion from the colour temperature of one light source to another, from which suitable filters can then be selected. All you need to remember is that the mired shift is constant for any given filter, regardless of the light source.

### Colour-balancing filters

Colour temperature is not always adequate to describe the quality of a light source, especially where technical or scientific applications are concerned. More precisely detailed information is given by a spectral energy distribution curve, which indicates energy intensity plotted against wavelength. Thus mean noon sunlight (5500 K) has a peak in the green region, falling somewhat in the blue-violet and red regions. Electronic flash, on the other hand, has a much more irregular curve, as do other discharge sources.

## Mired nomograph for light-source conversion

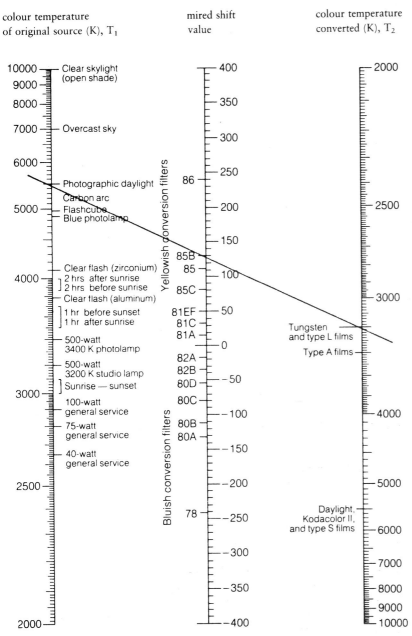

colour temperature of original source (K), $T_1$

mired shift value

colour temperature converted (K), $T_2$

In discussing filters for use with black-and-white films, we saw that comparison between the spectral response curves of the films under certain lighting conditions and the spectral transmission curves of the filters indicated which filter was needed to achieve a particular effect. Theoretically, matching the colour temperature of the light source with that of the film (by using a suitable mired shift filter) should similarly solve such problems. Regrettably, this is not so. The method is sufficiently accurate for general photography using colour-balancing filters, but for accurate work in scientific and technical applications this is not always so.

The reasons for this lie in the differing spectral response curves of the various makes and types of films, and the widely varying transmittance or absorption curves of the filters. The various makes of filter differ considerably from one another, and do not necessarily conform to a theoretically precise curve; likewise the spectral response of films. Film manufacturers tend to recommend one particular make and type of filter for use with a particular product, to achieve a desired effect. Bearing in mind that the spectral response of a film is often modified to compensate for imperfections in the colour dyes used to produce the final image, that no film correctly reproduces all colours all the time, and that the transmission characteristics of nominally the same filter differ from one make to another and from batch to batch, it is not difficult to appreciate the size of the problem. Since the film manufacturers' aim is to have satisfied customers who will continue to buy their products, their recommended film-and-filter combinations are usually the optimum for all average conditions. But personal colour vision and appreciation vary; experience may lead the individual to choose alternative combinations.

Under certain circumstances there may be serious problems when a considerable shift is required to balance a particular light source for a particular film. A typical example is when using daylight-type film under artificial lights (or vice versa). With film

71

Far left: daylight film used in artificial light without a filter. Left: the same, but with an 80B filter.

Far left: tungsten film used in daylight without a filter. Left: the same, but with an 85 filter.

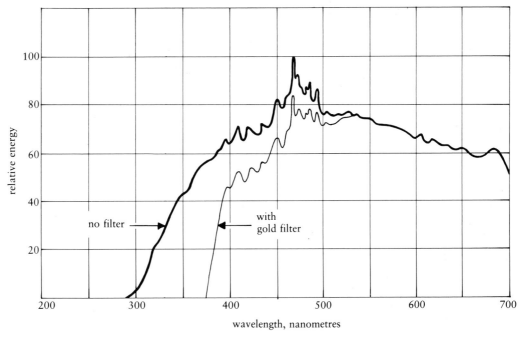

Spectral energy distribution of an electronic flash unit.

balanced for 5500 K and a light source of 3200 K, a B13 (80A) filter might be used, its main effect being to absorb the high red content of the light source. The exposure factor of this filter is high, about 3½×, and with slow films (such as Kodachrome 25) there is a real danger of reciprocity-law failure (page 118).

The combination of artificial-light-balanced film and a suitable salmon-pink (red series) filter, to enable the film to be exposed by daylight, presents slightly less of a problem. First, the salmon filter is less dense than the blue, owing to the high blue-sensitivity inherent in the material; thus the exposure factor (1⅔×) is more reasonable. In any event, the intensity of daylight is much greater than that of artificial light, so reasonably high shutter speeds and small apertures are usually possible. It is worth noting that a great many photographers, forced to use the same film for both daylight and artificial light, choose to work with artificial-light-type reversal film where, unfiltered,

its maximum effective speed is available. Also because of its colour rendering when filtered, its result is the more pleasing of the two types. Again it should be remembered that we are discussing colour-slide film, not film for colour prints. The latter does not require the use of a correction filter when used with tungsten lighting (at least for subjects of low to normal contrast). Even with this material, however, the exposure latitude is much reduced by use with the 'wrong' type of light source, and professional colour-negative films are available balanced for both daylight and tungsten light.

**Artificial light sources**
In discussing artificial light sources, mention has been made of Photoflood bulbs and studio lamps, and the difference between the two should be clearly understood. The former are bulbs that are 'overrun' so that they burn at a higher intensity and, consequently, have a higher colour temperature than normal household lamps.

**Two types of filter used for correcting colour balance**

The mired system is explained on page 69

**Kodak conversion filters for colour films**

| colour | | number | exposure increase | conversion (K) | mired shift value |
|--------|---|--------|-------------------|----------------|-------------------|
| blue |  | 80A | 2 stops | 3200 to 5500 | −131 |
|  |  | 80B | 1⅔ stops | 3400 to 5500 | −112 |
|  |  | 80C | 1 stop | 3800 to 5500 | −81 |
|  |  | 80D | ⅓ stop | 4200 to 5500 | −56 |
| amber |  | 85C | ⅓ stop | 5500 to 3800 | +81 |
|  |  | 85 | ⅔ stop | 5500 to 3400 | +112 |
|  | * | 85N3 | 1⅔ stops | 5500 to 3400 | +112 |
|  | * | 85N6 | 2⅔ stops | 5500 to 3400 | +112 |
|  | * | 85N9 | 3⅔ stops | 5500 to 3400 | +112 |
|  |  | 85B | ⅔ stop | 5500 to 3200 | +131 |
|  | * | 85BN3 | 1⅔ stops | 5500 to 3200 | +131 |
|  | * | 85BN6 | 2⅔ stops | 5500 to 3200 | +131 |

**Kodak light-balancing filters**

| colour | number | exposure increase | to obtain 3200K from: | to obtain 3400K from: | mired shift value |
|--------|--------|-------------------|-----------------------|-----------------------|-------------------|
| blue | 82C + 82C | 1⅓ stops | 2490K | 2610K | −89 |
|  | 82C + 82B | 1⅓ stops | 2570K | 2700K | −77 |
|  | 82C + 82A | 1 stop | 2650K | 2780K | −65 |
|  | 82C + 82 | 1 stop | 2720K | 2870K | −55 |
|  | 82C | ⅔ stop | 2800K | 2950K | −45 |
|  | 82B | ⅔ stop | 2900K | 3060K | −32 |
|  | 82A | ⅓ stop | 3000K | 3180K | −21 |
|  | 82 | ⅓ stop | 3100K | 3290K | −10 |
| amber | 81 | ⅓ stop | 3300K | 3510K | +9 |
|  | 81A | ⅓ stop | 3400K | 3630K | +18 |
|  | 81B | ⅓ stop | 3500K | 3740K | +27 |
|  | 81C | ⅓ stop | 3600K | 3850K | +35 |
|  | 81D | ⅔ stop | 3700K | 3970K | +42 |
|  | 81EF | ⅔ stop | 3850K | 4140K | +52 |

\*   Filters marked thus are loaded with neutral density to reduce the exposure given to the film. Although designed primarily for ciné work where the lens may not stop down far enough to suit the usual ciné shutter speed, they are useful also in still photography when it is wished to take advantage of selective focusing, as they reduce the light reaching the film without affecting the lens aperture.

When exposing daylight colour negative film in tungsten lighting an 80B (3×) filter should be used. If the light is poor this may mean very long exposures and reciprocity failure. It may therefore be better to use an 80C (2×) filter.

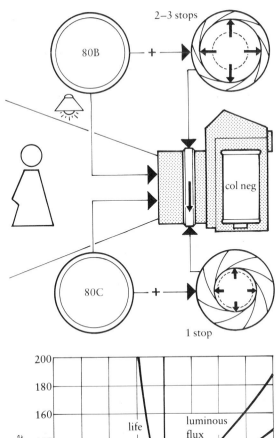

Photofloods are available in two sizes, No. 1 (275 W) and No. 2 (500 W); the former is the size of a 60 W household lamp and the latter is the size of a 150 W lamp. The life of these lamps is limited, 2–3 hours for a No. 1 and 6–10 hours for a No. 2, and their colour temperature is in the region of 3400–3450 K. Studio lamps, on the other hand, are usually rather larger, and the smallest is nominally rated at 500 W. Studio lamps have a much longer life than Photofloods, typically 50–500 hours, and burn at a slightly lower colour temperature, nominally 3200 K.

As lamps age, though, not only does their output diminish slightly, but their colour temperature also falls. In the case of Photofloods with their restricted life, this fall is usually modest (in the region of about 100 K or 10 mireds) and is evident only if pictures are taken when the lamps are new compared with those taken when they are near the end of their working life. The later ones appear distinctly warm or reddish, compared with those taken when the lamps were new. This change could in theory be taken care of by appropriate filtration and increase in exposure, but in general it is far less trouble simply to change the lamps as soon as the tell-tale brownish patch becomes visible on the upper part of the inside surface of the glass envelope.

The supply voltage is also important. If it is only a few volts higher than that for which the lamp was designed, the lamp burns at a greater intensity and a higher colour temperature, and with a greatly reduced life. There is also a serious risk of overheating and shattering. It is very risky to run any lamp at a voltage higher than that for which it is rated. On the other hand, if the supply voltage is lower than the rated voltage for the lamp the life of the lamp will be increased, but at the expense of intensity and a marked reduction in colour temperature. This may not be of much importance when working with black-and-white films, but is very apparent with colour; it may need considerable filtering to compensate. The increased

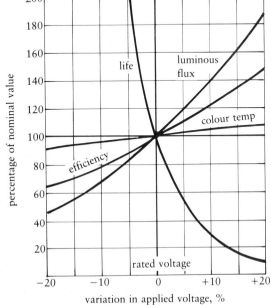

Variation in the characteristics of a tungsten lamp with applied voltage.

filtration demands an increase in exposure, and as under-run lamps have a low output this inevitably leads to inconveniently long exposures.

**Tungsten-halogen lighting** Although Photofloods continue to be popular with amateur photographers because of their cheapness, professional studios are going over more and more to tungsten-halogen lighting. This type of lamp is initially more expensive than the conventional filament lamp, but it has a much longer life and a high colour temperature (3400 K), the same as a Photoflood. It also has a more compact filament, which means that spotlights using this type of lamp can give a much cleaner beam. Tungsten-halogen lamps are filled with bromine or iodine ('halogen') vapour instead of the inert gas used in conventional filament lamps. This vapour 'mops up' tungsten molecules evaporating on to the walls of the lamp, and redeposits them on the filament, thus lengthening its life considerably. As this process can take place only if the envelope of the lamp is very hot, this has to be made of fused quartz instead of glass, hence the alternative name quartz-halogen. It looks as though tungsten-halogen lighting is set to become standard in all professional laboratories, and this type of lighting is now beginning to enter the amateur market.

**Domestic lamps** Domestic lamps are no substitute for Photofloods or studio lamps, other than in emergency. They are generally of low wattage and operate at a low colour temperature (about 2800 K), much lower than that for which any colour film is blanced. The conversion filter for daylight film is −182 mireds, with a filter factor of more than 8×, demanding impossibly long exposures. In emergency it is best to use the Kodak 80A (−130 mired) filter and put up with the peach-coloured result. The filter for Photoflood-balanced film is −63 mireds, which is more reasonable.

**Flashbulbs** Flashbulbs are a source of artificial lighting mainly used by amateurs, though large powerful flashbulbs are still used for specialised purposes such as the photographing of road accident scenes at night, and other forensic work. All amateur flashbulbs have a blue coating which matches their output to standard daylight, so that they can be used for supplementary lighting in daylight colour shots.

**Electronic flash** When an electrical discharge passes through a gas at low pressure, one of the effects is a vivid flash of light. The colour quality of this light depends on the nature of the gas. With xenon, mixed with a small quantity of other gases such as argon, the flash has a quality very close to that of daylight. By incorporating dyes in the transparent protective cover, or by coating the flashtube itself with an ultra-thin layer of a metallic substance, the light quality can be modified to produce what is virtually an exact replica of daylight (5500 K). Electronic flash produces a light of very high intensity, of extremely short duration (typically 0.1 to 1.0 millisecond); it is thus particularly useful in indoor sports photography and in fashion work, where the subject may be moving quite rapidly. Small electronic flash units have now become so cheap that flashbulbs are on the point of disappearing, except for special purposes. Indeed, the majority of snapshot cameras already have a built-in electronic flash, often programmed to fire automatically when the light level is too low for available-light photography.

**Other sources** Various other light sources such as mercury-vapour lamps and fluorescent tubes are available for general photography, but few are suitable for colour films if accurate representation of the subject colours is important. Mercury-vapour lamps emit light which is totally devoid of red; no amount of filtration will produce normal full-colour photographs. Fluorescent tubes emit light throughout the visible spectrum, but not uniformly, and this means that colour casts produced by their use cannot be corrected by filters in the normal way. Some tubes do produce light that is a visual match for a specific colour

Shots taken in fluorescent light, without a filter (right) and with an FL-D filter (below right).

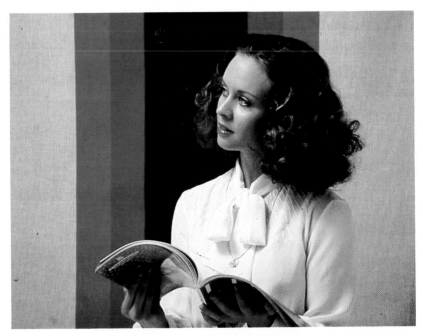

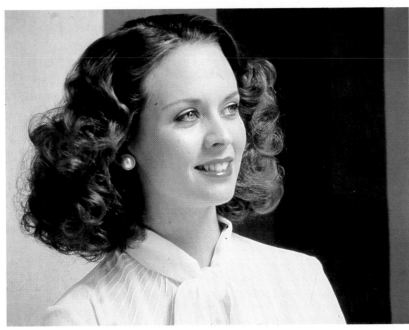

temperature, e.g. 'daylight', rated at 6500 K, and 'warm white' at 3000 K, but it must be stressed that these are visual matches only, and normal photometric filters will not produce a true rendering of colours. The correct filtration can only be found for any given tube by experiment, but a guide is given in the accompanying table. Some filter manufacturers produce special filters for use with fluorescent tubes. These are usually designated FL-D (for daylight films) and FL-A (for tungsten-light films), and are intended for use with 'daylight' fluorescent tubes. However, 'warm-white' tubes vary from one manufacturer to another, and for these no positive recommendation can be given other than perhaps to try artificial-light film and weak filters, or to work only with colour-negative film, where errors in colour balance can be dealt with at the printing stage.

### Filter factors and colour

Black-and-white films have considerable exposure latitude. If a filter factor is incorrectly estimated, up to one stop either way, the picture will not be a failure, though the effect hoped for may not be achieved. In particular, if you overexpose a photograph taken through a filter its effect is reduced; if you underexpose, the effect will be exaggerated. This is not true of colour films, at least of colour-slide films, which have very little exposure latitude. Even errors in exposure as small as one-third of a stop may be noticeable. Underexposure results in a slide of high overall density, full colour saturation in general being retained; overexposure results in overall lack of density and severe desaturation of colours. Consequently, it is not only very important that you should get the exposure factor exactly right for any filter you use, but also that your measured exposure without the filter is right too. Meters vary slightly from one to the other, but shutters, especially on cheaper or aging cameras, vary even more. If you are in any doubt about the performance of your shutter, give it a test. You need a complete film. Before you load it, however, operate the shutter a number of times, so that the

**Filters and exposure increases for fluorescent lamps**

| type of lamp | daylight film filter | exposure increase | tungsten film filter | exposure increase |
|---|---|---|---|---|
| daylight | 40M + 30Y | 1 stop | 85B + 30M + 10Y | 1⅔ stops |
| white | 20C + 30M | 1 stop | 40M + 40Y | 1 stop |
| warm white | 40C + 40M | 1⅓ stops | 30M + 20Y | 1 stop |
| warm white deluxe | 60C + 30M | 1⅔ stops | 10Y | ⅓ stop |
| cool white | 30M | ⅔ stop | 50M + 60Y | 1⅓ stops |
| cool white deluxe | 30C + 20M | 1 stop | 10M + 30Y | ⅔ stop |

mechanism settles down and the exposure is consistent. Make a series of exposures, using a range of apertures as indicated by your meter, say ½ second at f/22, ¼ second at f/16, ⅛ second at f/11 and so on. Make a second and third set, respectively one-half stop and one full stop down, then a fourth and fifth set one-half stop and one full stop up. When you receive the film back from processing you will be able to see immediately whether your shutter is giving consistent exposure times, and whether your film speed selection was correct.

The most accurate test for correct exposure of a colour transparency is very simple. All you have to do is to place the transparency, emulsion down, on a piece of white paper, and examine the image. The brightest highlights (not metallic reflections) should be just slightly veiled, and detail should be visible in all the lighter tones. If the transparency is somewhat dark it may still be usable if you have a powerful projector and a good blackout; in fact some people feel that a transparency that is about half a stop underexposed shows richer colours than one which is 'correctly' exposed (not everyone would agree). A transparency which is a little on the light side, say half a stop overexposed, will certainly show less saturation than a correctly-exposed one, though if the projector has a very long throw or it is impossible to obtain a good blackout it may be better to use the lighter version. In any case, under such conditions you cannot hope to get good picture quality anyway. If after

examining the slides you decide that one of the other exposures give better results than your estimated exposure from the meter, change the film-speed rating on the meter, to a higher value for a denser transparency and to a lower value for a lighter one.

In addition to exposure adjustments to take care of inaccuracies or shortcomings in equipment or to satisfy personal preferences, you may find you need to make modifications to exposure depending on the contrast of the subject matter. High-contrast scenes may need a reduction in exposure of about half a stop, to avoid the highlights being burnt out; this also applies to scenes containing mainly dark colours. In both cases the reason is that the meter reads the average luminance of the scene, and is calibrated for a mid-grey. In the same way, if the subject is of low contrast or composed of mainly light colours, you may find you get the best result by giving half a stop more than the meter suggests. If you have a separate exposure meter, use it in the incident-light mode. To use a meter in this manner (which *always* indicates the correct exposure regardless of subject matter), fit the opal diffuser to the cell window, place the meter at the subject (or in the same illumination as the subject if it is distant), point it at the camera (*not* at the light source), and take your reading. This method is not necessary for colour-negative film, where normal metering methods are satisfactory for almost any subject, and the exposure latitude of the film will take care of small discrepancies in exposure.

Absorption characteristics of conversion filters in the 80 series (blue) and 85 series (amber).

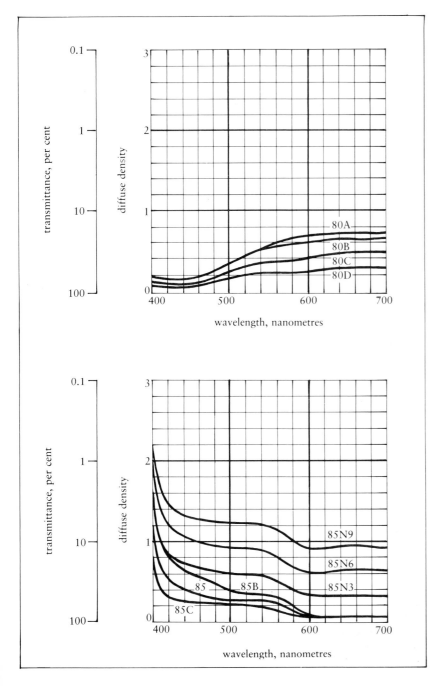

transmittance, per cent

diffuse density

80A
80B
80C
80D

wavelength, nanometres

transmittance, per cent

diffuse density

85N9
85N6
85
85B
85N3
85C

wavelength, nanometres

Exposure factors for light-balancing filters are very much easier to determine than those for filters used with black-and-white films, as the spectral sensitivity of the material and the quality of the light have remarkably little effect on the filter factor. Should they become apparent, minor deviations can be dealt with by the tests described. Although for a given mired shift the blue-series filters generally have a higher factor than the red-series, the factor still depends on the precise mired shift, a fact to be considered when using different makes. When filters are used in combination to achieve a particular mired shift, you should remember that whereas their mired values are added, their factors are multiplied together. The factor of a weak filter may often be ignored when it is used singly, but when used in combination it must be taken into account.

An exception to the mired shift addition rule is when combining one filter from each of the red and blue series to achieve an intermediate mired shift value. Here the effective mired shift is the difference between the mired values of the two filters, but the exposure increase factor is still the product of the individual factors. Combining filters should be avoided whenever possible, because the more that are combined the greater the number of reflecting surfaces. This is of course of less significance with filters having anti-reflection coated surfaces than with uncoated filters. In the latter case, you should increase the exposure factor by approximately 10 per cent for each filter used, and not use more than two at a time if possible. A mired shift that is slightly too high or too low is usually preferable to the addition of a third filter.

Unlike black-and-white work, where exposure factors of one-quarter to one-third stop can be ignored, such small factors can make a considerable difference with colour-slide material. If your particular camera has a built-in meter with readings that can be modified in fractions of a stop, you can use this facility to make the necessary fine adjustments. With TTL metering systems you can

take the reading through the filter if it is a red-series one, but it may be advisable to use manual compensation for a blue-series filter, if your camera is not particularly new. Financial considerations (and space in your camera holdall) may demand that you purchase and use only a small number of light-balancing filters. If you are working only by daylight, probably two each from the red and blue series should prove sufficient: say an R1.5 and R3 plus a B2 and B4. In addition a B12 and R12 for converting daylight film for use respectively under Photofloods and vice versa will be adequate. Manufacturers of filters rarely produce every filter in the series, restricting their range to four or five low-value filters and one or two higher ones. This is usually sufficient, as combinations of the same or opposite hues can be used to make up most values.

It is not necessary to use filters that exactly match or add up to the exact mired shift correction indicated by your calculations, especially when you possess only a limited number of filters. Certain corrections could even demand the use of three or more filters, and this is undesirable from an optical point of view. It is sufficient to round off the figure to the nearest ten (e.g. 137 can be rounded up to 140 or down to 130, whichever is the simpler). When in doubt, aim for a pictorially satisfying result rather than a theoretically correct one.

### Colour casts

Certain colour casts may not be immediately obvious. A typical example is a picture taken by daylight in dull or rainy weather, where an overall blue cast would result. The use of a weak red-series filter R1.5 or R3 helps to avoid such a cast, which could also lead to the picture appearing too 'cold', though of course it cannot do anything about the lack of colour saturation unavoidable under such lighting. Early morning, late afternoon and other times of low-level sunlighting all produce an overall red cast, but compensating by using the 'correct' mired-value fitler could destroy the overall warmth of the scene and again make it appear too cold. Experience will soon indicate a compromise.

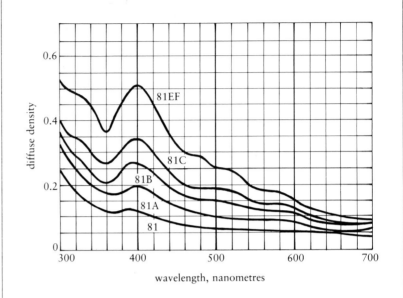

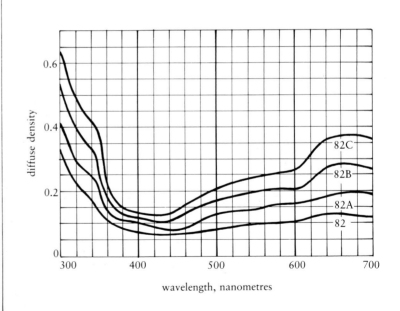

Left: absorption characteristics of light-balancing filters in the 81 series (salmon: positive mired shift) and 82 series (blue: negative mired shift).

Below: snow scenes reflect a high proportion of ultraviolet radiation.

Right: without and (far right) with a skylight filter. *Cokin.*

Below right: taken with a polarising filter. *Frank Peeters.*

Where only part of the picture suffers a cast (from reflections from a nearby object for instance) fitting a filter to correct for this will influence other parts of the picture unaffected by the cast. If it is possible to fit a filter so that it only partially covers the lens, acting only on the affected areas, that is ideal. If not, aim at ensuring the main subject is free from casts, and reduce the affected area of the picture by changing to a lens of longer length, by moving closer, by altering the composition of the picture or by selecting another viewpoint. Casts in shadow areas are less likely to be noticed than those affecting the main subject. Aim at getting skin tones, teeth and white clothing correct and free from casts, as colour casts are more obvious in light tones.

Not all casts need to be corrected. A cast may provide a pictorial effect, or add to the mood of a picture; to filter it out would destroy the effect. Similarly, if the cast caused by a reflection, say, is seen at the time of taking the picture, it could be more natural to include it in the scene by recording it unfiltered. What could be more natural than a child admiring the effect of a bright yellow buttercup, with the yellow of the flower reflected from its skin, or the rosy glow of a bonfire on its face? All of these are part of the pictorial effect of the scene and demand to be recorded. Likewise, reflections created by skylight are naturally blue; this blueness is part of the pictorial beauty of the subject and could contrast pleasantly with stark white walls in another part of the scene. So in considering casts and their effect, you need to distinguish between those that are natural and those that are unnatural, those that are overall and those that are local. Unnatural casts can be intrusive, whereas natural casts are acceptable and, indeed, necessary. In some cases, even an 'unnatural' cast may prove pictorially effective. In the main, it is blue casts that are the least acceptable. Except when used for quasi-moonlight or other special effects, an overall blue cast will not be tolerated by the observer, who will find the effect disturbing and unnatural. Red and yellow

casts can be tolerated more readily. Green casts, from light filtering through dense foliage, for example, are less acceptable, but are only rarely experienced.

**Ultraviolet-absorbing filters for colour work**
Colour films, like black and white, are sensitive to ultraviolet radiation; but instead of recording UV as a grey tone that obscures detail in the subject, colour films record them as an overall blue cast (another example of this familiar enemy). To make matters worse, colour film does not record this wavelength only as violet, or within that region, because UV radiation affects the blue-sensitive layer of the emulsion, effectively one-third of the colour-sensitive emulsion. And yet this radiation is invisible to the human eye.

The UV-absorbing filter normally used with colour films (a typical example is the Kodak 2B) is usually a pale straw colour and is ideal for absorbing UV radiation at high altitudes and under other conditions with a deep blue sky. Unfortunately, though, used as a general-purpose UV filter, the pale straw one can give somewhat unpleasant effects, especially with lenses or colour films (or a combination of the two) that give slightly cool colour renderings. Some of the most popular colour films, in fact, do give a decidedly cool rendering. On the other hand there are lenses and films that give a warm rendition, and the straw-coloured filter is ideal when using either or both of these to bring back the balance towards neutral.

In regions where the weather conditions are often cloudy or hazy, many photographers prefer to use another type of haze filter, generally referred to as a skylight filter, which is pale pink in colour. This filter is also useful for absorbing ultraviolet radiation. Typical of skylight filters are the Kodak 1A and 1B; the latter has its peak absorption in the green. This filter is also useful in many outdoor scenes where grass, foliage, trees etc. predominate; these can create problems with colour casts, especially in portraits under a blue sky. It is also a

satisfactory solution to the problem of countering cool rendering of colours by certain lenses and colour films. Skylight filters do not penetrate haze, merely counteract the excessive blue. A completely clear and colourless UV-absorbing filter may also be used with colour films. This penetrates haze in distant landscapes without affecting any of the colours or renderings of optics or materials.

### Polarising and neutral-density filters

Polarising and neutral-density filters play as valuable a part in colour photography as they do in black-and-white. In fact, on occasion, either may provide the only solution to a particular exposure problem, e.g. finding a means of controlling the effect of one large area (such as the sky) without affecting the rest. Graduated neutral-density filters can also prove very useful in this respect. Neutral-density filters used with colour film must be truly neutral, otherwise an overall cast will result. Some types do have a slight colour tint; avoid their use with colour film.

While polarising filters used in conjunction with colour film reduce or eliminate reflections from non-metallic objects, their effect can also be used to control minute catchlights, for example from foliage or a dew-coated lawn. These may reflect blue light from the sky, resulting in a blue cast. If you rotate the polarising filter while you look through it, you will see the colour of the catchlights varying from blue-green through to yellow-green, the warmer glow of the latter often appearing more attrctive for general photography. However, for snow or quasi-moonlight pictures, the blue catchlight is often more desirable, enhancing the effect. The darkening effect of a suitably aligned polarising filter on blue sky can have a profound influence on the mood of a colour photograph. Not only does this disguise an otherwise bald, cloudless sky that could spoil an outdoor scene, but the additional saturation it gives can add to the pictorial effect. Equally important, in darkening the sky the polarising filter has no effect on other parts of the scene; these will all be recorded naturally.

Most polarising filters have an exposure factor of approximately 3½×. Therefore increasing the normal exposure by 1½ stops gives the correct exposure; it is of no consequence how the filter is oriented, as only the reflected highlights will be affected (they will be prevented from 'burning out'). However, it is sometimes preferable to take a meter reading through the screen once it has been aligned for the desired effect. One particular instance is a subject illuminated by or containing polarised light. Taking a meter reading through the filter takes the light reflection effect into account. If your camera has TTL metering utilising a beamsplitter, carry out the test described on page 57, to see whether the use of a polarising filter affects the reliability of its readings.

# Filters for special effects

Photographers are currently enjoying a sudden rise in interest in filters for 'special effects'. This began with the introduction of a system of coloured resin filters and effects attachments invented by the French photographer Louis Coquin. Professional photographers have always made full use of filters and various other optical devices for special pictorial effects. Quite often, techniques for achieving many of these effects have been closely guarded secrets, for obvious business reasons; advertising, commercial and fashion photography is highly competitive. In introducing his special-effects filter system, however, Coquin also produced a lavishly illustrated booklet, which showed a wide variety of pictorial results, and gave details of how they were obtained. This aroused considerable interest among amateur photographers anxious to try new methods and accessories. Since then, several other manufacturers have introduced their own versions of these filters, all basically similar in scope and application, design and method of attachment to Coquin's system, although their actual size varies somewhat from one version to another.

## Compendium filter sets

Each of these filter systems is based on a universal filter holder peculiar to that system. The holder fits to the camera lens by means of an interchangeable adaptor that screws into the filter-mount thread on the front of the lens. Adaptor rings are available in the majority of popular sizes. The unthreaded side of the adaptor ring fits into the rear of the holder, which may be rotated for vertical or horizontal pictures. The filter holder has two sets of slots which hold one square filter or effects attachment each. Most of the filters designed for these systems are in the region of 75–80 mm square; polarising filters and other effects attachments that need to be capable of rotation are in circular mounts held in

place by springs formed from the material of the holder. This is a lightweight plastics material, so despite their apparent bulk most of these filter holders weigh only about 25 grams including the adaptor ring. The filters themselves are made of optical-quality synthetic resin, and weigh only about 10 grams each. These figures compare very favourably with glass filters in metal rims, which are not only comparatively heavy, but in general are more expensive and fit only one size of lens filter thread.

Because of its shape, the basic filter holder also does duty as a lens hood, though additional hoods are available with some systems. This provides a further saving in cost. At least one system includes a range of masks and cutouts that may be used in addition to the filters, for special effects (page 105). The advantage of this system is that you only need one set of filters and a single holder, and an adaptor for each of your various lens diameters. Many photographers use a variety of lenses of different focal lengths, and adaptor rings are relatively inexpensive. This method of fitting also enables cameras of different formats to be used with the same filter system, so that effects produced with one format may be repeated on another with complete confidence.

Nearly all the filters designed for these systems (or compendia as they are now becoming known) are made from optical-quality synthetic resin, either dyed in the mass or surface-coated. Advantages claimed for this method are that scratches etc. do not remove the colour, so the filter's effect cannot be reduced, and the precise colour of the mix can be more quickly and accurately controlled without waste, by adding the dye until the precise characteristics required are achieved. Filters must be treated and handled very carefully, and cleaned only with a soft brush, lens tissue or the specially recommended liquid cleaner. Most of these filters in fact last well, and when dirty or fingermarked they can be washed in warm water to which a little washing-up fluid has been added. Don't rub the

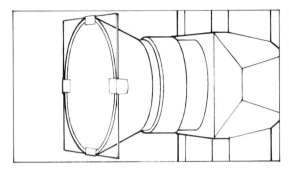

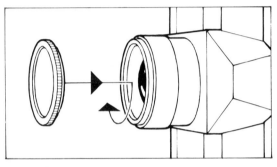

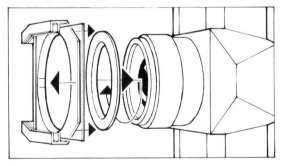

Types of filter mounting. Top: gelatin or acetate filter secured to the lens hood with tape. Centre: filter in a mount that screws into the front of the lens. Bottom: a 'compendium' filter holder (see text).

filter surface when it is dry, or it becomes charged with static electricity and attracts dust.

In addition to the standard filters already discussed for corrective work in black-and-white or colour, most of the effects of so-called creative filter systems include blends, combinations, graduations and various other devices including filters with clear centres and/or a diffused surrounding area, diffusion filters for soft focus, and fog filters in different densities. Compendium filter systems not

only provide satisfactory, economical and efficient means of using filters, but they are also very flexible, enabling filters to be used for overall or partial effects, two or more filters in combination, with or without a polariser, diffuser, multiple-image or colour-fringing device.

## Filters for effect

Until now, we have been concerned mainly with producing a faithful reproduction of the subject to compensate for the differing characteristics of the film and the human eye, so that the photographic image matches the perceived impression. This is fine for the great majority of photographic recording work: portraiture, landscape, still life, architecture, document copying, etc. But it must be accepted that photography is also a means of pictorial self-expression, and is used by many contemporary artists. Purists may insist that all or any manipulation is wrong. But all photography involves manipulation in some form. With black-and-white film, photographers have for years used filters to accentuate the contrast between different shades of green, to create a dramatic cloud effect by using an orange filter, or even a moonlight effect by underexposing through a red filter. Is it unreasonable for a photographer to wish to change the colour of a sky or the shade of skin tones, to distort or multiply images?

Suppose, for example, you are taking a low-angle shot of a dark statue against a clear sky. If you give a full exposure, detail in the statue will be visible but the sky will appear bald and uninteresting. Take the picture through a colour filter, though, and the sky becomes a coloured background to frame the subject, complementing it or even contrasting with its mood for dramatic effect. You can reduce the exposure, throwing the statue into silhouette against an darker sky. Add a red filter and the effect is truly dramatic. Use blue instead, and the picture might have been taken at night. Shoot through a green filter and the effect is almost science-fiction. For best results with these effects, choose a subject of high contrast or having bold lines, the simpler the better. Going to the other extreme, the delicate effect of pale, pastel shades can create a soft and romantic mood in portraits, landscapes or seascapes. Combine them with a diffusing screen and even the harshest contrasty light is softened. Highlights become muted and shadows take on a coloured tint. You can make old-fashioned style portraits directly on colour film, or by photographing a black-and-white original on to colour using a tobacco- or sepia-coloured filter to produce an attractive sepia effect. You can get the same effect by using daylight-type slide films by tungsten light without a filter; this could be used for still-life pictures of antiques, and for portrait photography. Adding a diffusing screen gives portraits a glamorous soft-focus effect.

It is difficult for the average photographer to control just part of the picture. Sometimes detail in a sky or background can prove distracting, and pulls the viewer's attention away from the main subject, no matter how carefully the picture is composed. One solution is to use a graduated neutral-density filter to suppress this unwanted information, while keeping its original colour. You can often use a graduated colour filter, which either changes the colour of the background to one that complements the subject, or provides a contrast to throw it into sharp relief. A graduated filter increases in colour density across its width from clear to full density. Most are designed so that the dense area occupies less than half of the entire area of the filter, which avoids the image's being, as it were, divided in half. By varying the position of the coloured area, the background of the subject can be suitably controlled. A variation on this was necessary when I was once photographing some white cliffs and a grey sea. The picture was in vertical format, with the horizon off the top of the frame; as I wanted a blue sea and white cliffs for a travel poster, I turned a graduated blue filter on its side so that the transparent area covered the cliffs and the blue area progessed from the beach out to the sea. The result looked truly natural, and very attractive.

In addition to strongly coloured, pastel and graduated filters, any of which can be used in combination with another or with diffusion screens and other special-effects attachments, there are those with a clear central disc. The same type of filter is also available with an overall diffuser in the filtered area. To use these filters you need to confine the main subject matter to the central, clear area. Not only does this concentrate attention on the subject, but it can also be used to change the mood of the photograph without distorting the colours of the subject itself. The effect can be controlled by a combination of focal length and iris diaphragm opening. With short-focus lenses the central image will be smaller and more sharply defined. With long-focus lenses the central area will be increased, but with a more diffused outline. In all cases, the smaller the lens aperture the more pronounced the effect of a clear centre with diffused surround.

Whenever you use filters for effects, do not be afraid to experiment. Many pictorially pleasing or exciting effects can be created with the right choice of subject and filter, some combinations of which may at first seem unpromising. Always keep notes for future reference, and when using filters for the first time make bracketed exposures by shooting extra pictures above and below the settings indicated by the meter. There is no 'correct' exposure when using filters for special effects, because the appearance depends on the effect you are trying to achieve. The actual result is not always easy to anticipate. In many cases, overexposure with colour-slide film leads to partial or complete loss of the effect of the filter. When taking meter readings through a graduated filter, a useful rule of thumb is to close the lens diaphragm by an additional half a stop below the indicated reading with pale colours, and by one stop for dark ones.

Effects filters can be used successfully with flash. In addition to the effects so far described, which are within the scope of subjects normally photographed by flash, it is even possible, by using

Left: red filter. *Frank Peeters*. Below left: a long exposure with daylight colour film of a moonlight scene in Crete.

Diffusing screen used in combination with a pale orange filter. *Cokin*.

two complementary filters butted together, to modify the background to a picture without affecting the foreground subject.

## Multiple-exposure techniques

Many a dull picture has been enlivened by binding it with another picture in the same transparency mount. This is a useful means of adding a specially filtered sky or overall colour background to produce interesting or dramatic effects. You might, for example, sandwich a silhouette of tall wrought-iron gates with a bold sunset photographed through a deep red or deep blue filter. You can also achieve unusual and attractive effects using different filters, by making double or multiple exposures on the same film frame. The simplest method is to make separate exposures through each of the chosen filters until the total effect is created. For this the camera should be mounted on a tripod or similar firm support, and the subject must, of course, be stationary. If you have a zoom lens you can try a variation on this, by altering the image size between exposure. As before, the camera should be firmly mounted and the subject either stationary or going through repetitive movement. As an exposure is made through each filter, change the focal length of the lens so that the image size is different for each colour. You need to take particular care to avoid moving the camera, however slightly, between exposures if you are to get the best effect. The technique is simplest if the largest of the images is recorded first and the progressively smaller images are recorded on top of this, though of course the order in which the exposures are made makes no difference to the final image.

Exposure for this type of picture can create its own problems. For normal multiple-exposure work without filters the basic combination of shutter speed and lens aperture for the subject is divided by the number of individual exposures, and each exposure is given a proportion of the whole, i.e. for a picture made up four separate exposures, each is given one-quarter of the total. But since filters have an exposure factor, this often compensates for the risk of overexposure. As a guide, simply increase the indicated combination by one stop (or the equivalent shutter speed) for each exposure made. For example, if the exposure meter indicates a reading of $\frac{1}{500}$ second at $f/11$ for a particular scene, set the camera either to $\frac{1}{500}$ second at $f/8$ or $\frac{1}{250}$ second at $f/11$, for the exposure through each of the different filters. If the subject moves between exposures (e.g. a tree in a slight breeze, smoke from a bonfire, or a water fountain), the result may show rainbow-coloured effects in the highlights.

Moving subjects or even action photographs can be taken using multiple-filter techniques to produce creative impressions of movement. Tape the required filters together in strip form (i.e. end to end, or side by side) also taping a piece of black card to each end of the strip. With the camera set to B or a shutter speed of $\frac{1}{2}$ second, and panning the camera so as to keep the subject correctly framed, pass the filters in a continuous movement across the lens (the black card at each end of the strip prevents unfiltered exposure while the shutter is open). The precise shutter speed depends on how quickly the filters can be passed in front of the lens. You will probably have to make several attempts before you achieve the desired effect, but the result will be a creative, attractive and colourful impression of flowing movement.

## Home-made filters

So far we have only considered optical filters that can be placed in front of a lens without affecting the image resolution, although brief mention was made of fog filters and diffusers. But it is worth mentioning that almost any transparent coloured material can be used to filter light passing to the lens, provided that its optical properties are unimportant. After all, there are many subjects that readily lend themselves to creative distortion, and with only a little imagination many materials and substances can be pressed into service. Many plastics used as wrappers are ideal for colourful effects when stretched in front of a lens, as too are

coloured bubble-blowing liquids. Various liquid gelatins, plastics and rubbers are available in different colours, and can be made to form a thin membrane over a suitable loop of wire. The oily dye discs used with projectors in discos are excellent for experimentation. As they rarely transmit pure colours, you can obtain interesting and varied effects.

With gels, foils, pieces of plastic or other coloured materials, or any liquid that has set semi-solid, a small area can be cut from the centre using a sharp pointed blade, to produce a filter that will give pictures having a clear central area with a diffused coloured surround. All of these can be held in front of the lens or mounted using adhesive tape or an elastic band. It is always well worth while experimenting. That is how photographers discover useful effects and tricks; it is, after all, what led to the introduction of special effects filters in the first place.

One other effect has so far been mentioned in passing: the result of deliberately using film under lighting for which it is not balanced, without using colour conversion filters. There are also colour films made for special applications (such as infrared false-colour) which you use for experiments with or without the 'correct' filters. You can produce intentionally warm effects by using daylight-balanced colour films under artificial light, or even candlelight. The warm orange cast which results can produce very attractive, romantic mood effects. These can prove pleasing for low-light-level portraiture, particularly of women, interiors of caves that are artificially illuminated, and church interiors where daylight filtering through windows is mixed with artificial light inside. Conversely, you can use tungsten-balanced film to photograph snowy mountain scenes, glaciers, icicles hanging from roofs against a blue sky, sunbeams breaking through heavy cloud. All of these take on a stark and dramatic blue cast with deeply-saturated blues and (with underexposure), a quasi-moonlight effect.

## Special effects with infrared films

Infrared (IR) film has serious uses in scientific and technical photography, of course, but it has pictorial applications too; these are all the more dramatic because they include effects which in nature are completely invisible. Infrared monochrome film is normally exposed through a deep red filter, though infrared filters are obtainable which are totally opaque to visible light. As mentioned earlier (page 61), chlorophyll reflects infrared very strongly; however, other materials such as water and road-surfacing material absorb it, and blue skylight contains no infrared. Consequently, a landscape photographed with infrared film looks like moonlight, with inky-black skies, water and roads, and dazzling white foliage. Infrared radiation is less absorbed by haze than visible light, and distant panoramic views appear in startling contrast, aerial perspective being totally absent.

Infrared colour is a false-colour system. In a true colour film, red appears red, green appears green, blue appears blue and infrared appears black (being invisible). Infrared colour film is sensitised to IR, red and green; a deep yellow (blue-absorbing) filter prevents blue light from reaching the emulsion. In the final transparency IR records as red, red as green, and green as blue; blue, of course, comes out as black. The main purpose in evolving this material was agricultural: live vegetation reflects IR and green strongly, and thus appears in the false-colour transparency as red + blue, i.e. magenta, whereas diseased or dying vegetation no longer reflects IR and appears a greenish blue. Infrared colour film has other uses, for example in forensic photography and in aerial photographic reconnaissance.

Creative photographers have seized on this material as one way of obtaining bizarre twists of colour reproduction. Used without a filter, infrared colour film produces quite different results, most of the hues in the image ranging from violet to magenta. Few strong colours appear, and the results are not

Near right: the same subject taken with normal daylight colour film and with an infrared material (both Kodak). The camouflage material beneath the plant pot had not been treated to reflect infrared, whereas the helmet cover had.

Far right: daylight film was deliberately used without a conversion filter, to create a special effect. Exposure was 30 seconds at $f/8$.

Top: the photograph of Whitby Abbey was re-shot with a separate sunset slide. *Colin Raw*.

Above: false-colour infrared film.

Right: red cellophane used as a filter.

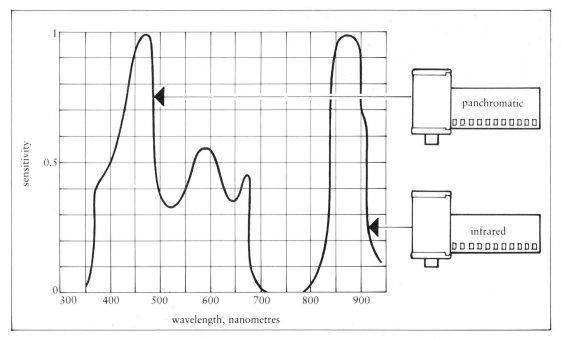

Left: relative sensitivity of panchromatic and infrared film (behind a suitable IR filter).

Right: infrared film was used here with a red filter. *Frank Peeters.*

unlike those obtained by using artificial-light-type film in daylight without a filter. The use of a light orange filter causes blues to be rendered cyan instead of dark blue-grey; foliage as a fairly saturated reddish magenta; and reds (which usually reflect IR, and come out yellow with yellow filtering) as almost white. A red filter results in an image composed mainly of red through to yellow-green; an infrared filter that is opaque to visible light results in an image that is entirely in red, and has the same tonal characteristics as a print from black-and-white IR film. With a light green filter the image is composed mainly of hues from cyan through blue to violet, and with a deep green filter the image is an almost monochrome deep blue.

When used for special effects in this manner, the exposure required depends to a great extent on the colour of the filter and the colour quality of the illumination (this, of course, including its infrared content). Whether you get the exposure right also depends on the type of meter cell. Cadmium sulphide (CdS) cells are sensitive to IR and usually give reliable readings. Selenium cells (used in meters without batteries) and silicon cells (all TTL meters that require batteries) are rather less sensitive to red and IR, and may indicate exposure settings that are too high. With these types of cell, exposures will probably be fairly accurate around midday in the open, but require reducing in the morning or evening by about half a stop, and for exposures made under tungsten-filament lighting (which is rich in IR) by about one stop.

It cannot be emphasised too strongly that in any experimental work of this type you should always keep a full exposure record. Used with the filters described above, or indeed with any of the special-effects filters described in this chapter, infrared films, both colour and monochrome, can provide many varied and unusual effects even with the most mundane of subjects; but you will be sure of getting successful results only if your pictures are

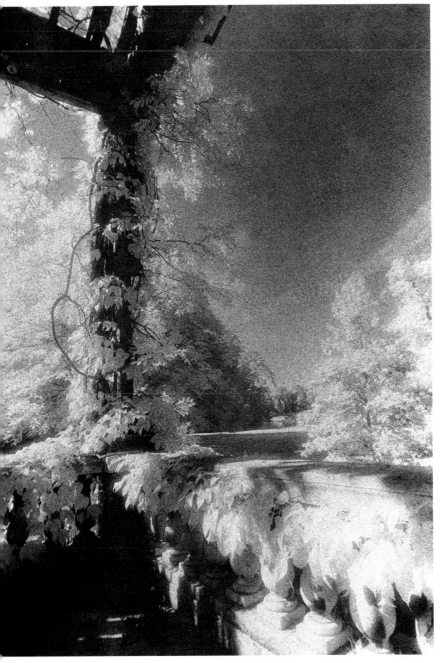

taken in the light of the know-how you have built up by your experiments.

## Other effects

Photographed singly or collectively, fireworks make quite interesting pictures. You can achieve the best results by making a number of separate exposures on the same film frame, using the technique for obtaining multiple exposures described on page 90. Alternatively you can keep the shutter open and make separate exposures using the lens cap. You can get even more interesting effects by making successive exposures through different filters. Bonfires especially lend themselves to this techniques, the flames producing a multi-coloured effect with different-coloured tongues of flame against the dark sky. Try making exposures of sparklers, fountains, catherine wheels, and, of course, starbursts.

Manufacturers of small portable electronic flash units often supply as accessories coloured screens for fitting over the flash head. These are intended for producing an overall coloured effect and can, if you use them with imagination, lead to excellent results. In general you should choose a colour which either matches or contrasts with that of your main subject, otherwise the effect is of an accidental colour cast. These small flash units are also very good for providing localised coloured effects for multiple-light set-ups, multi-coloured effects on long or multiple exposures, and even 'strobe' effects, with a different colour for each exposure. The flash can also be used to 'bounce' a coloured light, or to provide a coloured fill-in or effects light in daylight. With a little imagination a novice can achieve successful results, and, in the case of guns possessing automatic flash control, without additional exposure problems.

Varied and interesting pictures can be made by photographing different types of transparent or translucent plastics under stress, using a polarising filter. Stretched, crumpled or otherwise distorted plastics backlit with either white or coloured

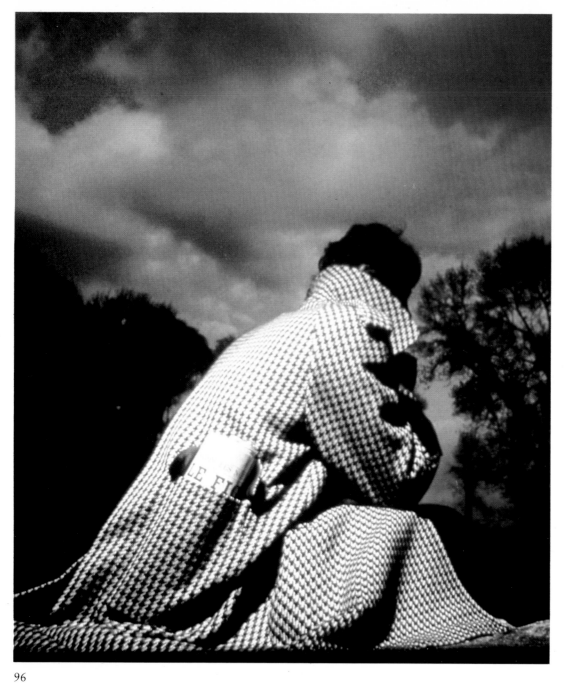

Complementary filters give interesting effects. For this shot there was an orange filter over the camera lens and a blue filter on the flash. *Cokin.*

polarised light produce beautiful patterns of colour. The simplest method of working is to take two sheets of polarising material, place the stressed plastics material between them, and photograph it using a macro lens or extension tubes, or a close-up lens. You will probably need to rotate one of the polarising sheets until you get the best effect. Alternatively, you can use one polarising sheet on the farther side of the subject matter and simply use a polarising filter on the camera lens. Suitable materials for subject matter are cellulose tape, clear plastics such as polystyrene and Perspex, cling-film, sweet wrappers, Cellophane and polythene. Polarising sheet can be purchased fairly cheaply and cut to shape as required.

A simple arrangement is shown in the diagram. Bind the piece of stressed material in a colour slide mount, or between two pieces of glass, and tape this to a sheet of polarising material. Set this up with a light behind it. Set up the camera, loaded with colour film, on a tripod or other firm stand, at such a distance that the slide area fills the viewfinder. Make sure the slide (or glass sandwich) is precisely aligned with the lens, or it may not be possible to get it all in focus. Now place the second polarising sheet over the subject (or fit a polarising filter to the camera lens), and rotate this, while you look through the finder, until the colours and shapes look most pleasing. Check the focus of the lens, close down the aperture to *f*/16 or so, and make the exposure. You may find you can get several good shots of the same subject, using different settings of the nearer polariser (i.e. the analyser). Ring the changes by folding the material (single layers may give weak colours), creasing it differently, binding it up with a different material, or changing it for a different type of material. Try coloured filters in front of the light source, too.

Finally, a word of warning about colour negatives. As long as you are using colour-slide material you can be sure that what you get back from the processing laboratory will look exactly the same as it did through your viewfinder (except, of course, for infrared colour), at least if you got the exposure more or less right. If, on the other hand, you have been working with colour-negative film for prints, the results may look quite different. This is because the automatic printing equipment used in processing laboratories is programmed to deal with ordinary snapshots, which as a rule contain all colours in roughly equal proportions. It will regard your careful creative work as nothing more than variations in the colour balance of the illumination under which the photograph was taken. Your quasi-moonlight shot will come back in tones not of deep blue and violet, but of murky yellow-grey; and your white cat on a blue carpet will come back as a red cat on a slatey-grey carpet. It is essential (if you do not make your own prints) to instruct the printers to print without automatic correction. If you do so, and still get a red cat, demand your money back and try a different lab; better still, go to one of the labs that cater for professional photographers, most of whom will accept work from amateur photographers with special needs.

An arrangement for photographing plastics under stress, using polarising filters.

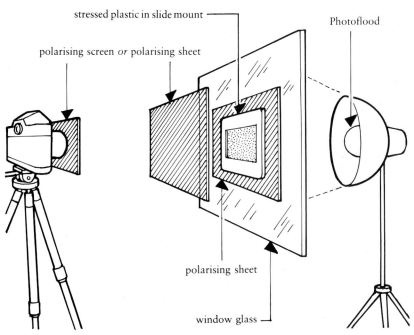

stressed plastic in slide mount

Photoflood

polarising screen *or* polarising sheet

polarising sheet

window glass

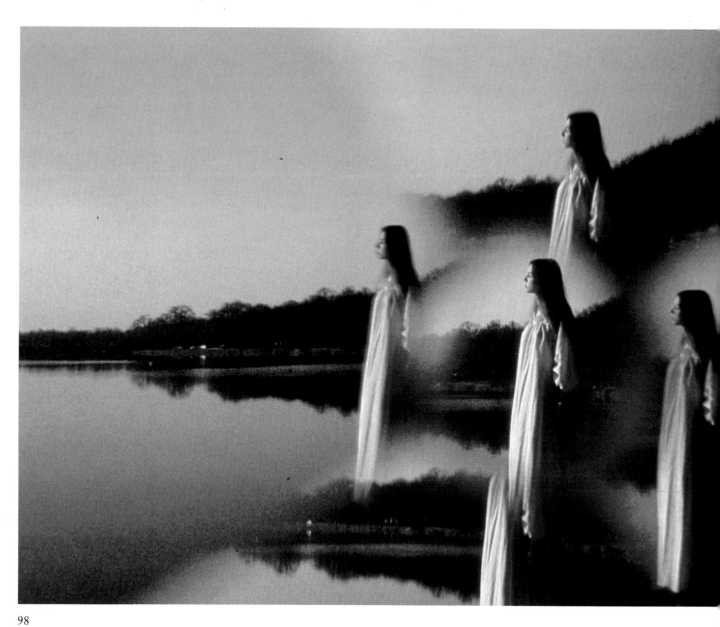

# Lens attachments

*Raymond Lea*

For many years photographers have placed variously-shaped objects in front of their lenses to achieve artistic pictorial effects. Paper or card cut to various shapes, reflecting materials, glass objects, diffusers, mirrors, all have been tried at various times. But with all these devices the difficulty is to reproduce the effect when the object used originally is no longer available. Now, with the advent of compendium systems, and the variety of filters and special-effects attachments available for them, the photographer is in a position to produce repeatable results every time. It is now possible to produce multiple images in a single exposure, star-shaped highlight reflections, fans of coloured light, and many other effects, simply by adding a suitable attachment to the front of the lens. Users of SLR cameras can observe the optical image directly in their viewfinder, while those with optical viewfinders must hold the attachment in front of the viewfinder or their eye. A careful scrutiny through the viewfinder (or the attachment) will show the subject transformed in shape, colour or surround to a totally new pictorial dimension. By the simple act of fitting an effects attachment even the most humdrum subject can be given a new creative dimension and, by the choice of a suitable optical effect, transformed into a unique pictorial impression. For the more imaginative, there is the added pleasure and reward of producing results which give full rein to their creative talents.

In addition to attachments fitted in front of the lens to produce special effects, there are those which permit the expansion of the optical and photographic scope of the camera lens. In a standard camera lens the scale of the image is directly proportional to its focal length; in zoom lenses the focal length, and thus the image scale, is under the control of the photographer. The minimum focusing distance also varies from one

lens to another: the cheapest lenses focus to about one metre, whereas macro lenses can focus down to a few centimetres. Extension tubes or bellows attachments allow even cheaper lenses to focus close enough to produce images full size or even larger than full size. A further range of attachments, while not directly affecting the optical image, either prevents this from being impaired or provides direct protection for the optics themselves. Each of these makes a valuable addition to the equipment used for recording the final photograph and thus forms a useful (and, at times necessary) part of the camera outfit.

### Prism attachments

These attachments vary in type and the number of prism facets they contain. They are supplied fitted in rotating mounts that can be locked in any position according to the composition desired and the effect each facet creates. Some have the prisms arranged in a parallel form, while others have several prisms grouped around a central prism. These attachments enable the subject to be repeated within the format in a single exposure. The effect looks best with a plain or simple unfussy background. Some attachments have coloured facets, and thus reproduce each image of the subject in a different colour. All can be rotated, so the final arrangement of the various images is left to the photographer.

Prism attachments produce pure spectral hues. In the case of multi-facets arranged around a central one, each of those on the outside displays a separate colour, while the one in the centre displays a balanced rendering of them all. The fewer the facets, the more separated are the various images; the greater number of images produced by a large number of facets, the more interwoven their perimeters become and the more their central image predominates. A three-facet prism, for example, can be arranged so that the subject is recorded with the repeating image in a horizontal, diagonal or vertical plane. A five-facet attachment, on the other hand, provides a central image surrounded by

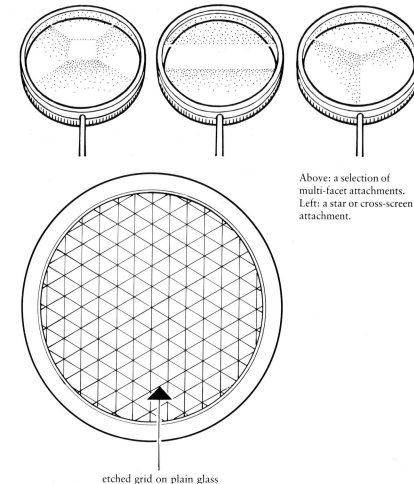

Above: a selection of multi-facet attachments. Left: a star or cross-screen attachment.

etched grid on plain glass

secondary images that can take up corner positions, the positions of the main quarters on a clockface, or any position between.

Parallel prisms are a means of producing a repetitive pattern of a narrow shape, line or motif such as an illuminated sign. In sport, such as table tennis, a photograph of a player about to strike the ball will give quasi-stroboscopic effect that creates the impression of rapid movement frozen several times within a split second. Close-up multi-prism

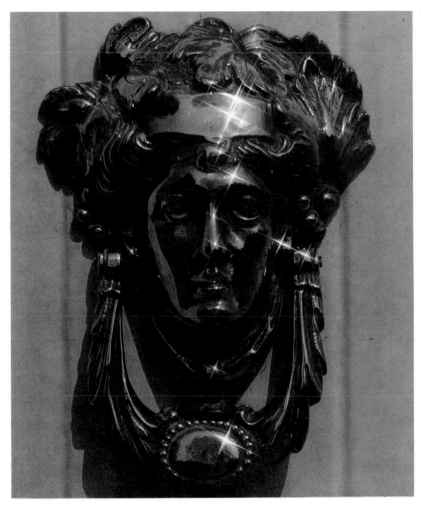

A brass door-knocker given extra sparkle with a cross-screen attachment. *Neville Newman.*

movement of stationary subjects, and can prove useful if attention is to be focused on only one particular aspect.

### Starburst effects

There are a large number of optical-effects attachments that fit in front of the lens. These produce star- or halo-like effects from highlights in the picture area, and are known variously as star-burst, cross-screen, spectra etc. according to the type of effect. They consist of a clear base across which is etched a series of extremely fine grids, the number of lines per millimetre, and the orientations, varying according to the effect required. In some cases the grid is combined with or replaced by thousands of tiny prismatic crystals. Grid-pattern types are made producing stars with any number of points from 2 to 72 around highlights. The prismatic types give less of a star and more of a radiating-beam effect, each beam displaying all the colours of the spectrum in sequence. These stars and coloured beams give an impression of brilliance to the highlights and can be used in combination with other filters and special effects attachments.

Street lamps, neon signs, reflections from glass or water, the sun or moon, even catchlights in a person's eyes or the sparkle of jewellery, can all be given an increased pictorial effect in a photograph by using one of these attachments. You can vary the position of the actual points by rotating the mount. A further variation is the variable cross-screen, in which a pair of transparent colourless screens, with parallel lines etched on their surfaces, are mounted within independently rotating frames in a single unit. Incidentally, no exposure increase is required with any of the attachments described above, nor do they cause a shift in focus of the subject, so they can also be used with rangefinder cameras. A point worth noting is that the length of the arms of the 'star' varies according to the diameter of the light source or highlight in the subject. The nearer to a point-source the light, the more pronounced is the effect and the more sharply defined are the arms;

attachments are also available; these enable pictures to be taken as close as 20 cm from the subject. They consist of prisms that have been ground to the shape of a lens element. They are best used with an SLR camera, where precise focus and composition can be carried out through the viewfinder. For best results, the subject should be situated against a dark background. Multi-facet prism attachments are very successful in cinematography and video work. The effect of rotating the attachment provides apparent

reflections from a large area produce a more diffuse effect, with less well-defined arms, as do moving subjects such as sparkling water.

## Diffraction gratings

Another type of attachment is a kind of diffraction grating. A diffraction grating has lines so finely ruled and so close together that they stretch out points of light into spectra. It produces patterned light streaks with black-and-white film and rainbow-coloured streaks with colour materials. The result gives the impression of a ghost image on either side of the subject, or above and below if the attachment is rotated. It works best with simple subjects such as portraits with neutral or dark backgrounds. If you use a longish exposure time and rotate the attachment during the exposure, you get a very attractive, softly diffused effect that is especially pleasing in portraits of young women.

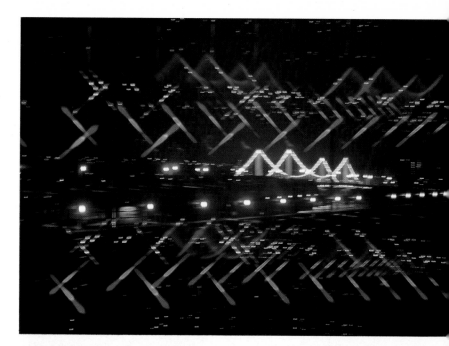

A popular type of optical device is clear down one side and has a grating of fine parallel lines running from the clear area to the opposite edge. Often referred to as an 'action-maker', this works best with simple, uncluttered subjects and at large apertures, and gives the impression of the subject 'frozen' in rapid motion. Tall buildings can appear to be shooting upwards, a stationary hand holding a table tennis bat appears to be about to strike the ball, for example, all at great speed. The effect can be varied from a blur to parallel straight lines, depending on the lens aperture and focal length.

## Diffusing attachments

There are numerous different types of proprietary attachments available to create a soft-focus effect or to diffuse the image produced by a lens. They differ widely in their use and effect, and vary from an optically engineered lens element to a frosted plate. When the latter is placed in front of a camera lens, the effect is to reduce the sharpness of the film image; the result is much the same as if the camera lens were defocused, namely an unsharp image who unsharpness increases with degree of enlargement. The effect of a soft-focus attachment is quite

Left: a multi-facet
attachment used with a star
screen (upper picture); a
diffusing attachment (lower
picture).

Below and right: diffraction
gratings or star screens
break light up into its
component colours. The
effect is centred on
highlights.

different, and the amount of 'softness' depends on the aperture of the lens used to take the picture.

Soft-focus attachments have a series of engraved concentric lines which scatter some of the image-forming light entering the lens. Light entering the lens between these concentric lines is unaffected. Thus the optical image is formed from both sharp and diffuse rays; the resolving power of the lens and the contrast of the image are somewhat reduced. The overall effect is similar to that of a specially-designed soft-focus lens (see below). Thus a soft-focus image consists of a sharply focused and resolved image overlapped by irradiations from the image rays scattered by the concentric lines. The image displays a plasticity that also makes the subject stand out boldly from the background. By contrast, an out-of-focus image (or an image from a lens having poor resolution) is blurred, lacks detail and becomes more blurred as it is enlarged. Stopping down reduces the soft-focus effect, which is at a maximum at full aperture.

Large studios specialising in portraiture produce soft-focus effects using a specially-designed soft-focus lens such as the Rodenstock Imagon, which is intentionally under-corrected for spherical aberration. Such lenses have a special front-mounted aperture disc with a large central aperture surrounded by numerous smaller ones which can be progressively closed off. The central aperture produces a sharp image and the outer small ones a diffuse image, so that the amount of diffusion can be controlled by changing the aperture or interchanging aperture discs. This allows considerable control over the nature of the soft-focus effect as well as the degree of diffusion.

Soft-focus attachments were first made for cameras having non-interchangeable lenses and much used for portraiture, typically the Rolleiflex. Before their introduction devices such as spectacle lenses, fine-meshed grids and even Vaseline were used, but these were inconvenient and often inefficient. Soft-focus attachments could be manufactured to photographic optical quality and could be attached directly to the lens, leaving the photographer's hands free to operate the camera. Also, normal and soft-focus photographs could be taken in rapid succession. When a soft-focus attachment is used on a camera lens the result is a spreading of highlights into adjacent areas, giving an overall impression of brightness. When used on an enlarger lens the result is a spreading of shadows into adjacent areas, giving a much more sombre impression.

Diffusion screen attachments have an etched or ground surface. They also give soft effects. The effect is different from a ruled soft-focus attachment, in that there is no completely sharp image underlying the blur; the image detail is uniformly diffuse and is not sharpened by closing down the lens aperture. Diffusion screens are available in different degrees of coarseness, colourless or dyed with a tint, and with or without a clear central disc. This last type gives a more or less sharply defined circular central area in which the image is sharp, diffused outer area. These screens can be used in combination with filters and other attachments. Stopping down slightly sharpens the outline of the central disc, but also increases the diffusing effect outside it. Lenses of short to medium focal length work best with diffusion screens having a central hole. Those of long focal length, with their narrow acceptance angle, may 'see' little or none of the surrounding diffuse area.

Another type of diffusion screen is known as a fog, mist or sand filter, not to reduce the effects of fog or mist, as one might suppose, but to create it. There are two basic types, graduated (or partial) and all-over; each comes in a variety of grades depending on the effect required. These screens are intended to degrade the image, giving a veiled, fog-like appearance to part or all of the subject. Available clear or coloured, and for use in combination with other filters or attachments as desired, the effect of these screens ranges from a

clear foreground merging into a misty background (or vice versa), to an all-over flat, low-contrast effect with veiled highlights and softened shadows – very effective for picturesque outdoor 'mood' pictures and portraits. Further variations on soft-focus, fog and clear-centre screens are available, some of them a mixture of the three effects. One is a combination of an optically clear centre with a very smoky surround that totally diffuses the outer areas, while leaving the centre section unaffected. Another has a lightly etched outer portion giving slight diffusion. A third variation is a colour filter having a clear disc in its centre, to produce pictures of the subject in natural colours surrounded by a deeply coloured area.

### Multi-coloured filters

Mention was made earlier of prisms and other attachments for fitting in front of a lens to produce multiple bands or areas of colour in a photograph. Another system for achieving this is to fit more than one filter only part-way in front of the lens so that their colours affect only certain areas of the subject. With compendia this is easily achieved because the filters are square (or rectangular, depending on the particular system) and are slid into grooves within the unit. In addition there are filters made up from a bisected circular piece of coloured gelatin mounted between optical flats. This type gives an attachment only half of which is a filter, the remainder being clear. Another type has two pieces of gelatin sandwiched between optical flats, usually coloured red and blue, orange and green or yellow or pink. Some have three or more colours in stripes, or divided into quadrants or sectors. Rotating the multiple filter controls the position of the various colours in the photograph; as before, the effect varies with the focal length and the lens aperture used. Other variations include a coloured polarising filter bound with a graduated neutral-density filter.

### Vignettes and masks

From attachments having diffused or coloured (or both) areas surrounding a clear central opening, it is a short step to vignettes and masking frames that form a shaped surround to the subject. These are usually supplied with a holder for fitting to the camera lens; they also form part of the accessory range for a compendium. They consist of masks with shaped cut-outs through which the pictures are taken. Vignettes usually have serrated central cut-outs that fade the image into the surrounding area. The vignette may be coloured, frosted or black. At a large aperture, the shape is diffuse; stopping down the lens progressively sharpens the outline of the vignette. In the same class are various masks with cut-out shapes resembling hearts, keyholes, stars, squares, circles, etc. Used imaginatively, these can add variety to pictures; again, their effect can be varied. A short-focus lens or a large aperture gives very diffused outlines; a long focal length or small aperture renders the outline more sharply.

Other attachment accessories in this series are masks to permit double or multiple exposures. These consist of pairs of black masks, one with a cutout area through which one picture is taken, the black portion masking off the rest of the picture area, the second (for the second exposure) with a black area corresponding to the transparent portion of the first mask. All vignettes and masks can be used in combination. It is of course necessary in multiple-exposure work to be able to reset your shutter without winding the film over.

Professional 35 mm cameras usually have this facility. If your camera does not, you can manage as follows. First, take up any slack on the film-feed side by turning the rewind knob clockwise. Hold the knob firmly with your left thumb, depress the rewind button, and operate the film-wind lever. This resets the shutter without winding on the film. When you have finished your multiple exposure wind the film over the normal way, put the lens cap on, operate the shutter and wind the film again. This is to avoid possible overlap, as the measuring sprocket does not always engage immediately the film wind lever is operated.

County Hall in London, photographed using various multi-coloured filters: no filter/green, red/blue, red/green, deep pink/no filter.

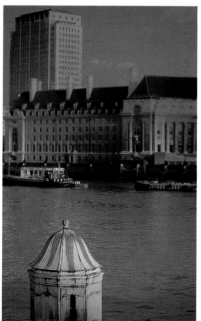

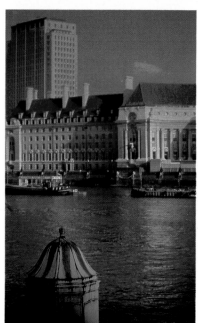

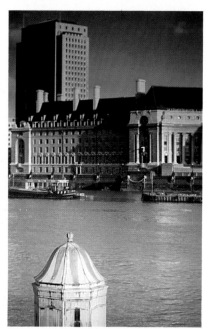

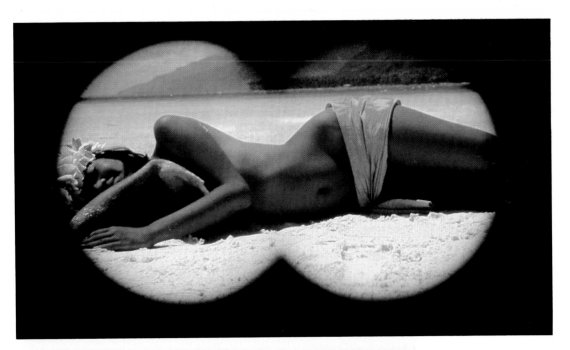

Various attachments can be fitted in front of the lens to form a shaped surround (or even double-exposure masks).

## Lens hoods

Filters and close-up lenses are rarely made to the same high standard as camera lenses, so if you want optimum results use filters and close-up lenses that are surface coated, or fit an efficient lens hood, preferably both. The very large areas of gelatin and plastics filters makes them particularly prone to reflections, and compendia having a lens hood as part of the outfit are to be preferred to those which do not. Bear in mind that if you fit a filter or close-up lens the lens hood is a few millimetres forward of its usual position in relation to the front surface of the lens. In some instances, this can cause cut-off at the corners of the image, especially if two or more attachments are fitted simultaneously, in which case you need to fit a shallower lens hood. A bellows-type lens hood is available for some reflex cameras. This can be used with a wide range of focal lengths, with or without accessories, the length of the bellows being adjusted until cut-off is just eliminated.

Whether one chooses a lens hood that is circular or rectangular, rubber or metal, fixed or bellows-type, is a matter of personal preference and cost. Metal hoods may need internal reblackening from time to time, whereas rubber or bellows hoods are efficient and fold up almost flat. Rubber hoods can often be left in place and folded back over the lens, but both bellows-type and rubber hoods will perish in time. Many lenses with built-in hoods enable the hood to be used by sliding it forward over the lens front element. The fitting of a mounted filter or close-up lens may make such a hood inoperative. This applies especially to a compendium. Yet this is often when the hood is needed most! Therefore when buying an auxiliary lens, don't let a built-in sliding lens hood become a dominant factor. It could prove of limited value in the long run.

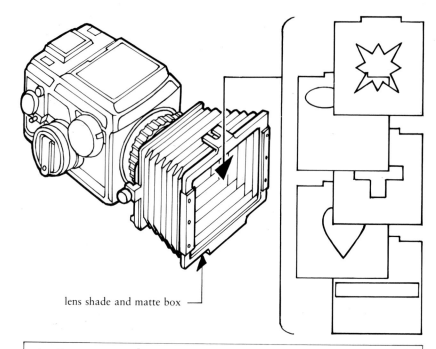

lens shade and matte box

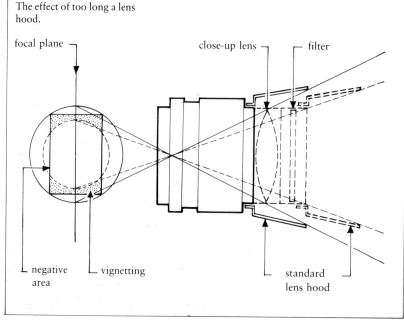

The effect of too long a lens hood.

focal plane

close-up lens

filter

negative area

vignetting

standard lens hood

108

# Studio and cine photography

Early photographers, who often prepared their own emulsions, soon discovered they could modify the limited spectral response of their materials by placing a suitably-coloured filter over the camera lens, thereby reducing some of the limitations in recording colours. Early in the twentieth century, when black-and-white photography was the norm, the majority of casual photographers were quite accustomed to seeing their pictures displaying bald skies, different colours rendered in similar or even identical grey tones, and false rendering of certain colours, such as blue rendered too dark by artificial light. As they became more experienced and knowledgeable, they began to use a few filters, appreciating the way their pictures began to improve and take on a more professional appearance.

Professional photographers, on the other hand, knew well the influence that a suitable filter had on their work. For this reason, they kept their acquired knowledge to themselves, as in many cases this was all that kept their work ahead of the skilful amateur. In the early days of the motion-picture industry the use of filters was widespread, and necessary too, owing to the types of artificial light sources being used, the limited colour sensitivity of the emulsions available, the relatively small-aperture lenses and the requirements of depth of field. With the arrival of panchromatic emulsions colour cinematography became possible. Before the advent of multi-layer colour emulsions it was necessary to make simultaneous exposures through red, green and blue filters on three films (using a special camera equipped with beamsplitters), from which a print was made by superimposing three coloured images made from the films. An alternative method was exposure of a single film through a multi-coloured mosaic, and projection through the same mosaic. A correction

*Ed Buziak*

109

filter was required, and this varied from one emulsion to another, there being uncontrollable changes in spectral sensitivity from batch to batch.

With the advent of modern multi-layer emulsions such as Kodachrome, for example, photographers were released from the tyranny of filtered exposures with colour materials, and could make use of the film's full speed. Filtration became simply a matter of reducing the effects of haze, too much light, stray reflections, unwanted background colours, and the creation of colours where none or insufficient colour existed. The demands and competitiveness of professional and commercial photography, and the need for photography in scientific, medical, research and industrial applications, have called on the professional photographer to develop skills and techniques previously unthought of, and many of these have demanded the use of filters, both solid and liquid. Special-effects filters and their uses have been discussed in a previous chapter; filters for graphic arts, scientific, medical and technical applications will be described later. This chapter is concerned mainly with studio work.

### Portraiture

A major problem faced by portrait photographers, professional or amateur, is the correct rendition of skin tones when taking photographs by artificial light. This is not such an acute problem when shooting in colour under suitable lighting, such as daylight-type film with electronic flash, or tungsten-light film with a suitable conversion filter. It is usually necessary only to modify the blue content slightly to achieve a more flattering result. For this, a pale pink filter is usually adequate, and no allowance need be made when calculating the exposure. The particular filter to use depends to a great extent on the precise skin tone required, which in turn depends on the rendition of the colour film used, the colour transmission characteristics of the lens, the precise colour temperature of the light source and the effect of any nearby reflecting surfaces which may need to be

taken in account. The result of all of this will rest on controlled tests and notes carefully taken for future reference. Even then, slight changes may be necessary owing to batch-to-batch or processing variations of the film.

With colour-negative films, slight inaccuracies in the colour rendering of skin tones can usually be identified during the printing stage; whether due to unwanted reflections, not-quite-suitable lights, inaccurate exposure, or variations in emulsion characteristics, errors can be rectified by filtering during the enlarging exposure. You need, of course, to take into account the colour temperature of the light under which the print will be viewed. In black-and-white photography, the problems concerned with producing accurate (or satisfying) rendition of the skin (the two criteria might be quite separate) are rather different, and involve tones and contrast rather than actual hues. In portraits of women, you will probably be seeking a flattering effect. With men, in particular those with very characteristic features, you may need a more dramatic effect, possibly with emphasis on details of skin texture, and perhaps even blemishes. With a small child you want a smooth, rounded texture. One method of working is to apply make-up to the subject to enhance certain areas and subdue or disguise others. Since most tungsten-filament lamps are high in red content and panchromatic films have moderately high sensitivity to red, most red shades will be rendered lighter than in fact they are. Consequently, women should wear a lipstick a shade darker than normal. Spots and freckles, being reddish, will be slightly less obvious on the final print than they are to the eye. To disguise blemishes with make-up, ensure that this matches the surrounding areas.

Since most blemishes of the skin are usually some shade of red (e.g. rash, sunburn, spots, freckles) they can be further reduced, or even eliminated, by using a yellow or orange filter fitted over the camera lens. This also has the effect of making the complexion appear paler than normal, which may

A soft-focus diffuser gives a flattering result to many portraits. *Hasselblad.*

or may not be considered an attractive or desirable effect. To enhance freckles, to darken the lips, or give a slightly suntanned appearance, fit a pale green or bluish filter over the lens. This trick is often used by fashion photographers to give a swim-suited model the appearance of a tan, for holiday brochures to make hotel guests appear tanned, or to illustrate the effect of cosmetics. The pale blue filter also helps to prevent blue eyes from being rendered too dark.

An orange or red filter can be used to lighten a black or brown face, or to give an almost ghostly appearance to a white one; a green or blue filter can be used to make a white face appear more swarthy. It must be remembered, however, that any filter on the camera lens has an effect on all parts of the subject (clothes, background, etc.), so it may be preferable to filter only the particular light source directly illuminating the subject. With a typical lighting set-up that has a keylight, various fill-in lights, lights on the hair and others on the background, it is sufficient simply to place a suitably-coloured filter in front of the main light, for example lighting the face, while leaving other lights illuminating clothes etc. unaffected. You can also modify the appearance of the skin texture of your model by fitting a polarising filter. This will remove any unwanted shine from the skin, reflections on the forehead, nose etc. You can also use a polarising filter to control unwanted reflections on spectacles and some types of jewellery.

## Photographing objects
So far we have considered portraits and the effect of artificial (tungsten) light sources on skin tones. But filters are also invaluable for correcting, modifying or eliminating certain colours (or the tonal rendition of them, in black and white) when photographing objects under artificial light. Whereas daylight has no predominant hue, the light of tungsten-filament lamps is rich in red, and it is necessary to bear this mind when considering the effect of any given filter. Brown or reddish leather

and wood, for example, are reproduced lighter on the final print when photographed by tungsten lighting than if photographed by daylight, with the result that a green or even a blue filter may be needed to make them appear in the correct tone. Conversely, if you fit an orange or red filter over the lens, the contrast within the particular shades of the material is increased. The detail of the grain in the wood is enhanced, and the effect created by shadows and highlight is exaggerated. When photographing a range of products of similar colours, a filter of the same basic hue fitted over the camera lens helps to separate the different tones. On the other hand, if it is necessary to make items appear to match one another, this can be achieved by fitting the camera (or light) with a filter of a contrasting hue.

## Copying and duplicating
Mention has already been made of using filters in black-and-white copying work, i.e. making a stain-free copy of an old original by using a filter that matches as closely as possible the colour of the stain. In colour work, you can use filters to modify or reduce a cast in an original, whether caused by a fault local to the subject, unsuitable original lighting, old or badly stored film stock, reciprocity-law failure, a badly made print, etc. This is done by placing appropriate filters over the copying camera lens when photographing the original. This method also enables coloured copies to be made from black-and-white or other monochromatic originals, and even contrived special effects to be produced. Accurate reproduction of an original colour photograph presents many of the pitfalls facing the photographer of any coloured subject, plus those peculiar to copying: uniformity of illumination, freedom from surface reflections, etc. To maintain accurate colour rendering, the film should match the light source being used (or vice versa), and every effort should be made to avoid colour casts caused by local reflections. When copying a colour print, for example, it should be surrounded by matt black card and, if necessary, hooded with more card.

A star screen has produced an attractive effect in this commercial shot of technical apparatus.

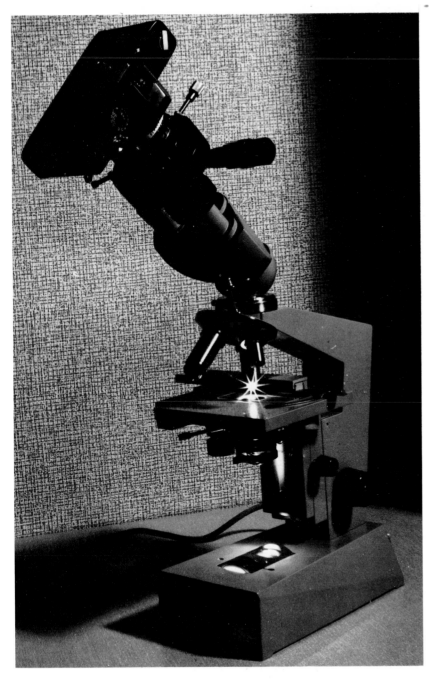

Colour transparencies should either be surrounded by black card or mounted in a slide mount.

Illumination for prints or slides should be Photofloods, studio lamps or electronic flash. The last of them is to be preferred for its high intensity, constant colour temperature and close match to daylight, and short duration, avoiding the risk of blur due to vibration. Daylight itself is a poor source of illumination for copying, as it varies in both intensity and colour quality over quite short periods of time. For the odd one-off, or where critical matching is not of paramount importance (as in most amateur work) you can use direct sunlight, provided the sun is at a sufficiently small grazing angle (45° or less) to avoid the risk of direct reflections from the paper surface. It is frequently recommended, in amateur magazines, that a colour slide should be taped to glass (such as a window) and rephotographed. Unfortunately, many glasses are not absolutely colourless, and often transmit a greenish hue that gives the resulting duplicates an overall cast.

The photography of drawings and other black-and-white documents presents its own problems. True black on white (or white on black) needs no filtering to reproduce in excellent contrast. When you want to eliminate coloured lines, as with graph paper or lined paper, photographing through a filter of the same colour as the lines, e.g. blue for blue lines and red for red lines, will eliminate them; drawing or writing in black is unaffected. Photography of old documents, photographs, newspapers etc. usually involves the elimination (or at least the minimising) of stains, foxing, bronzing and yellowing of the original materials in the copy. To filter out these faults use a suitable deep yellow, orange or red filter over the camera lens. If you want strictly accurate tonal reproduction, say, of an oil painting by daylight, use a yellow-green pan-correction filter over the camera lens. This is necessary, as explained earlier (page 57), because the response of panchromatic film is different from that of the human eye. In

daylight it reproduces blues too light, greens too dark and reds also rather lighter than we see them, hence the need for the yellow-green filter. Similar considerations apply for pictures taken by tungsten light: reds are rendered much too pale, and greens and blues too dark. Again, as explained earlier, an appropriate bluish filter is necessary for accurate colour rendition.

### Coloured lighting effects

In addition to being fitted in front of the camera lens to alter or correct tonal rendition in black-and-white work, or for correction or conversion in colour, coloured filters have a very wide application in studio photography in colour. Used in front of a light source, sheets of coloured transparent materials can throw coloured light on to the subject for overall effect, or on to a specific area of the subject or background. Coloured light can be directed on to a woman's hair, for example, to create a glamorous appearance. You can avoid the necessity of having a number of different coloured backgrounds if you use a plain white or grey backdrop and illuminate it with coloured light. Coloured gels in front of lights allow you to mix light sources such as Photofloods and daylight or electronic flash, or to correct the falling colour temperatures of ageing studio lamps. In practice, as discussed earlier (page 75), it is usually simpler to replace them. Do not discard the old lamps, though, as they will still provide valuable service for black-and-white work, and during the initial setting up for colour. Replace them with new bulbs before taking meter readings and making the exposure.

You can provide a coloured background for photographing small objects on a sheet of opal glass or Perspex, if you light it from behind with a coloured gel over the lamp. The effects are simple to achieve and the possibilities endless. The gels can be cheap sheets of acetate, polyester, cellophane, plastics, glass etc., without special optical properties, as they are not in the image-forming light between the subject and the film. The only

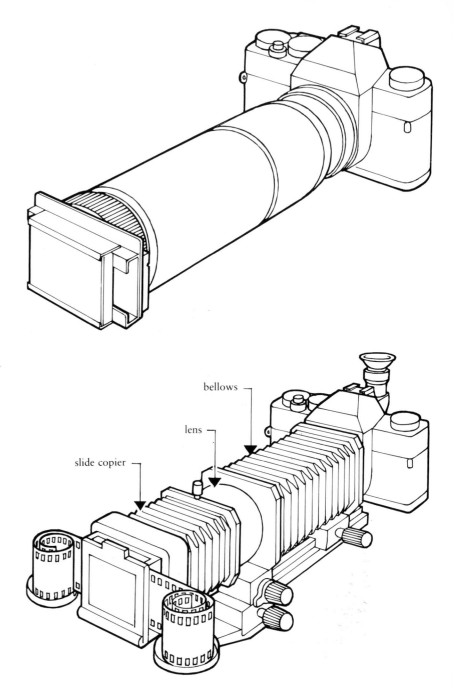

bellows

lens

slide copier

necessary precaution is to ensure that the gel or filter material is at a sufficient distance from the lamp to avoid blistering or other damage from the heat, and to allow sufficient cooling air to reach the lamp. These conditions do not apply to electronic flash-heads, as the heat generated by the firing of the tube is very short-lived. You can also use coloured gels or other types of filters in front of the light source to simulate the effect of other sources: the glow from firelight, moonlight through a window, sodium street-lights, traffic lights, a bonfire, the flash of fireworks or even the glow from a cigarette. If you think of all the effects that are created in stage plays and movies, you will realise the endless possibilities.

### Electronic flash in the studio

Electronic flash is eminently suitable as a main source of artificial light for all indoor and studio work, especially where this demands very short exposures. These may be individual, or linked for

time-lapse movies. Many modern electronic flashguns recycle so quickly that they can be used for quite rapid sequence work. Because of the high colour temperature of its light, electronic flash can be used successfully with daylight-balanced colour films. Early units emitted a flash having a colour temperature in the region of 6500 K, but modern units either have a pale yellow or gold-coloured filter in front of the flashtube, or the tube itself is gold-coated. This brings the colour temperature down to about 5500 K, the colour temperature for which most daylight-type colour films are balanced. If using an older unit giving the higher colour temperature light, you will need to fit a suitable filter either in front of the flashgun or in front of the camera lens. If the unit emits a flash of 6500 K, for example, the filter should be either an R2 or R3 (6500 K = 154 mireds, 5500 K = 182 mireds, so the precise colour shift required is 28 mireds). Whether the filter should be fitted over the camera lens or each of the flash-heads depends on several factors. If you are using a single flash-head with a range of lenses of different front-cell diameters it is obviously more economic to fit a non-optical-quality filter in front of the flash-head. On the other hand, if you are using a number of flash-heads, a compendium-system filter would be preferable. If you use only one lens and one flash-head, filter the light source itself, leaving the camera optics unaffected.

### Neutral-density filters

Neutral-density filters are as much an aid in the studio as out of doors, when circumstances put the necessary exposure beyond the available range of the camera controls. Typical instances are where a slow-speed film is needed for a particular effect; when some or all of the lights cannot be moved further away because their precise position is demanded by the particular arrangement; where their output cannot be reduced because this would affect the colour temperature of their light; where a large lens aperture must be used to minimise depth of field; where high shutter speeds cannot be used owing to the limitations of flash synchronisation,

or a combination of any of them. In these cases you simply fit neutral-density filters.

Neutral-density filters are also useful for shielding part of the subject, in multiple-flood or multiple-flash set-ups, or where lighting must be arranged to cover a wide area or varying distances. In such cases, foreground detail is frequently overexposed if distant areas of the subject are to receive sufficient exposure. A neutral-density filter, placed so as to shade only the foreground, helps to give uniform illumination. In close-up work it may be impossible to reduce the intensity of studio lamps or flash sufficiently to avoid overexposure. Reducing the power supply to studio lamps will reduce their intensity, but this will also be accompanied by a fall in the colour temperature of their light, often making them unsuitable for use with colour films. Certain lamps, such as tungsten-halogen types, cannot have their output reduced beyond a nominal point, because their life cycle depends on the operating temperature remaining above a certain level (page 76). Fitting a neutral-density filter may in any of these cases provide the only solution. Again, sufficient air space should be provided to allow the built-up heat to be dissipated.

Further uses for neutral-density filters in the studio include situations where light sources of differing intensity need to be mixed (e.g. Photofloods and tungsten-halogen lamps) owing to lack of sufficient matching equipment; graduated lighting to achieve varying intensity over an uninterrupted area; balancing the intensity of daylight entering a window with flood or flash (by covering the window or part of it with a sheet of suitable neutral-density material); using a lamp within the picture area as part of the composition (a suitable neutral-density filter is fitted in front of it), etc.

**Neutral-density filters in cinematography** In movie work, neutral-density filters and screens are frequently used. This is especially so since the demands for high-speed films, camera lenses with

large maximum apertures and shutters with wide open-sector angles (to transmit the maximum amount of light during each fixed-speed exposure) have all been met. All these features are ideal for filming under available-light conditions; they are frequently sufficient to obviate the need for auxiliary lighting, but they work to the cameraman's disadvantage when he wishes to film in sunlight. Under such circumstances there is a very serious risk that the film will be overexposed, even at the smallest lens aperture.

Manufacturers of high-speed lenses are rarely able to provide minimum apertures smaller than $f/16$. Very small apertures introduce the risk of diffraction effects, which impair the quality of the image. There are also mechanical problems associated with achieving very small apertures. One solution to this problem, first employed by Kodak, was to fit neutral-density filters into the tails of the iris diaphragm leaves. Such filters give a suitable effective level of light transmission equivalent to a small aperture, without the accompanying optical or mechanical problems. To limit depth of field by use of a large aperture, a neutral-density filter must be fitted in front of the lens. Some older cameras whose built-in metering system is not programmed for high-speed film can still use this material so long as a suitable neutral-density filter is fitted over the lens to compensate for the risk of overexposure. This does not work with TTL metering, which must be overriden by setting the apertures manually. In professional motion-picture work it is not uncommon for the cameraman to fit a coloured filter for a particular effect, such as tone or contrast control, colour balancing or conversion, which incorporates a neutral-density filter. These filters usually incorporate the ND factor in their code number (pages 52–53).

While on the subject of movie-making, it is as well to mention that all Super 8 cine cameras are designed for use with artificial-light-type film. Since the average artificially-lit indoor scene is darker than the average daylight one, all the features of the

camera concerned with the transmission of light from the subject to the film are designed to transmit the maximum amount possible, e.g. with ultra-fast lenses having effective apertures of $f/1.1$ or thereabouts, and wide shutter openings of 220° instead of the normal 175–180°. To make maximum use of the effective speed of the film, it is necessary to be able to use it free from a conversion filter, so artificial-light-type material is chosen. Type A Kodachrome, for example, the most popular amateur movie film of all, has a film speed of ISO 40/17° to tungsten (Photoflood) lighting. But when filtered for use in daylight, its effective speed becomes ISO 25/15°, the same as unfiltered daylight Kodachrome. To make things easier for the user, all Super 8 cine cameras have an appropriate orange conversion filter built-in to permit artificial-light-type film to be exposed by daylight. The filter must be removed for shooting by artificial light; this is done simply by moving a switch, or by turning a key inserted into a socket on the camera top-plate.

### Types of cine film

Most Super 8 movie films are type A, but Kodak has produced a type G (general purpose) film which may be exposed by daylight or artificial light. This film is balanced for 4500 K light, midway between daylight (5500 K) and Photoflood (3200 K). Although scenes exposed by artificial light appear slightly warm and those by daylight slightly cool, the overall effect is quite acceptable; however, some flesh tones can appear rather red by Photoflood light, especially if slightly underexposed. Since many multi-coated, multi-component zoom lenses (such as are fitted to the majority of Super 8 cameras) give a slightly warmer than average image colour, the slight blue cast is often less intense; it can be further reduced by fitting a pale pink or straw-coloured skylight filter.

Type G film is used with the built-in orange A–D switched out of the light path, and is intended for the novice or casual moviemaker who wants to film indoors and out, without having to remember to

adjust the built-in filter. While its colour rendering under different light sources cannot match normal films for fidelity, it is nonetheless perfectly satisfactory for average domestic and non-critical work. With suitable colour-balancing filters its overall performance can be vastly improved, though this rather defeats its original aim of simplicity.

### Variations between emulsion batches

Film emulsion technology is a precise science, and emulsion manufacture is carefully controlled to achieve the minimum of variation in emulsion characteristics from batch to batch. But variations do occur, and although this is normally of little significance with black-and-white materials, batch-to-batch variations of colour balance may be quite noticeable with colour materials. Most professional photographers purchase their films in quantity, store them under refrigerated conditions (not necessary, or indeed advisable, for films sold for normal amateur use), and ensure that films used for any one job come from the same batch. This is especially important when precise colour matching is needed for fashion, portrait, display or advertising photography, for example.

Most professionals prefer to run tests on each new batch of film before risking an important job, or even just to test its reaction to a particular set-up or process run. Included in the tests, which are carried out as far as possible under normal working conditions, are pictures of a neutral-grey-tone test card, either separate from or included in a test scene. Exposures are bracketed, usually to one stop each side of the indicated exposure, in half-stop increments. Exposures are then repeated using 0.1-density colour-compensating filters in all six primary and complementary hues. After processing, the results are evaluated, and any necessary shift in exposure or apparent need to use a particular compensating filter can be noted and used for all subsequent work.

## Reciprocity-law failure

The professional's reliance on adding filters for colour correction or conversion can sometimes cause problems when exposing colour films that may require additional compensating filters to be added to modify the colour balance. Most colour films, especially those for professional use, are intended to yield their best results when given exposures shorter than $\frac{1}{8}$ second. At low light intensities demanding exposure times longer than this, the various colour-sensitive layers of the emulsion react differently from one another, causing a shift in overall colour balance. This phenomenon is known as reciprocity-law failure. The law of reciprocity states that the effect of light on a photographic emulsion is directly proportional to the total light energy, i.e. the product of the intensity of the light incident on the film and the duration of the exposure. In theory, this means that a large quantity of light falling on the emulsion for a short time should give the same density as a small quantity for a proportionately long time. In practice many combinations of shutter speed and aperture do just this. But the law breaks down for very low levels of illumination, which require more exposure than is indicated by an exposure meter. The amount of increase depends on the light level and the type of emulsion being used. For example, with a general-purpose film the exposure time may need to be doubled for an exposure indicated by the meter of 8 seconds.

Serious problems are rarely met with most black-and-white films because of the exposure latitude of most emulsions and the flexibility of the development process; but with colour the effect can be more serious. Because the three colour-sensitive layers that make up the emulsion react differently from one another for very long exposures, the resulting overall colour balance may produce unpredictable and unnatural results. In particular the colour balance may be skewed, with shadows of one colour cast (say orange) and highlights of a complementary cast (bluish). Even with colour-negative material it is not possible to obtain a satisfactory print without difficult and laborious masking techniques. To combat low-level reciprocity failure, special professional films are made for long exposures, usually designated type L films. (Short-exposure professional films are designated type S.) These give correct colour balance with a range of longer exposure times, ideally between one and eight seconds. Very long exposures still result in colour casts, but they are uniform throughout the tone scale, and can be corrected by filtration according to tables supplied with the film or obtainable from the manufacturer.

Very high light levels demanding extremely short exposure times can also give rise to reciprocity failure, at least in theory. However, modern emulsion research has for practical purposes eliminated this fault from present-day films. The research was rendered necessary by the advent of modern automatically-controlled flashguns, which in close-up work give flash durations that are frequently as short as $\frac{1}{10000}$ second. Scientific research and development programmes often involve high-speed photography using exposure durations of less than a millionth of a second, and quite ordinary processing techniques produce perfectly satisfactory results. The single exception is type L film, which if used for very short exposure durations gives a result of low contrast and low exposure, and an overall bluish cast. In all cases, the manufacturer of a particular film will on request provide detailed recommendations with regard to any necessary modifications to exposure and development, and filtration in the case of colour materials. However, where precise colour balance is important each emulsion batch should be subjected to controlled tests.

## Pan-vision filters

The general unreliability of the human eye in judgements of the photographic qualities of a subject, especially with regard to the interpretation of colours into grey tones, is well known to all professional and most keen amateur photographers. The mechanism of visual

**Typical reciprocity-failure corrections needed for reversal films (upper section) and colour negative films (lower section)**

| | | exposure time: seconds | | | | | |
| --- | --- | --- | --- | --- | --- | --- | --- |
| | | 1/1000 | 1/100 | 1/10 | 1 | 10 | 100 |
| Ektachrome 64 | daylight | none | none | none | +1 stop CC10M | +1½ stops CC15M | NR |
| Ektachrome 50 professional | tungsten | NR | none | none | none | +½ stop CC10B | NR |
| Ektachrome 200 | daylight | +½ stop NF | none | none | +½ stop CC10R | NR | NR |
| Ektachrome 160 | tungsten | none | none | none | +½ stop CC10R | +1 stop CC15R | NR |
| Ektachrome 400 | daylight | none | none | none | +½ stop NF | +1½ stops CC10C | +2½ stops CC10C |
| Ektachrome Infrared | | none | none | +1 stop CC20B | NR | NR | NR |
| Kodachrome 25 | daylight | none | none | none | +½ stop NF | +2 stops CC10B | +3 stops CC20B |
| Kodachrome 64 | daylight | none | none | none | +½ stop NF | NR | NR |
| Agfachrome 64/100 | daylight | none | none | none | no increase CC05M | +⅔ stop CC10M | NR |
| Agfachrome 50L | tungsten | none | none | none | no increase | +⅓ stop | +½ stop |
| Agfachrome CT18 | daylight | none | none | none | long exposures produce yellow-green cast | | |
| Agfachrome CT21 | daylight | none | none | none | long exposures produce yellow-green cast | | |
| Fujichrome 100 | daylight | none | none | none | none | +1 stop CC05C | +1⅓ stops CC10C |
| Kodacolor II | daylight | none | none | none | +½ stop NF | +1½ stops CC10C | +2½ stops CC10C +10G |
| Kodacolor 400 | daylight | none | none | none | +½ stop NF | +1½ stop CC10M | +2 stops CC10M |
| Agfacolor CNS | daylight | none | none | none | +⅓ stop | +1 stop | +2 stops |
| Agfacolor CNS 400 | daylight | none | none | none | +1 stop NF | +2 stops NF | +3 stops NF |
| Agfacolor 80S | daylight | none | none | none | none | +1 stop NF | NR |
| Vericolor II prof. type S | daylight | none | none | none | NR | NR | NR |
| Vericolor II prof. type L | tungsten | see data sheet packed with film | | | | | |

perception is notoriously accommodating, and constantly compensates for variations in contrast or luminosity. Therefore, before shooting a picture of a subject that has been difficult or time-consuming to set up, or that cannot be repeated, many photographers view the final scene through a special viewing filter called a pan-vision filter, which is purple in hue and has two very useful properties. The first is that it modifies the effective colour sensitivity of the eye so that it matches that of a typical (unfiltered) panchromatic emulsion. In fact, if you put a yellow-green correction filter (page 58) in front of the PV filter and look through it, it appears almost a neutral grey. This means that when you look through a PV filter you see all colours in the tones they will appear relative to one another in the final print. The second property is that the scene appears somewhat decolorised, so that you get something of the impression that a monochrome print will given in terms of tones. Pan-vision filters are nowadays less often used in professional photography than in former times, partly because the relative amount of black-and-white photography is decreasing, and partly because of the common practice of making trial exposures on Polaroid film, making final adjustments after inspection of the print. However, a pan-vision filter is still useful for the amateur black-and-white worker, who can try out the effect of any filter by placing it in front of the PV filter and examining the scene through the pair. PV filters are intended for viewing only, and have no use as 'taking' filters.

A second type of filter for viewing, also (rather unfortunately) often called a pan-vision filter, though more correctly called a monochrome-vision filter, transmits only a band of wavelengths of approximately 555–630 nm. It is dark amber or brown. It is more effective than the true PV filter in affording a monochrome view of a subject, but has the serious disadvantage that it does not give the correct values to colours, for example rendering blues very dark.

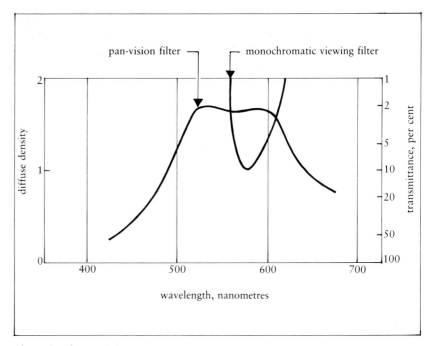

Absorption characteristics of two viewing filters used to obtain a visual impression of a scene in monochrome.

# Filters in industrial and scientific work

In industry and science, photography is used as a means of recording information, sometimes the only reliable means. It is used for data storage and retrieval purposes; for analysis, for medical, scientific and technological research and development; for astronomical or botanical sciences, and for the study of many other subjects that affect our daily (and future) lives. In many of these applications filters play an important part in the manner already described. But there are also numerous conditions that demand the use of special filters: those which transmit only a particular narrow band or wavelength; those for which the highest optical quality is demanded; and many that would have no useful place in normal photography. Some of the filters used in industrial and scientific work are very strongly coloured, while others are exceedingly pale, having an almost imperceptible tint. Seldom are exposure factors quoted for such filters; tests must be carried out under the conditions of use.

### Interference filters

Conventional filters using dyes have many disadvantages for much scientific work. For example, they are prone to fade. Furthermore, even with very carefully controlled mixes, it may still prove impossible to produce a suitable filter, accurate enough to transmit or absorb a particular narrow waveband. In these cases, interference filters are used. The effect of these depends on an interference phenomenon similar to the method of preventing surface reflections by anti-reflection coatings applied to lens elements and other optical surfaces. An interference filter is made by coating an optically flat glass support with ultra-thin layers of transparent substances of alternate high and low refractive index. The actual thickness of the layers is one-quarter of the wavelength of the centre of the band it is desired to transmit. The coatings, which

in some instances may number twenty or more, are applied to the surface by evaporation or electron bombardment in a high vacuum. To ensure that the transmission characteristics meet the necessary requirements, the number of layers, their respective thicknesses and their refractive indices are all carefully chosen. Destructive interference occurs between the light waves of all but the required wavelength at the interfaces of the layers, giving the required transmission characteristics. Since spectral transmission depends on the angle of incidence of the light waves, interference filters need to be used in a collimated light beam. The accompanying curve for a typical interference filter is conspicuous for its very narrow transmission band.

Interference filters have many advantages over conventional filters. They can be made to more precise specifications than any type made for general photography. Equally important, apart from their spectral transmission characteristics, they have no effect on the image-forming properties of the optics with which they are used. Indeed, in some circumstances, the surface on which the filter layers are coated may be part of the optical and image-forming set-up. Furthermore, interference filters transmit very much more light within their transmission band than the equivalent absorption-type filters. Owing to the difficulties in coating large surfaces, interference filters are generally made only in relatively small sizes. They are also expensive, but in view of their very long life their cost is usually justified.

### Photomicrography
Practised by amateurs and professionals alike, this fascinating branch of photography not only lends itself to producing pictures of objects too small to be perceived by the unaided eye, but also reveals detail for study and research available by no other means. Apart from practical considerations, such as the specification of the items of equipment, their features, and problems associated with coupling them in a safe, rigid and accurately aligned set-up, there are others concerned with optics and

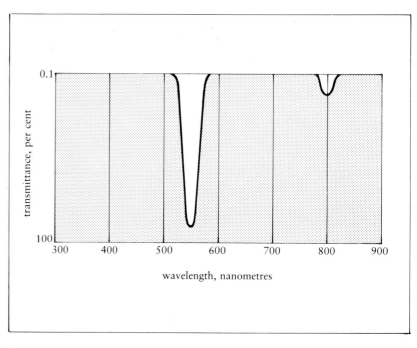

illumination. One problem arises because the majority of microscope objectives, with the possible exception of the more optically refined (and expensive) types fitted to the very best microscopes, are not corrected for bringing all colours of the visible spectrum to the same point of focus. This result is called axial chromatic aberration. The effect is that colours of short wavelengths of light are refracted more strongly than longer wavelengths, and are brought to a focus closer to the lens than the longer ones. Because the various spectral colours come to a focus in different planes (blue nearer to the lens than red, for example) the result is a series of unsharp coloured fringes surrounding the colour that is correctly focused.

Microscope objectives are computed to visual standards, and consequently are designed for focusing light within the yellow-green area of the spectrum, the region of the eye's greatest sensitivity. The eye tends to ignore the unsharp fringes, but when the microscope is used for photographic

Absorption characteristic of a typical monochromatic interference filter; unwanted transmission at 800 nm can be suppressed by an additional filter.

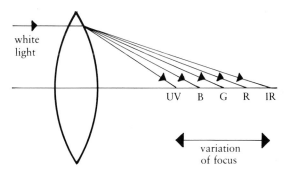

Axial chromatic aberration in a lens causes coloured fringes surrounding the colour that is correctly focused.

white light

UV  B  G  R  IR

variation of focus

recording purposes the unsharp colours are recorded, and the resulting pictures are often quite unsuitable for scientific or technical evaluation. The simple solution, when using microscope objectives displaying any form of chromatic aberration, is to filter out the unwanted wavelengths. These are usually the red and blue wavelengths for which the objective is not corrected, and a yellow-green filter is used for this purpose. Filtration of this nature is not required for objectives corrected for chromatic aberration. Better-class objectives are made up of pairs of components of different dispersive properties, which cancel out each others' chromatic aberrations. Such objectives are called achromats. These are fitted to the more expensive type of microscope. With the greater use being made of photography, microscopes with achromatic objectives are becoming commonplace in educational and research units where photographic data for recording and analysis are required.

In achromats chromatic aberration is corrected fully only at two wavelengths, typically yellow-green and blue. In some applications, notably colour separation and graphic arts work, for example, lenses are required with coincident foci for three wavelengths, the three primaries red, green and blue. Such lenses are called apochromats, and these too are used in high-quality microscopes. More recently even higher correction has become possible, four wavelengths being brought to a common focus. The wavelengths usually chosen for

this are primaries plus infrared. These lenses, called superachromats, require no focus correction, by filters or other means, for wavelengths between 400 and 1000 nm.

Axial chromatic aberration should not be confused with lateral or transverse chromatic aberration. The latter is an aberration that affects image magnification and appears as colour fringing at the edges of the image. This fault is rarely manifest with short-focus lenses, being usually found with those of a long or extra long focal length. Especially troublesome in photomechanical colour-separation work, where accurate image size is critical, this is a difficult fault to correct and worsens as the focal length is increased.

Another area in which filters help to improve the image sharpness of a microscope objective is in the control of aberrations with colourless subjects such as metals. Here the transmission can be restricted to a very narrow waveband to make the most of the transmission and focusing characteristics of the objective, by choosing a dominant wavelength, possibly by combining two or more filters. If restricted to an area within the yellow-green band, it should be possible to focus the microscope visually without the filters (when the combination is too dense to do this with them in place), and this focus should hold good for photographic purposes.

Another aspect of photomicrography calling for the use of filters is the need for contrast in studying certain objects or phenomena. These may be stress marks, stains, infected tissue etc., for all of which the differences in the subject or area and its surroundings are more important than correct colour or tonal rendition. For example, certain objects such as bacteria show up only if stained and photographed through a suitable contrast filter. The stains most often used in photomicrography are red and blue, and the most appropriate filters for these colours are usually their respective complementaries. Some suggestions as to suitable filters to use for certain stains is given in the

accompanying table; as can be seen, there are one or two exceptions to the complementary-filter rule. What is important, though, is that the subject must be made to stand out from the remaining and surrounding areas.

There are many instances where infrared photography provides a means of recording areas otherwise invisible under normal spectral radiation. Many insects and shell-fish, for example, have a hard outer covering of chitin (a substance which also forms most of the hard parts of joint-footed animals) which is transparent to infrared radiation. This effect enables inner organs and components to be photographed using infrared film combined with suitable infrared filters. Initially focusing is through a deep red filter; this is replaced by infrared for the actual exposure. Even carbonised remains of chitin in addition to many other carbonised fossils such as animal hairs, fish scales, pollen grains, skeletal remains etc. can all be penetrated by infrared to reveal detail. IR also penetrates the keratin of hair.

There is a long detailed history of the development and use of IR photomicrography, dating back to the early 1930s. The invisible detail of the cellular structure of living plants was revealed at a very early stage to scientists experimenting with IR radiation. In some cases, the omission of the usual IR filter produced first-class photomicrographs of kidney and muscle sections. These combined a sharp image in the blue regions to which IR film is also sensitive, in addition to the IR image. One scientist called Maresh worked with radiations of 1300 nm, using an infrared microscope coupled to an electron image converter tube. By producing magnifications of 600× he was able to reveal the pores under the scales of a moth's wing, and to reveal detail in the visually-opaque modified forewing that forms a casing for the hind wing of a metallic wood-boring beetle.

Filters for photomicrography are usually inserted between the light source and the sub-stage condenser, some instruments having a special

| stain | | negative material | filter |
|---|---|---|---|
| blue | cyanine | orthochromatic | green or orange |
| | gentian violet | | |
| | Giemsa | | |
| | haematoxylin | | |
| | methylene blue | | medium yellow |
| red | eosin | panchromatic | light blue |
| | fuchsine | | |
| | carmine | orthochromatic | green |
| yellow | safranine | panchromatic | red (to lighten) |
| | Sudan | orthochromatic | blue (to darken) |
| green | picric acid plus | panchromatic | red |
| | indigo carmine | | |

attachment fitted to the sub-stage itself. When choosing a filter, an excess of contrast should be avoided, as this may cause blocked-up shadow areas devoid of detail. Because of the position they occupy, filters used in micrography, either for viewing or for photography, do not have to be of optical quality. Nor need their actual colour be particularly accurate. Often almost any transparent coloured material may do. However, mounted close to the lamp, fragile gelatin or acetate filters may be damaged. Gelatin-in-glass filters are better, and dyed-in-the-mass types better still. The most popular sizes are 32 mm diameter discs and 50 mm squares. The former fit via a sub-stage mount and the latter in front of the lamp.

Mounting methods depend on the form of illumination employed. A condenser mount should be used when the light is reflected from the source by a mirror, but a more rigid mounting is necessary if the light source is an integral part of the microscope. If necessary, an optical-quality filter can be fitted immediately beneath the slide on the stage itself. Where a particular spectral transmittance is not available in glass or gelatin form, liquid-filled cells are used. These are plane

parallel-sided cells made from glass. In emergency they can be constructed using two pieces of acrylic sheet, between which is clamped a U-shape formed from an accurately-cut piece of 20 mm diameter rubber tube opened out. Formularies for the different transmittances of liquid filters can be found in the literature. Interference filters are also used in photomicrography; they are especially useful for really narrow waveband transmission where dye filters achieving the same performance would be too dense. Interference filters combine high selectivity with high light transmission, as noted above.

Curiously, there are circumstances in photomicrography when the illumination is too high. With infrared colour film, for example, pulsed xenon arcs or tungsten-halogen lamps are excellent forms of illumination, but because of the relatively high speed of the film a neutral-density filter is required to reduce the intensity of the light. Ideally the neutral density should be made of carbon and silver filters in the proportion of 1 : 2 to maintain the colour balance of the light source to suit the film. If using electronic flash or photographic equipment having either limited or fixed shutter speeds, and black-and-white pictures are required, neutral-density filters intended for general camera work may be used. Many crystalline substances polarise light, and often (for example in petrology) it is necessary to employ polarising filters to produce satisfactory photomicrographs. This is usually done by placing crossed polarising filters one each side of the specimen, and rotating the analyser filter as necessary to get maximum contrast.

### Photography by infrared
The areas of technical, scientific and research photography are too numerous to list, but in most, if not all of them, filters play an important role in acquiring the necessary data. Many areas, such as copying or investigative work on documents and paintings, aerial survey, plant pathology, hydrology, geology, ecology, archaeology and

many more, rely on techniques using infrared radiation, materials and filters. A number of these, notably surveillance work, for law enforcement, or where fear or timidity on the part of animals or human beings is concerned, call for techniques to be employed in total darkness. These techniques are well documented, but are not really within the scope of this book. The spectral response of the materials available calls for the use of filters if a satisfactory result is to be achieved. As a rule, infrared films are sensitised to wavelengths in the 700–850 nm regions; various scientific emulsions record longer wavelengths still. The two basic methods of infrared photography are the recording of subjects irradiated (illuminated) by the IR portion of daylight, and the recording of subjects illuminated by an artificial IR source. IR-sensitive black-and-white films appear appreciably slower than normal materials because exposure is made through a deep red or IR filter.

Because infrared radiation is scattered far less by the atmosphere than other wavelengths, outdoor photographs taken through an IR filter show detail at great distances, with improved contrast and almost no aerial perspective. This makes IR photography especially suitable for aerial reconnaisance and survey work. The high IR reflectance of chlorophyll lends itself to aerial work for agricultural identification and husbandry, especially in the detection and control of diseases (page 91). As IR-sensitive emulsions are inherently grainy, and (unless specially computed) lenses do not perform well in the IR region, such photography tends to be somewhat wanting in definition. For this reason IR aerial photography is usually backed up by photography on panchromatic film with a deep yellow (haze-cutting) filter. Infrared photography thus frees the aerial photographer from being limited to working only on clear days. IR materials eliminate haze between an aircraft and the ground, which would otherwise obscure detail and reduce contrast. In misty or light foggy conditions, where visibility is relatively limited, infrared photography

doubles the visibility distance and can be particularly dramatic in telephoto or long-distance work. It will not, however, penetrate fog, whatever science fiction may say. You cannot break the laws of refraction.

Both flashbulbs and electronic flash have a high infrared content, and can be used in many outdoor and indoor situations. When it is vital that no visible light escapes, a bag is fitted over the flashhead. This bag is made of several layers of infrared-transmitting material. Indoors, much use is made in forensic work, for example, of the fact that the majority of materials artificially coloured by dyes or pigments have infrared reflecting characteristics different from those of naturally-coloured materials or substances which they may appear to match under normal daylight or artificial lighting. Inks and paints that may appear similar or even identical by visible light are revealed as different. These differences become apparent when the materials are lit solely by IR radiation and photographed on IR film through an appropriate filter. This technique is useful for investigative work for detecting forgeries, dating fabrics, identifying philatelic fakes, examining restored paintings, etc. When comparisons of substances and materials are made, both the product under investigation and the known sample are photographed simultaneously to avoid the risk of differences being caused by exposure or processing etc. In medical work, the structure of blood vessels immediately beneath the skin is revealed by IR photography. Areas of human skin tissue are transparent to IR radiation, and photographs are made using the IR reflectance from layers beneath the skin surface, which accounts for lack of surface detail in the appearance of human faces in IR photographs.

The sensitivity and spectral response of IR materials deteriorate in storage. It is advisable to purchase them immediately before they are required for use. Black-and-white IR films should be stored under refrigerated conditions at about

Kodak filter 25

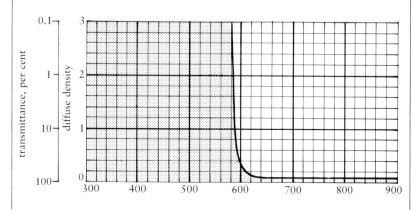

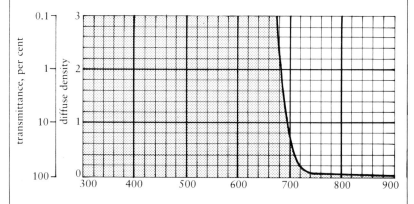
Kodak filter 89B

13 °C (55 °F) or lower, in their original containers. For prolonged storage periods, i.e. six months or longer, or for critical use, the film should be stored at −18° to −23 °C (0° to −10 °F). The films should then be removed from the freezer about four hours before use. This avoids not only the risk of physical damage to the film (which is brittle when cold), but also condensation forming from atmospheric moisture. If the film cannot be processed immediately after exposure, it should be returned to cold storage.

As explained earlier (page 91) infrared colour film is a false-colour film. Used with a blue-absorbing filter in aerial photography, it is capable of recording otherwise invisible variations in geology and vegetation, which make it particularly useful in the study of forestry and agriculture, Earth resources, and archaeology. Like black-and-white IR films, IR colour films deteriorate when subjected to high temperatures or humidities, suffering a loss of IR sensitivity and a shift in colour balance

towards cyan, as well as a general loss of speed and contrast; they should be stored in the same conditions as black-and-white IR films. Both types of film should be given plenty of time to reach ambient temperature (6−8 hours if possible) to avoid the risk of condensation.

Filters are necessary for infrared photography, and one type of filter transmits no visible light at all. Such filters are also used in some photographic accessories, a typical example being a remote control for a camera shutter. It consists of a transmitter and a receiver, the latter being connected to the shutter. Both are covered by IR filters which are opaque to visible light. Operating the transmitter sends an IR signal which is detected by the receiver, which then fires the shutter. The accessory can be used by day or night.

### Photography by ultraviolet

Other areas of technical, scientific and research photography employ ultraviolet radiation. Specific applications include dermatology, document investigations, fingerprints, metallurgy, mineralogy and photomicrography. Ultraviolet radiation extends from about 10 nm to about 380 nm, but between 10 and 200 nm it is absorbed by the atmosphere, and is therefore known as 'vacuum-UV radiation'. These wavelengths are of little general photographic value, though they are valuable in astronomical studies from outside the atmosphere. The remaining wavelengths are divided into UV-A (320−380 nm) and UV-B (200−320 nm), chiefly on biological grounds (A-radiation tans the skin, B-radiation burns it).

Earthbound UV sources emit both A- and B-type radiation, and can be dangerous if you do not know exactly what you are doing. It is not just a matter of sunburn, either. If you look directly at a UV source without a suitable eyeshield you may do irreparable damage to the cornea (the front surface) of your eye. UV sources have quartz envelopes, and lenses for UV work are also made of quartz, as glass is opaque to most of the ultraviolet spectrum. UV-A

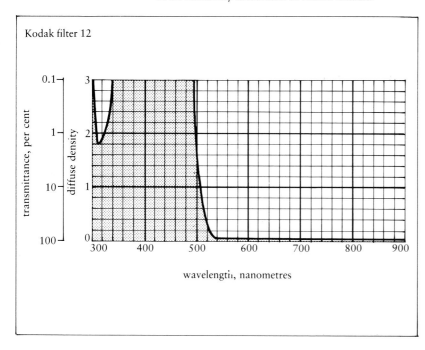

Kodak filter 12

transmittance, per cent / diffuse density / wavelength, nanometres

radiation is transmitted to some extent by many camera lenses, as we have seen (page 47). Images of subjects illuminated by radiation in this region will be recorded without the need for quartz lenses, though with some modern lenses with low UV-transmittance the exposure may be quite long, or may demand the use of a large aperture. UV-A radiation has more practical applications in photography than UV-B, and is confined to specialised work.

Ultraviolet is present in sunlight, of course, but it is also radiated by various artificial sources. Fluorescent tubes can be made suitable for UV photography by coating them internally with a phosphor which absorbs UV-B radiation and emits UV-A radiation. Tubes which emit only UV and no visible wavelengths are often referred to as 'black-light tubes'. The glass envelope is made opaque to visible light by additives such as colloidal silver. These low-pressure mercury-vapour tubes can be used in standard light fitments. So-called high-pressure mercury-vapour tubes are small tubular lamps with quartz envelopes, and require a step-up mains transformer; they take several minutes to warm up, and then produce a high output of UV-A radiation which, because of the small size of the source, is particular useful in photomicrography and UV spectrography. By incorporating certain chemical compounds into the cores of the carbon rods, arc lamps can be made to produce intense UV radiation. The 'arc' is a stream of extremely hot ionised gas which carries the current between the two electrodes and provides the light. An electromagnetically operated device maintains the correct separation of the electrodes as the carbon is consumed. In spite of their intensity, carbon arcs have the disadvantage of being erratic and inconvenient to use. A more efficient alternative is to use cadmium electrodes, which produce a high-intensity arc with a dominant wavelength of 275 nm. When operated in a quartz tube filled with xenon gas, visible light and infrared radiation are produced in addition. This is another valuable source of illumination for photomicrography. Electronic flashguns also emit UV radiation, those containing krypton or argon in addition to xenon emitting rather more. Even flashbulbs emit a certain amount of UV.

In order to make full use of the properties of UV radiation it is necessary to exclude visible light from the film. There are no gelatin filters suitable for this work, and glass filters transparent to UV-A radiation are the norm (e.g. the Kodak 18A). You need to take care to ensure all visible radiation is excluded from the lens. Screw-in filters are best; if a compendium holder is used it is necessary to shield stray light from entering at the sides. When considering a filter for UV photography you need to study its spectral absorption curve. It should if possible be totally opaque to visible light and totally transparent to UV. For work in the UV-B region you would have to use a lens made up of quartz elements. Such lenses are available for professional cameras, and can be hired from specialist suppliers, also filters of the interference type. Special techniques are required to determine exposure and to focus the camera. If a specially-designed exposure meter is not available, place the UV-transmitting filter over the cell of an ordinary meter, or on the lens for a TTL metering system. Exposures are likely to be quite long, and it is advisable to bracket upwards rather than downwards. There may be a slight shift in focus, UV wavelengths tending to focus slightly closer to the lens than visible light. A simple means of coping with this shift is to reduce the lens aperture by an additional two stops to increase the depth of focus at the film.

**Fluorescence photography** Another common use of UV photography is in the recording of fluorescence. Normal glass lens elements can be used for this work, as it is the visible fluorescence that is to be recorded and not the reflected UV radiation. This technique is much used in forensic work: even when fluorescence is present to only a very small extent, colour film is able to record the characteristic hues produced by the fluorescence of

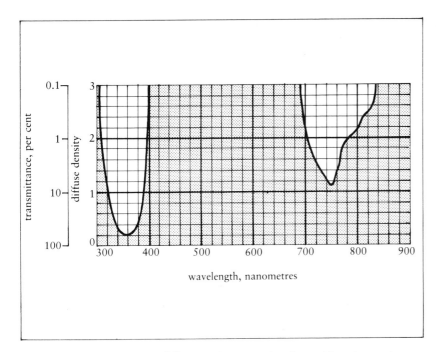

Absorption characteristic of a visibly opaque filter (18A) that transmits only in the ultraviolet and infrared. As noted in the text, it is used in UV photography.

spectral sensitivity of even the older-type CdS cells. Other colours may demand a series of bracketed exposures. These should be undertaken, in any case, since not only does the actual spectral sensitivity of the cells differ slightly from one cell to another, but also the sensitivity to fluorescent wavelengths varies between the different colour films.

### Specialised applications

The number of specialist technical applications for filters in industry and science is wide and varied, and many areas overlap. In many cases normal photographic filters are used. Special lenses intended for close-up work have their own built-in ring flash surrounding the front components, and may be used with polarising or neutral-density filters. Often light from the flashgun reflecting off moist lips, gums or teeth or internal organs may have to be subdued or eliminated if detail is to be recorded, and in ultra-close-up work the flash intensity may need to be reduced.

**'Notch' filters**  Special filters are available to isolate certain wavelengths in mercury-vapour lighting. There are three main filters, a yellow monochromat that transmits within the 577 and 579 nm lines and all longer wavelengths; a violet monochromat that transmits the blue-violet lines at 436 nm and deep violet at 408 nm, as well as one of the ultra-violet lines at 398 nm, and a green monochromat filter, which transmits wavelengths at approx 10 per cent of the green line at 546 nm and approx 0.2 per cent of the yellow lines. All these figures vary slightly depending on the manufacturer. Recent advances in interference-coating technology have resulted in filters of less than 9 nm bandwidth. These can isolate any line of the mercury spectrum with better than 90 per cent transmittance. One important use of these filters is in the display of laser transmission holograms.

**Graphics**  For graphic arts work, special colour-separation filters with narrow pass-bands that are optically uniform are required. Gelatins are

different substances, thereby enabling them to be identified. Liquids in fabrics (even after repeated washing), stains of body fluids, various paper types and erased matter from documents are typical subjects for detection by fluorescence photography. Lighting set-ups for fluorescence photography are basically similar to those used for photographing by direct ultraviolet radiation, except that a UV-transmitting (visually opaque) filter is placed in front of the mercury-vapour light source to restrict the radiation reaching the subject to UV, and a UV-absorbing filter is fitted in front of the camera lens to block any UV that might otherwise be transmitted by the lens. This ensures that only the fluorescence is recorded.

If bright enough, the fluorescing image may be focused visually on a reflex-camera focusing screen, but through-the-lens exposure readings should be accepted with caution. Those taken of orange-fluorescing objects, for example, will be reasonably accurate, since this is well within the

normally used to minimise the risk of variations in image size, which could make accuate registration impossible. In addition, as combinations of the various inks used for colour printing are unable to reproduce grey tones accurately or provide adequate density for a neutral black, an extra plate, referred to as a grey printer, is made in addition to the three separations for the colours. This is normally made from the original using a yellow filter, which gives approximately the right emphasis to the neutral areas. When halftone negatives are needed from a print on a fluorescent base it may be necessary to use a UV-absorbing filter over the light source if this is a carbon-arc or mercury-vapour lamp. Contrast control is achieved by means of weak yellow or magenta colour-compensating filters. A yellow filter may also improve the performance of a poor process lens when 'dot-for-dot' copying is undertaken.

**Photometric filters**  Special photometric filters may be needed when comparing the intensity of different light sources using a photometer. If these sources are of considerably different colour temperatures, it may prove difficult, if not impossible, to balance the photometer. In this case a selectively-absorbing photometric filter is placed over one side of the photometer head to reduce the colour differences of the sources so that actual brightness may be judged. Designed for purely visual use, this particular variety of photometric filter is normally supplied in two series, blue and yellow, the former usually being placed on the reference-lamp side of the photometer. The yellow series is used on the comparison or test side of the unit. The various filters in each series raise or lower the colour temperature by fixed mired shifts against a standard, usually a small filament lamp slightly under-run to prolong its working life. These filters are designed specifically for visual comparisons, and are not suitable for photography.

**Liquid filters**  In addition to their use for photomicrographic work (page 124), liquid filters are used in other scientific applications, for example to achieve accurate colour temperature control in the laboratory. Christiansen and Davis-Gibson filters play an important role in sensitometric measurements. For many colour-temperature measurements, that of mean noon sunlight is an important standard. This was chosen arbitrarily by the United States National Bureau of Standards, by averaging readings taken at midday at the summer and winter solstices, 21 June and 21 December 1926. A similar quality is reproduced in the laboratory by a tungsten lamp under specified conditions whereby it emits light of a given colour temperature which is then screened by the Davis-Gibson filter. This is two cells, each containing a different liquid, of specified chemical composition.

**Built-in filters**
Apart from filters built into lenses and enlargers (pages 39 and 140), filters are also used inside cameras and flashguns. In non-reflex cameras having rangefinder focusing devices, one of the images seen through the rangefinder windows is coloured (usually pale yellow, pink or straw-coloured) to provide contrast between the two images. This makes it much easier to determine precisely when the two images coincide for correct focus, especially when the subject is white or lightly coloured. Filters are fitted in front of meter cells to modify their spectral sensitivity to match more closely that of normal panchromatic or colour film. Sometimes the cell is encapsulated in the filter screen. Neutral-density filters are used in many flashguns, in some cases to 'modify' the sensor to compensate for slow-speed films. In others, neutral-density filters are slid in front of the sensor when the flashgun's output is reduced to half or quarter power (or less) when close-up work is being undertaken. They may also be fitted internally to exposure meters to change from 'low' to 'high' scales.

A safelight for small darkrooms; the coloured covers are interchangeable. *Paterson.*

130

# Filters in the darkroom

The majority of the filters so far discussed are used for modifying the light for picture-taking, whether fitted before, within or behind the lens, or on the source of light illuminating the subject. Those used in the image-forming light-path, i.e. between the subject and the film on which the image is recorded, have to be of high optical quality, so as not to distort the image – unless a special effect is required, when one of the various special-effects filters (pages 85–97) or the attachments detailed in pages 99–108 are used. Filters placed in front of the light source, affecting only the light falling on the subject or other parts of the picture area, need not be of optical quality. It is important only that they transmit or absorb the required wavelengths of the visible (or invisible) spectrum, reduce reflections, or fulfil whatever other purpose for which they are used with the necessary degree of accuracy.

There are also a number of different types of filters used for the second stage of the photographic process which takes place after the picture has been recorded. These are filters used during the processing of films and the exposing and processing of subsequent prints. Some of these filters modify the colour of the background working light, while others modify the spectral quality of the exposing light. Darkroom filters can therefore be divided into safelight and inspection filters, and printing filters. With the exception of those printing filters that are used between the enlarger lens and the printing paper during the exposure, the optical qualities and properties of other types of light filter used in the darkroom are of no consequence. Therefore they are less expensive to produce and to buy than optical-quality camera filters, and slight damage to them is generally less important, as long as their spectral quality is not impaired. Nevertheless, they should not, of course, be abused.

## Safelight filters

First, what is a safelight? Photographic films and printing papers are sensitive in varying degrees to different bands of wavelengths of the spectrum. As far as darkroom filters are concerned, this involves the visible spectrum, though colour materials are also sensitive to some ultraviolet wavelengths. A safelight, therefore, is simply a light source that emits visible radiation in the wavelengths to which the material is either least sensitive or totally insensitive. In the former case, the illumination has to be of sufficiently low intensity, at a sufficient distance and the material exposed to this illumination for a sufficiently brief time not to cause it to react. In the latter case, the insensitivity of the material to the particular band of wavelengths means that you do not need to be quite so careful.

Apart from the materials used to support their emulsions and the size and form in which they are available and used, the basic difference between general-purpose black-and-white camera films and black-and-white printing papers is in their spectral sensitivity. The vast majority of films are panchromatic, whereas black-and-white printing and enlarging papers are mainly blue or blue-and-green sensitive; the cut-off wavelength varies according to the type of paper. In the case of variable-contrast papers such as Ilfospeed Multigrade and Kodak Polycontrast, for example, the sensitivity of the emulsion is extended into the green region; this material is sensitive to radiations within wavelengths of approx 350–570 nm.

It will be appreciated that in theory there is no light within the visible spectrum under which panchromatic films may be handled without the risk of their becoming fogged. In practice. though, certain safelight colours are recommended by film manufacturers: usually a very dim green for panchromatic emulsions, as long as the material is exposed only to its indirect light, and for very short periods. Ideally panchromatic films should always be developed in total darkness. Orthochromatic emulsions may be quite safely handled under a deep red safelight, as red is a colour to which they are not sensitive. Black-and-white printing papers, on the other hand, can be handled under a wide range of safelight colours, provided that these contain only wavelengths to which the emulsions are insensitive. As long as the spectral energy of the safelight is restricted to these regions and the light is in good condition, the paper may be handled for prolonged periods in direct light almost regardless of its intensity. In practice few safelights transmit and absorb radiations sufficiently accurately for total safety. Also, with the average small enclosure used to house the lamp and the screen, the size of the lamp is restricted, because ventilation is usually by convection; too powerful a lamp will cause the safelight screen to bleach or crack, and begin transmitting other wavelengths. Therefore each safelight has a recommended lamp size and working distance.

Typical wavelengths to which general-purpose black-and-white enlarging papers are insensitive are red, orange and yellow; many are also insensitive to green. Ilford Multigrade papers may be handled in the light of a light brown safelight No 902, as long as the wattage of the bulb does not exceed 15 W. Depending on the materials used and the construction of the unit, the permitted wattage of a safelight lamp is usually in the region of 15–40 W. One popular type safelight consists of a conical, tubular or bottle-shaped plastics container, the base of which houses the lampholder and provides the wall support or stand. A screw-on or clamp-on self-coloured translucent cover provides the safelight filter screen. Another popular type consists of a metal box, again containing the lamp and providing the means of support, but with one face open. Into this opening is slid a suitably-coloured safelight filter screen, which may be made from dyed glass, or may be a glass-and-gelatin sandwich.

The plastics types are relatively inexpensive and are popular with beginners and owners of small

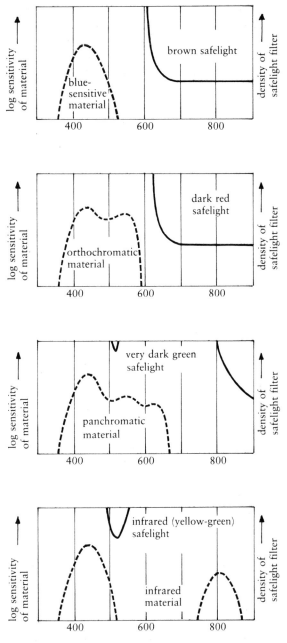

Absorption characteristics of commonly used safelight filters, and the spectral sensitivity characteristics of materials for which they are appropriate.

darkrooms; they give a good level of illumination, and only the dome or cover need be replaced as the filter screen ages. This type may be stood on a flat surface or hung horizontally. It should not be allowed to hang upside-down or it may overheat. In no case should the recommended lamp size be exceeded. The box unit is far more practical and efficient for the professional or advanced amateur and those with a large darkroom. It is available in various sizes up to $20 \times 25\,\text{cm}$ ($8 \times 10\,\text{in}$) and larger to order; it may be stood or suspended at any angle; and filter screens are easily and quickly changed according to the material being handled. Initial cost is higher than the plastics type described above, but filter screens are relatively inexpensive; this type of safelight also takes larger lamps and gives more light. At one time 'safelight' lamp-bulbs were available. Similar in shape to a domestic lamp, these were lacquered a suitable colour and could be fitted into a domestic bayonet lamp socket. In time the heat generated would cause the lacquer to bleach, sometimes to crack, and even to peel off the glass envelope, rendering them useless. These bulbs have virtually disappeared, having been replaced by more efficient and reliable safelights.

Bright lighting for blue-sensitive emulsions is provided by a sodium-vapour lamp similar to yellow sodium street lamps. Unlike tungsten-filament lamps, most of whose light is wasted by being absorbed by the filter screen, sodium lamps emit virtually all their radiation in a very narrow band of wavelengths at 589 nm, and only a very weak continuous spectrum (which is due to their high operating temperature). By fitting a narrow-pass filter screen which absorbs the continuous background, better use is made of the light output and less power consumed. Another very efficient safelight that has been recently developed for printing darkrooms is a fluorescent tube lined with a single phosphor fluorescing only in the yellow band of the spectrum. The tube is sprayed with a filter lacquer which absorbs ultraviolet and any stray actinic radiation. This type of safelight has the great merit of being almost

shadowless, owing to its length of 1.2 metres (4 feet). Another advantage is that such lamps run comparatively cool, and the life of the tube is very long. They fit into a standard household fitting, but are more often supplied in a double fitting, paired with a white colour-matching fluorescent tube; pulling a cord switches one tube off and the other on.

Another recent development is a darkroom safelight, suitable for colour printing, employing light-emitting diodes (LEDs). These are specially selected so that they emit the particular required wavelength over a very narrow bandwith, less than 20 nm, the extremes of their spectral transmission curve being cut off by a limiting filter screen. An even more recent development uses the same principle, but the LEDs are pulsed; this has the effect of giving light which is two and a half times as bright, though with the same restricted bandwidth. Such a solid-state light source has several advatages: it is flat, it is totally free from the danger of fading or changing in colour, and it emits no heat. Different safelights are available for colour negative-positive processing and colour-transparency printing and for infrared work; it is permissible to expose materials to these safelights for up to 10 minutes at one metre distance.

More conventional safelights are also available for handling colour materials. Those for colour-negative printing paper are orange-brown in appearance, the transmittance band of the filter being calculated so as to fall into the gap between the sensitivities of the red-sensitive and green-sensitive emulsions. A similar, though rather darker, safelight is available for direct-positive colour papers used for making prints from transparencies. This is much less safe, and it is recommended that, in general, direct-positive prints should be processed in total darkness. There are also safelight filters available for infrared monochrome film (green) and for holographic emulsions sensitised for use with helium-neon and ruby laser light (blue-green); emulsions for argon

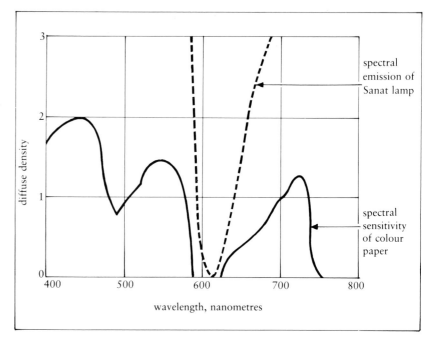

The emission of the Sanat sodium lamp. Colour paper is insensitive to the peak emission wavelength but slightly sensitive to emissions above 650 nm, so exposure time should be limited to avoid any fogging.

and helium-cadmium laser light can be processed under a red (orthochromatic) safelight. X-ray emulsions can also be handled under an ortho safelight, though a special red-brown one is available.

Darkroom safelights should be positioned so as to provide adequate overall shadowless illumination of workbench, timer and processing area. All cables must be kept clear of doors (including those of cupboards and dryer), trimmer and enlarger, and well out of reach of accidentally-splashed liquids. Indirect lighting bounced off a white ceiling or wall provides an even, shadowless illumination which is efficient and lessens the risk of eyestrain. Remember, though, that no 'safelight' is safe under all circumstances, especially those intended for panchromatic or colour material. It is, in particular, unwise to increase the wattage of the lamp bulb beyond the recommended power, or to bring the lamp nearer the working surface than the recommended distance. At best the outcome will be

a print with veiled highlights; at worst it will be a muddy print lacking in contrast, that may need to be snatched from the developer to prevent it from going black.

**Testing for safety** When using any new safelight filter screen for the first time, it is good practice to carry out a test to ascertain the safe working distance and handling time for the materials with which it is to be used. This is done by exposing the material in its usual working place, in test strip fashion, for varying times, including those in excess of the norm. Photographic materials are generally more sensitive to fogging after exposure than before it. The tests are therefore best carried out after the material has been given a basic exposure to overcome its inertia threshold.

First, in total darkness take a reasonably-sized piece of paper, say $13 \times 20\,\text{cm}$ ($5 \times 8\,\text{in}$); expose it by the light of the enlarger, for example, without a negative in the carrier, and the aperture closed down, for a second or two, so that it is lightly fogged to a very pale grey. Try several exposures, develop the strips fully, and compare the result with a strip which has been fixed without development. For this test do not use the enlarger's red swing filter; like other safelight filters under discussion, this one is susceptible to fading, and it, too, should be checked at regular intervals. It is cheaper to replace a safelight filter than to waste quantities of enlarging papers.

Next, still in total darkness, place six coins on one of your strips, in a straight line. Switch on the safelight for 15 seconds and then cover up the part of the strip bearing the first coin, using an opaque card. Give the remainder a further 15-second exposure to the safelight and then cover up another strip. Expose the rest to the safelight and repeat the process for 30 seconds, 1, 2 and 4 minutes exposures. The strips will then have had exposures of 15 seconds, 30 seconds and 1, 2, 4 and 8 minutes respectively. Switch off the safelight and process the paper in the normal way, but in total darkness.

After processing, examine the paper to see whether the outlines of any of the coins are visible. Any that are visible will indicate times that should not be reached for the material to be handled under the safelight at a particular distance, otherwise fogging will occur. Choose the next step down (i.e. shorter exposure) from the first one with visible outlines as the maximum time that the material may be exposed to the safelight before processing.

Incidentally, this test is valid only if the darkroom itself is free from stray light, including that from various parts of the enlarger etc. during exposure. Any light leaks negate the value of the results and give a false impression, usually to the detriment of the safelight. You can test for light leaks in exactly the same way, this time with the safelight off. Remember that the enlarger lamphouse can also be a source of light leaks, so do a separate test with the enlarger switched on and its lens cap in position.

**Safelights for colour**
Colour-printing papers and print materials, quite naturally, are sensitive to all colours of the spectrum (as well as ultraviolet and infrared). Consequently they are best handled in total darkness. Since this involves only the extracting of sheets from the packet or box and placing in the masking frame prior to exposure and then from the frame into a light-tight drum for processing, this is no hardship. Papers for printing from colour negatives have three emulsion layers, but their sensitivity peaks are farther apart than those of the three layers in colour films. In particular, there is a gap between the spectral sensitivities of the 'red' and 'green' emulsions, and a special safelight is designed to exploit this gap, having a spectral passband in the region of minimum sensitivity. If prints are to be dish-processed, the lamp may prove useful for initial location of dishes etc., but do not reduce the recommended minimum working distance or the paper may become fogged. Colour film should be handled and processed in total darkness. Manufacturers give specific recommendations for safelights suitable for their

various products, and these (or their direct equivalent) should be adhered to at all times. When in doubt, increase the working distance; better still, work by indirect light or in total darkness.

**Enlarger swing filters**
Another type of 'safelight' is the red or deep orange filter mounted beneath the lens of most enlargers. This is swung into the light path to help to accurately position the paper on the baseboard before exposure and to make final adjustments to composition. The exposure can be made by swinging the filter out of the light path and swinging it back to cap the lens when the exposure is completed. This filter is suitable only for black-and-white enlarging papers and cannot be used to protect colour materials. In the same way as for your printing safelight, you should make a point of testing this filter with any kind of enlarging paper you use.

A more unusual use for a filter in the darkroom has recently been introduced in the 25 mm focal length $f$/2.8 Schneider Computar DL enlarging lens. This is a short-focus wide-angle lens designed to give big enlargements while avoiding a long extension, and to overcome the vignetting and unevenness of illumination that is characteristic of lenses of this type. A neutral-density coating is applied to some of the surfaces to restrict light rays passing through the central area; this coating acts in a way similar to the star-shaped metal masks that were dropped into the diaphragms slot of early wide-angle lenses used on field and studio cameras to restrict the passage of central rays and counteract the fall-off of illumination at the edges of the field that was common in those early designs.

**Filters for variable-contrast papers**
In order to make prints from a range of black-and-white negatives having widely varying contrasts, different photographic papers are available, each of which has an emulsion of different contrast characteristics. Papers usually described as soft, or grade 1, are used for printing

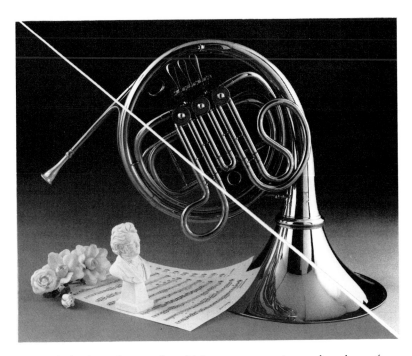

Above: the hardest and softest results obtainable from Multigrade variable-contrast paper.

Left: absorption characteristics of two colour-material safelight filters. The upper one is dark yellow (Kodak No.8), the lower one is dark amber (Kodak No.10). It is best to work in total darkness, however.

negative, and a high-contrast image by exposing only the blue-sensitive portion. By varying the proportion of blue and green in the exposing light, an infinitely variable contrast range between the two extremes can be achieved. Like other variable-contrast materials, Ilfospeed Multigrade is exposed through filters. There are seven of these, coated on a polyester base of high optical quality, and designed to be used below the lens of any small- or medium-format enlarger. They are also available in sets for use in the filter drawer of a colour enlarger.

High and low contrasts with Ilfospeed Multigrade are achieved manually using yellow filters which absorb blue light and transmit green light to produce the low-contrast image, and magenta filters which absorb green light and transmit blue light to produce the high-contrast image. By carefully selecting the saturation of these filters a range of regularly-spaced contrast 'grades' can be achieved. With Ilfospeed Multigrade paper, the seven filters give a contrast ranger wider than grades 0–4 of conventional Ilford printing papers. Each of the filters in the kit is supplied mounted in a plastic holder on which is clearly stamped its identity number. The filter with the lowest number is the densest yellow, that with the highest number the densest magenta. A special holder for mounting beneath the enlarger lens is also supplied as part of the kit. Prints of normal contrast are made unfiltered, but by using the filters the 'grade' steps are less widely spaced than with materials having a conventional emulsion. You can also get 'grades' between the steps by removing the filter for part of the exposure.

from high-contrast negatives such as those of high-contrast subjects, or those which have been accidentally or deliberately overdeveloped, where 'soft' prints having a limited tonal range are required. On the other hand, hard (grade 3) or extra hard (grade 4) papers are used for printing from low-contrast negatives, such as those of low-contrast subject matter, or ones that have been incorrectly exposed and/or underdeveloped.

In addition to these papers, manufacturers have produced variable- or multi-contrast papers, the best known of these being Ilford Multigrade, a resin-coated paper (i.e. the paper base is laminated with polyethylene on both sides). Variable contrast in a single emulsion is achieved by having the emulsion made up of a mixture of green-sensitive and blue-sensitive silver halide crystals, the green-sensitive crystals having a low inherent contrast compared with the blue-sensitive crystals. A low-contrast image is achieved by exposing only the green-sensitive portion of the emulsion to the

The change in exposure time when changing 'grades' using filters can be quickly calculated, whereas tests have to be made with conventional-emulsion papers and then assessed. The contrast of different areas of the print can be varied to suit the subject and the effect required, simply by choosing a suitable filter. This gives tremendous scope to the artistic and interpretive

skills of the photographer/printer. There are several advantages for the darkroom worker in using a variable-contrast paper for black-and-white print making. For example, it saves the need to have boxes of different grades of the paper in the same surface, weight, size etc. to cope with a wide range of negatives. Also it is possible to vary the contrast of selected areas of a print by dodging with a piece of filter material.

**Multigrade enlarger head** Ilford make a special filter-mixing head for fitting to medium- and large-format enlargers. This enables the range of Multigrade filters to be 'dialled-in' to the light path and to be easily changed or reset when exposing different areas of the print. Various enlarger manufacturers are designing special heads or adaptations for existing colour-mixing heads for filters suitable for Ilford Multigrade paper. One such manufacturer, Leitz, have produced a special Multigrade head for their 35 mm Valoy enlarger. This has a separate control that removes the filters from the lightpath for focusing etc. and replaces them when required for exposure. Incidentally, it is not vital to use either the filters produced by Ilford for its Multigrade materials nor the special heads being manufactured for various enlargers. If you possess an enlarger fitted with a colour-mixing head, it seems only logical to use the yellow and magenta filters that these contain for Multigrade printing. Adjustment of the yellow and magenta filters gives full contrast control; although the results from the particular settings may need some initial trials, because of their particular characteristics these are well worthwhile. It is unlikely that the filters in a normal enlarger colour-mixing head will obtain the highest contrast that can be achieved with the individual Ilford filters. Nor should the number of the Ilford filters be taken to represent or relate to the various contrast grades that they help to achieve.

### Filters for colour printing
Like those for colour films, the emulsions of colour enlarging papers are made up of layers sensitive to the individual primary colours: blue, green and red (though in general the peak sensitivities are spaced father apart in order to give full colour saturation and avoid overlap, or 'crosstalk'). The exposure of the negative (or transparency) is recorded in these layers, and on subsequent development the print displays the colours of the original. If all dyes used in colour materials were perfect and exactly matched from batch to batch, and if the print-exposing light exactly matched the light for

Unmounted gelatin foils for use in the filter drawer of a colour enlarger.

138

the original exposure and that for which the materials were balanced, the paper could be exposed to the negative or transparency without any intervening filtration. But fortunately it is not necessary to meet such difficult criteria, as we can use filters to control the colour of the light reaching the paper during enlarging.

There are two basic methods, additive and subtractive; each has its devotees. To make an exposure using the additive system, separate exposures are made through each of three primary-colour filters. The duration of the exposure through each is adjusted to achieved the desired colour balance. The subtractive method employs what are known as the subtractive (or complementary) hues: magenta, cyan and yellow. Magenta transmits blue and red and absorbs green; cyan transmits blue and green and absorbs red; and yellow transmits green and red and absorbs blue.

Filters can be inserted into the enlarger light path in three ways: beneath the lens (between lens and paper) in the image-forming light path; in a tray or drawer above the enlarger carrier; or within a mixing head or chamber within the lamphouse. The first of these positions is usually chosen for use with additive-method filters. This system has the advantage of requiring only three filters, but as these are inserted into the image-forming light path they must be of optical quality. Recently, Philips have introduced an enlarger having the three primary colour filters fitted into the lamphouse, each having its own low-wattage lamp with which to make the exposure. The second position, the filter drawer, is used mainly for the subtractive method, as different densities of the various filters may be required, and only a single exposure need be given through the filter pack. Using additive filters singly with the filter drawer risks movement between exposures.

Fitting filters within the lamphouse is the preferred method, though costly. The filters, called 'dichroic filters', are usually coated on glass and operate by optical interference (page 121). Dichroic filters are to be preferred for use in a colour-mixing head because they can resist high temperatures, and can be located at the small focused spot from the low-voltage tungsten-halogen lamps that are normally used as the light source. They depend for their efficiency on thorough mixing of light in a blending chamber, consisting of white polystyrene or other highly reflective material. One make of enlarger uses a fibre-optics rod to convey light from

Additive filters used beneath the enlarger lens must be of optical quality and scrupulously clean.

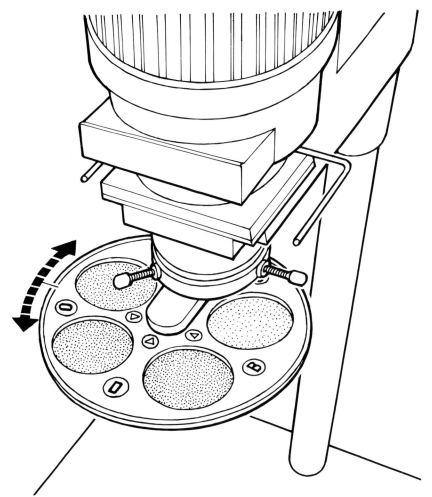

the blending chamber to the carrier, to minimise the possible light loss of a direct or indirect enlarger lighting system.

Controls for each filter enable the enlarger operator to adjust the mix of the light, moving the filters in accordance with a scale of reference units. Three series of units are currently in use: those for the Kodak system, those for Agfa and those for Durst. Most manufacturers of colour-printing paper indicate a basic filtration for each batch of material. This is usually printed on each paper packet or box and acts as a starting point from which initial test prints can be made. This basic filtration is nowadays usually about 40 magenta plus 40 yellow. This red bias means that it hardly ever necessary to dial-in cyan, which has a large filter factor.

To avoid over-long exposure times, it is usual to employ no more than two of the filters at a time for any colour mix. The addition of a third filter would be equivalent to putting a neutral-density into the filter pack, which would simply be a waste of light; the correct procedure is simply to lower the density of the filters that are already in the light path. Just occasionally it may be more convenient to introduce (say) 0.25 cyan rather than reduce both magenta and yellow by 0.25. To assist the user to determine the correct filtration for any given negative or colour slide, a colour analyser can be used. This is often combined with an electronic timer, for automatic compensation as the density of the filters is adjusted.

**Janpol lenses** An interesting development is an enlarging lens with subtractive colour-printing filters built in. Made by Warszawskie Zaklady Foto-Optyezne in Poland and marketed under the brand name of Janpol, these lenses are available in 55 mm and 80 mm focal lengths, each having a maximum aperture of *f*/5.6. The Janpol-Color lenses are high-quality four-element lanthanum-glass optics, and are available in standard 39 mm or 42 mm diameter screw-thread

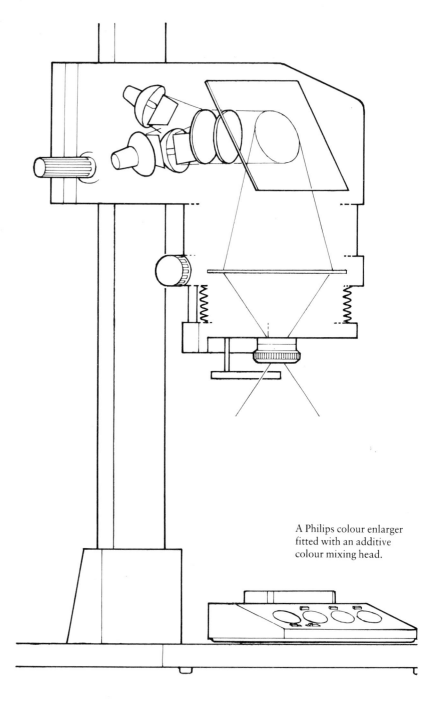

A Philips colour enlarger fitted with an additive colour mixing head.

fittings, so can be used on the majority of popular enlargers. Built into each are the subtractive filters yellow, magenta and cyan, made from optically-flat coloured glass; these are controlled by a pair of large knobs, one on each side of the unit. One knob controls yellow and magenta filters while the other controls yellow and cyan. Density scales are engraved on each knob (there is a choice of scales containing either Kodak or Agfa units) and a plastics light-guide bleeds illumination to the scales during initial setting-up. The knobs rotate without click-stops; thus the filter settings are infinitely variable. As Janpol-Color lenses have filters built in, they can be used for colour printing with the very simplest of enlargers designed for black-and-white work, and the filters are impervious to damage or fading, a worthwhile feature. Zero setting of each filter enables the lens to be used for black-and-white work, and its yellow and magenta filters enable it to be used for printing with Ilfospeed Multigrade papers.

## Heat-absorbing filters

Heat-absorbing filters are used in many areas of photography; they are to be found within enlargers and projectors, and equipment used for commercial printing. Generally referred to simply as 'heat filters', these are usually made from glass that transmits all the visible spectrum, but absorbs infrared radiation. They are positioned between the lamp and the negative or transparency to prevent the film from buckling in the heat. In some systems employing optical condensers, the condenser lenses may be made from glass having heat-absorbing properties, to perform both functions. A heat-absorbing filter is needed in many optical systems that employ a tungsten lamp as the light source, especially if the film is to be exposed to the lamp for long periods. A slide projector is a typical example, where the slide may be exposed to the lamp for 30 seconds or more.

Heat filters must be included in the original design of the optical system. This is because the filter absorbs infrared radiation, which it converts into

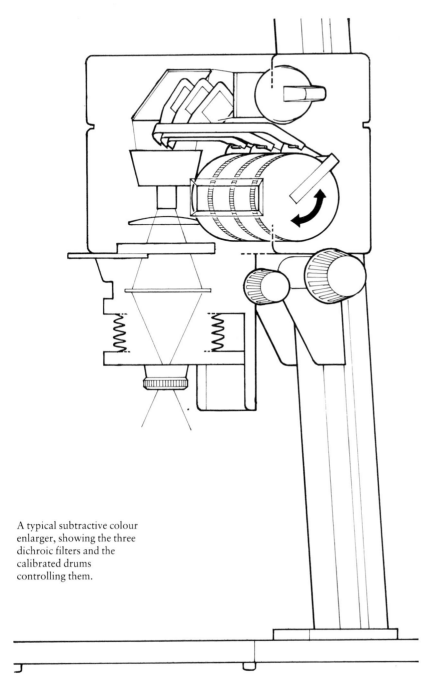

A typical subtractive colour enlarger, showing the three dichroic filters and the calibrated drums controlling them.

heat energy. This must be dissipated evenly by convection or forced draught, otherwise the filter will overheat and may become cracked or otherwise damaged. A damaged filter is unsafe to use. Consequently, a glass heat filter should not be introduced into a system where its use was not originally intended, unless you are certain that the design will accommodate it, or can be suitably modified. Recently, the need for a separate glass heat filter has to a great extent been overcome by employing a lamp reflector that is coated with an infrared-transmitting interference filter layer. This reflector is mounted close behind the lamp, or may even surround it, collar-like, in which case the reflector with its integral lamp is purchased as a single unit.

The heat filter consists of an interference (or 'dichroic') coating which reflects all colours of the visible spectrum while transmitting infrared radiation. In this way light from the lamp is reflected towards the film in the projector gate, but infrared radiation passes through the reflector, the heat energy being dissipated through vents or louvres in the unit by a built-in fan. The system has several advantages. The lamp is always at the optical centre of the reflector, so no critical alignment is necessary when the lamp is replaced; the temperature of the lamp can be accurately controlled for peak efficiency, and to maintain its chemical cycle if it is of the tungsten-halogen type; small-filament, low-voltage lamps can be used because each reflector is accurately matched to the lamp to ensure maximum light reflection and evenness of illumination.

Cine projectors rarely require a separate heat filter, as the film is in the heat of the lamp for only about 1/30 second. In stop-frame projection, though, a heat filter is automatically introduced into the film light path when the 'freeze' button is pressed, usually between the condenser and the film. This is essential, as the light beam is so concentrated that it would otherwise burn a hole in the film in seconds. Because of the intensity and concentration of the

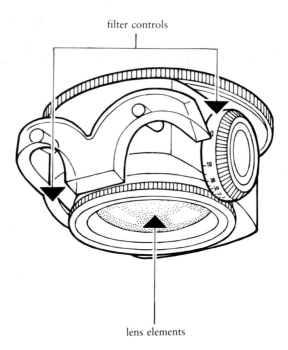

filter controls

lens elements

The Janpol enlarger lens has subtractive colour printing filters built in.

light from the lamp to an almost point source, the heat filter used in cine projectors is fairly dense and reduces the light that is transmitted by some 50–60 per cent. Most cine projectors, especially Super 8 and 16 mm types, now use low-voltage tungsten-halogen lamps with built-in dichroic reflectors. With some models a separate heat filter is introduced for single-frame projection, while in cheaper models the output of the lamp is reduced. In all cases, though, because of the dichroic reflector and its efficient infrared transmission properties, the projector cooling fan nowadays extracts rather than blows the hot air. The result is a less hard-working fan and a quieter-running projector, a valuable asset for sound models.

*Frank Peeters*

143

# Index